FLORIDA'S WATERS

Volume 3 of the Three-Volume Series

Florida's Natural Ecosystems and Native Species

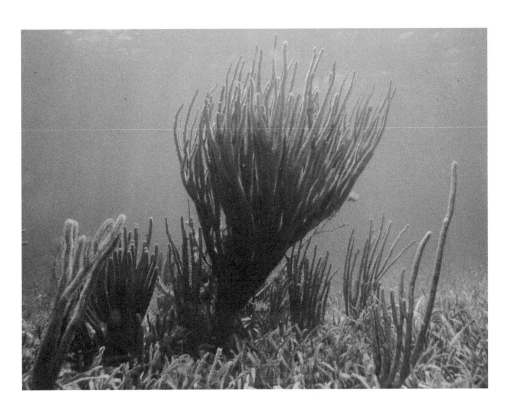

Ellie Whitney, Ph.D.

D. Bruce Means, Ph.D.

Anne Rudloe, Ph.D.

illustrated by

Eryk Jadaszewski

D1597553

PINEAPPLE PRESS, INC.
SARASOTA, FLORIDA

DEDICATIONS

*To the memory of my husband, Jack Yaeger, whose love for wild Florida
I now carry forward.*

—Ellie Whitney

*To all the animals, plants, and ecosystems that have gone extinct because
of mankind, and to those we are now threatening.*

—Bruce Means

*To all the kids now playing on the beach, who will continue this work
in the next generation.*

—Anne Rudloe

Inquiries should be addressed to:
Pineapple Press, Inc.
P.O. Box 3889
Sarasota, Florida 34230

www.pineapplepress.com

Library of Congress Cataloging-in-Publication Data

Whitney, Eleanor Noss, author.
 Florida's waters / Ellie Whitney, Ph.D., D. Bruce Means, Ph.D., Anne Rudloe, Ph.D.; illustrated by Eryk Jadaszewski.
 pages cm.
 Includes bibliographical references and index.
 ISBN 978-1-56164-868-9 (pbk.: alk. paper)
1. Aquatic ecology—Florida. 2. Biotic communities—Florida. I. Means, D. Bruce, author. II. Rudloe, Anne, author. III. Title.
 QH105.F6W456 2014
 577.609759—dc23
 2014024191

First Edition
10 9 8 7 6 5 4 3 2 1

Design by Ellie Whitney
Printed in the United States

CONTENTS

FOREWORD v

PREFACE vi

1. FLORIDA'S AQUATIC ECOSYSTEMS 1

2. INTERIOR WATERS: LAKES AND PONDS 17

3. ALLUVIAL, BLACKWATER, AND SEEPAGE STREAMS 35

4. AQUATIC CAVES, SINKS, SPRINGS, AND SPRING RUNS 53

5. COASTAL WATERS: ESTUARIES AND SEAFLOORS 67

6. SUBMARINE MEADOWS 87

7. SPONGE, ROCK, AND REEF COMMUNITIES 99

8. THE GULF AND THE OCEAN 113

* * *

REFERENCE NOTES 127

BIBLIOGRAPHY 129

APPENDIX: TERMS FOR FLORIDA'S AQUATIC ECOSYSTEMS 132

PHOTOGRAPHY CREDITS 134

INDEX TO SPECIES 135

GENERAL INDEX 140

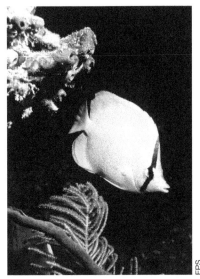

Spotfin butterfly fish (*Chaetodon ocellatus*), native to the Florida Keys.

ACKNOWLEDGMENTS

Anne Rudloe, Ph.D. was our coauthor on *Priceless Florida*, from which this book was adapted. She died in April, 2012, leaving behind many beautifully written publications and countless children and adults who learned from her to love the plants and animals of Florida's coastal wetlands and waters. We are grateful for her contributions to this book.

We are also indebted to many people for their contributions of expert knowledge and sound counsel: biologists Wilson Baker and Susan Cerulean; naturalist Giff Beaton; botanists Andre Clewell, Angus Gholson, and Roger Hammer; environmental specialist Rosalyn Kilcollins; educator Jim Lewis; geologists Harley Means and Tom Scott; meteorologist John Hope; and paleontologist S. David Webb.

Our associcates at Pineapple Press have been wonderfully supportive: June and David Cussen, Shé Heaton, and Doris Halle.

The photographers who have contributed images to these pages are listed on page 134. Every one of them has been cooperative and we sincerely thank them all.

Title Page Photograph

A soft coral growing in a seagrass bed off Florida's coast.

Photograph by Richard Poley.

FOREWORD

Priceless Florida was first published in 2004 as a 423-page book that presented all of Florida's upland, wetland, and aquatic ecosystems. Welcomed by a reading public eager to learn about natural Florida, it was widely shared and appreciated among visitors to the state as well as by year-round residents. Victoria Tschinkel, state director of The Nature Conservancy, Florida Chapter, wrote high praise into the Foreword:

> *Priceless Florida is one of the most important books ever crafted about Florida's natural history. . . . The scientific and educational lessons within these pages are simply astounding. Collected within this marvelous book are detailed natural histories of the native species and communities that comprise Florida. . . . Florida's inhabitants, human and other, depend on the state's fragile environment for survival, but the challenges ahead are enormous. Rapid growth drives the need to secure a system of parks, forests, and wildlife management lands. Without a core system of conservation lands to sustain the ecosystem functions and services upon which all life depends, the quality of life for every Floridian will suffer. Humans also need open space for recreation, water supply, rejuvenation of spirit, and reconnection with nature.*
>
> *I have no doubt that the readers of this book will become ardent proponents of this message, and most importantly, will love wild Florida even more.*

It is now time for a second edition—but because the original book was a large volume, we decided to split it into three smaller books this time: *Florida's Uplands*, *Florida's Wetlands*, and *Florida's Waters*. These are true derivatives of the earlier book. We have brought forward many of its beautiful photographs and much of the original text, updating it where necessary to keep it current.

It has been a pleasure to revisit Florida's natural ecosystems and to know that they remain, as before, beautiful examples of what nature has bequeathed us in this topographically diverse state. We hope that these books will bring pleasure and useful knowledge to readers today as before.

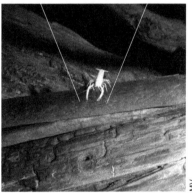

Woodville cave crayfish (*Procambarus orcinus*), a Florida endemic species that inhabits a single underwater cave system in Leon and Wakulla counties.

PREFACE

This is the third of three volumes presenting Florida's ecosystems. Volumes 1 and 2 present Florida's upland and wetland ecosystems respectively; this volume presents the aquatic ecosystems.

The emphasis is on *natural* ecosystems in healthy ecological condition, as far as scientific studies have determined. Many books present short descriptions of the natural world and then devote many pages to the damage that has been inflicted on them. Such books serve a useful purpose, but in this one, natural ecosystems are given all the space available.

Similarly, *native* species are in the spotlight throughout. They, too, are fascinating, because they evolved in and are specially adapted to Florida's aquatic environments. We have singled out one or more groups of species for special treatment in each chapter to demonstrate their diversity.

Lists of some of the native species of plants and animals in some ecosystems accompany the text of each chapter. The lists are not intended to provide exhaustive species inventories (encyclopedic references do that), but to show the reader some of the important species that are present in, and adapted to, each habitat.

About the names of species: Most readers doubtless are more comfortable with their common names, such as "bonnethead shark," whereas other readers prefer the precision of scientific names such as *"Sphyrna tiburo."* To accommodate both preferences, all species are identified by their common names, but those depicted in photos are identified both ways, and the Index to Species provides the scientific names for all species mentioned in the book.

Bonnethead shark *(Sphyrna tiburo).*

In this volume, Chapter 1 introduces the watery environments to which the creatures native to Florida's waters are adapted. The succeeding chapters display the aquatic ecosystems—first, the interior waters (lakes, ponds, streams, and springs) and then the coastal waters (estuaries, seagrass beds, sponge communities, and others). The concluding chapter is devoted to the Gulf of Mexico and the open ocean, and concludes with a description of the value of unspoiled, natural systems.

Only when one understands something, can one come to love and cherish it. We hope the readers of this book will gain an in-depth understanding of Florida's natural aquatic ecosystems, and thereby appreciate them more. Being better informed may empower readers to involve themselves in issues that deal with the conservation of Florida's natural treasures.

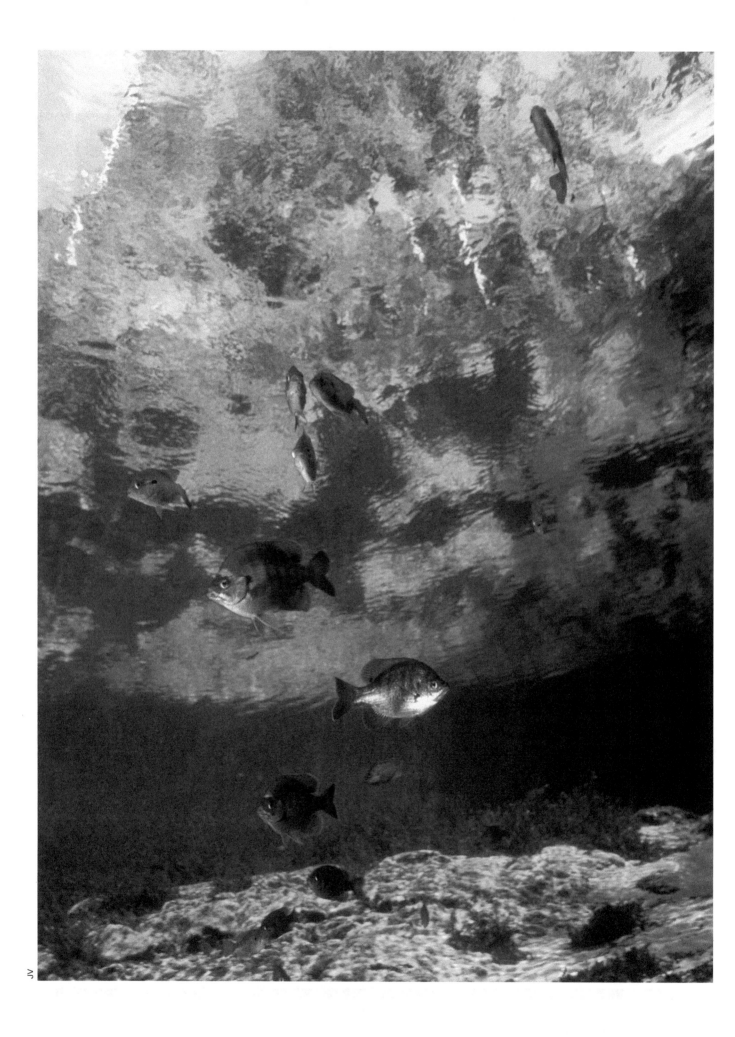

CHAPTER ONE

FLORIDA'S AQUATIC ECOSYSTEMS

Florida is officially known as the "Sunshine State," but it might better be called the "Water State." It receives about 97 full sunshine days a year on average, but it has about 116 days of rain, adding up to 43 to 63 inches a year.[1] In addition, water amounting to some 50 billion gallons a day flows into Florida from the states to the north.[2] Moreover, Florida is surrounded on three sides by the Gulf of Mexico and Atlantic Ocean and it has a 1,350-mile shoreline, longer than that of any other state except Alaska. Three million acres of Florida's landscape are occupied by lakes and ponds, more than 30,000 of them, including the nation's fourth largest lake, Okeechobee, which is 448,000 acres in area. Still larger is south Florida's Everglades marsh, a shallow, slow-flowing wetland, 734 square miles in extent. Moreover, Florida has the world's largest system of clearwater springs, more than a thousand of them, 33 of which are of first magnitude. Together, these springs discharge more than two billion gallons of crystal-clear water per day into dazzling, spring-run rivers. And north Florida boasts of several hundred "steepheads"— stream valleys formed by water seeping out of aquifers perched in deep sand. And as if that weren't enough, beneath the whole state there is abundant groundwater.

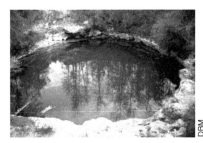

Pure, clear water is visible in this sinkhole, which is a window into a local aquifer. The white rocks around the sink are limestone.

A **first-magnitude spring** discharges more than 100 cubic feet of water per second or more than 65 million gallons per day to the surface. See Chapter 4.

Groundwater is defined as the water beneath the surface of the ground. It consists largely of rain water that has seeped down from the ground surface, and it is the source of the water in springs and wells.

FLORIDA'S EARLY HISTORY

Florida today, although thought by many to be a flat land, in fact possesses a varied topography composed of diverse materials that can support a wide array of species-rich natural communities. To appreciate it fully, one might best reflect on how Florida's surface materials were assembled.

Had we been able to view the Earth from space some 250 million years ago, we would have seen a planet covered with blue water, in which a single, huge land mass, the supercontinent Pangaea, lay exposed. And had we been able to watch a speeded-up film of the events that followed, we might have observed the scenes shown in Figure 1-1. Florida's foundation lay deep below the ocean at the beginning of that long history, but its bedrock was already present as a part of northwest Africa's bedrock, at the bottom of a rift in Pangaea.

OPPOSITE: Bluegill (*Lepomis macrochirus*) in Ginnie Springs, Gilchrist County.

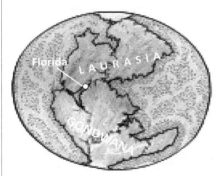

At one time in the past, all of Earth's continents were a single land mass.

550 mya* or before: Florida lies deep in the rift at the corners of several huge land masses, together known as the supercontinent Pangaea (pan-JEE-uh). Later, these land masses will become today's continents.

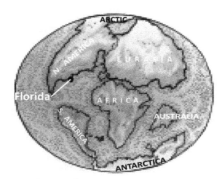

Then the continents split apart . . .

250 to 75 mya: First North America, then South America split away from Africa and migrated apart, leaving the Atlantic Ocean basin between them. Florida, still under water, moved with North America.

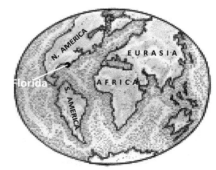

and began moving toward their present positions.

75 to 35 mya: The ocean basins widened and the continents took on further definition. Florida remained under water.

Sources: Pojeta and coauthors 1976; Opdyke and coauthors 1987; Dallmayer 1987.

***mya** stands for **million years ago**.

FIGURE 1-1

Florida's Undersea History

Sediments are loose materials that are deposited on the land or at the bottoms of water bodies. Florida's surface materials are of three main kinds: marine, clastic, and organic sediments.

Marine sediments originate from salts, shells, and the like that settle out of ocean water. Florida's major marine sediments are **limestone** and **dolostone**, whose principal ingredients are calcium and magnesium carbonates.

Between 250 and 75 million years ago, the crust beneath Pangaea pulled apart as the underlying tectonic plates moved away from each other. The resulting pieces dispersed at fractions of an inch per year, in the process known as continental drift. A small piece broke off of the plate that would come to underlie northern Africa and remained attached to the southeast corner of the North American plate. At first an undersea ridge, this piece became the deep bedrock foundation of Florida and limestone began to accumulate on top of it.[3] Meanwhile, living things had been evolving in the ocean; some had moved onto land, and in both realms they were diversifying into a great variety of species—plants, animals, fungi, single-celled organisms, and bacteria. By the time Florida was above water, there were thousands of species in nearby ecosystems ready to move in and colonize the newly exposed land.

Florida's Surface Sediments. By the time Florida arrived at its present latitude, it was layered with massive beds of limestone and other sediments that had accumulated on top of it from ocean salts, sand, and the remains of uncountable billions of tiny ocean organisms that had drifted down through the water and settled on the seafloor. There, under pressure from layer upon layer above them, the bottommost sediments became compacted to form the fossil-rich limestones of the Florida Platform (shown in Figure 1-2). These bottommost layers, having been under pressure for millennia, allow water to move through them only very slowly. The upper layers are more permeable to water.

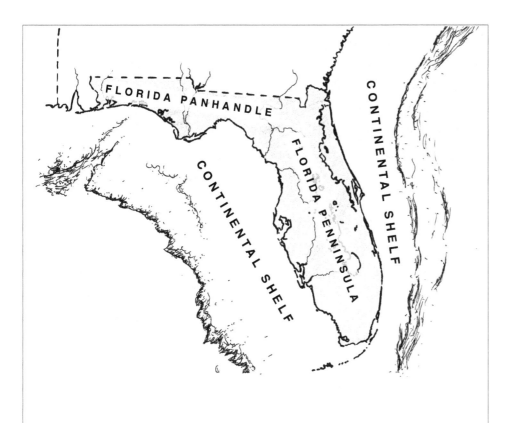

FIGURE 1-2

The Florida Platform

The **Florida Platform** consists of the entire geologic feature which includes the submerged beds of limestone that are known as the **continental shelf** and the emergent portion known as Florida.

The continental shelf extends far out into the Gulf of Mexico and the Atlantic Ocean. Its edge is the **continental slope**, and beyond that is the seafloor.

While Florida's great limestone beds were piling up under the sea, the Appalachian Mountains, which were already above sea level to the north, were being eroded by rain, and giving up innumerable small particles of rock to be carried down by streams and rivers to the edge of the ocean. The rivers deposited these clastic sediments in their deltas, which continuously migrated seaward, laying them down on top of the limestones. Today, immense beds of limestone still lie beneath Florida's surface, with lesser deposits of clastics spread out upon them. Figure 1-3 shows a quarry where the limestone layers are exposed to view and Figure 1-4 shows several ways in which limestone makes its presence known at the surface.

Florida's Debut. At last, about 30 million years ago, global sea level fell sufficiently to expose parts of the Florida Platform for the first time. Immediately, the newly exposed high ground began to receive in-migrating plants and animals that had been evolving in nearby ecosystems, but soon the sea rose and washed them away. These events repeated many times

Clastic sediments are fragments of rock. Florida's clastics are composed largely of quartz (silicon dioxide) and feldspar (aluminum silicate) particles that have been eroded and transported from the Appalachian mountains. In order of size from smallest to largest, they are **clay, silt, sand, gravel,** and **cobbles.**

Organic sediments are materials that are derived from the remains of living things. An example is **peat,** which greatly influences the suitability of soil for growing things.

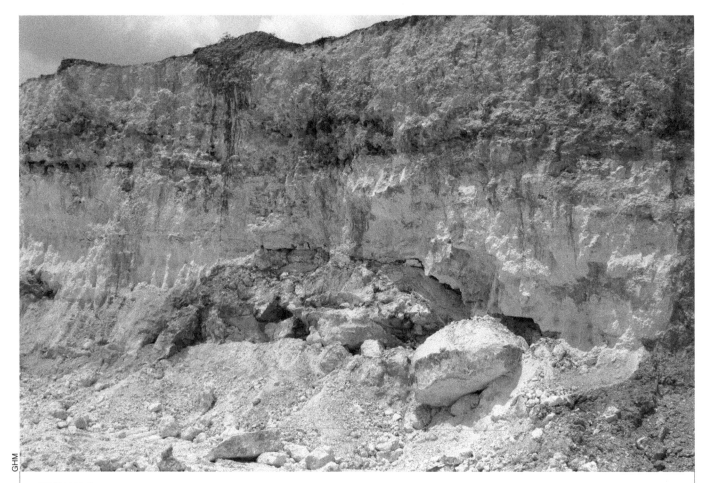

FIGURE 1-3

Florida's Subsurface Limestone

The presence of limestone near the land surface greatly influences the ecosystems of Florida. Limestone, as discussed in the text, underlies the entire state but varies in its proximity to the surface. Great thicknesses of this material, in excess of several thousand feet in some areas, comprise the Florida Platform. Much of the limestone that can be found in the Big Bend region, as seen in the photo, is very pure (99% calcium carbonate). However some limestone in Florida contains impurities such as quartz sand, clay, phosphate, and other minerals.

The stains in the limestone reflect differences in porosity. Where the limestone is most porous, groundwater can move easily. As the water passes through the limestone, it leaves behind insoluble constituents such as iron, which stains it a reddish color. As the limestone dissolves over time, the insoluble fraction is left behind and typically forms a layer overlying the limestone.

Since limestone is susceptible to being dissolved away by acidic groundwater it is common to see void spaces left behind in quarry walls. These void spaces, when large enough, are called caves and can be either air or water filled depending on the level of the water table. Eventually, the void spaces may no longer be able to support the overlying material and the land surface can subside or collapse forming a sinkhole, one of many kinds of karst features found in Florida. Caves and other karst features provide critical habitat for numerous organisms.

over, but by about 25 million years ago, the ocean had receded from the Panhandle's northern highlands and they have remained above sea level ever since then. Later, the Florida peninsula, which was lower in elevation, surfaced, then became submerged and surfaced again repeatedly, but now it, too, remains above sea level. Not since 23 million years ago has the peninsula been completely covered again by the ocean. The animals and plants that migrated in from the nearby continent stayed and continued evolving in Florida.

Limestone outcrops in the Waccasassa State Preserve, Levy County give evidence of Florida's submarine history.

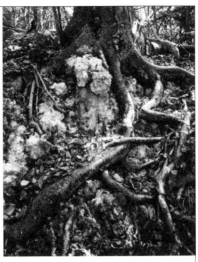

Roothold in limestone. The limestone yields to growing roots and then holds them in place.

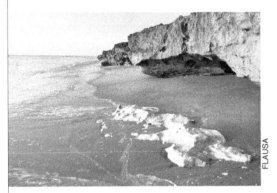

Limestone at the coast. Erosion has hollowed out a cave in a massive layer of limestone at the Blowing Rocks State Preserve, Palm Beach County.

FIGURE 1-4

Limestone at Florida's Surface

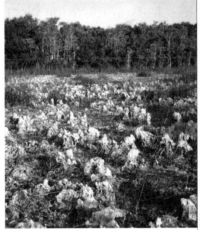

Pinnacle rock in the Everglades. Low water and a recent fire have exposed the limestone that underlies an expanse of organic sediment.

THE GROUNDWATER

Meanwhile, it rained. For as long as Florida was under the sea, whatever spaces were present in its limestone were filled with salt water, but once above sea level, the limestone could soak up fresh water. Not much mixing occurs between the two: they are chemically and physically quite distinct, and fresh water, being less dense than salt water, "floats" on top, pushing the salt water down. The bottom layers of Florida's groundwater are still salty today.

Anyway, rain fell, and in the limestone below the ground surface, cavities were growing. Most limestone is porous and soluble. If exposed to fresh water over centuries, limestone dissolves. Water works its way between horizontal layers (bedding planes), dissolving tunnels and cavities as it flows along these weak zones. Sinkholes and vertical cracks allow rain

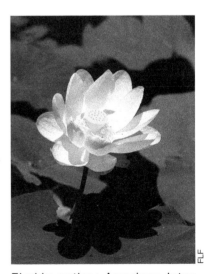

Florida native: American lotus (Nelumbo lutea). This lotus can grow rooted in bottom sediments up to five feet deep. Its big, yellow flowers grow up to six inches in diameter on long, stiff stalks.

water to percolate down and then spread into the horizontal cavities. Over millions of years the cavities have become so large that the volume of circulating groundwater they contain is unimaginably huge. According to the *Water Resources Atlas of Florida,* the spaces in the earth beneath the state hold more than a quadrillion gallons, as much water as in Lake Erie.[4]

All of the state's fresh water has come from rain—some recently, some eons ago. Today's rain moistens the soil of forests, flatwoods, and prairies, raises the water tables of wetlands and water bodies, replenishes the groundwater, is taken up by plants, and slakes the thirst of animals. And some rain that fell long ago on Florida—and even on adjacent states—finds its way into reservoirs deep below the ground surface.

All of this water is constantly on the move. Some moves rapidly as fast-flowing rivers in subterranean tunnels. Some is moving almost imperceptibly, as when water seeps down through beds of clay. Some is evaporating from the land and from lakes and streams to the sky. Some is drawn up from underground by tree roots and then transpired from the trees' leaf surfaces to the air. (Transpiration is a major way in which forests move water from the earth to the sky.) Some water is flowing overland in sheets, some is soaking into the ground and merging with groundwater, some is shooting up to the surface by way of limestone springs. And water is constantly flowing out to sea both in surface waterways and underground, and is constantly being replenished by rain on the land. This is the famous hydrologic cycle that governs life on land all over the earth.

People can visit or even live their entire lives in Florida, without being aware of the groundwater. Yet the groundwater plays a major role in supporting all of the living communities in Florida's waters and wetlands. When lakes and streams grow smaller or even dry up, it is almost invariably because the groundwater level is falling. When they grow larger, even to the

> The **water table** in a given region is the the level below which the ground is saturated with water.

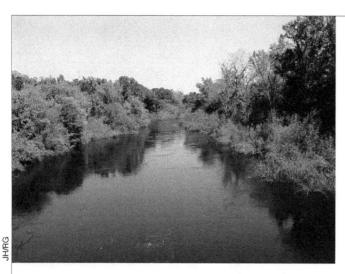 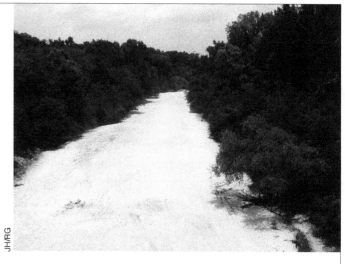

JH/RG JH/RG

FIGURE 1-5

The Alapaha River in the Rainy and Dry Seasons

The Alapaha River flows out of swamps in northeastern Florida. At left, the water table is high and the river is overflowing. On the right, the water table is low and the river is dry. Both phases of the river are normal.

point of flooding the surrounding land, it is because the groundwater level is rising again. Figure 1-5 shows two views of the Alapaha River, one during the rainy season, the other during the dry season. Both of these states of the river are normal responses to a rising and falling water table.

FLORIDA'S AQUIFERS

Florida's groundwater lies in aquifers, water-holding layers of the sediments that make up Florida's land. These aquifers vary: they may be located deep beneath other sediment beds or just below the surface of the land. They may be as small as a city block; many that feed seepage bogs in the Florida Panhandle are small. In contrast, some aquifers are as large as Great Lakes.

Shallow aquifers near the surface of the ground are called surficial aquifers. They can be visualized as underground "lakes" of water among the grains of sand, gravel, or clay in which they lie. They are shallow because they are perched on top of confining layers of relatively impermeable materials such as clay or limestone that retard water's downward migration.

Deeper aquifers often lie beneath impermeable layers; these are known as confined aquifers. A confined aquifer may be under pressure from higher-elevation groundwater nearby, to which it is connected. This pressure, known as a hydraulic head, may give rise to springs where the confining layer is breached near the coast or along major north Florida rivers.

Florida has three main aquifer systems, the Floridan, Surficial, and Intermediate systems. Ancient limestones lie beneath all of Florida as well as parts of the states to the north—Alabama, Georgia, and South Carolina. These ancient limestones no longer lie in horizontal layers as they originally were deposited. They have buckled upward in some places and become entrenched in others, and they incline deeply downward to the east and south. Their hill-and-valley surfaces now are hidden by clastic sediments and younger marine deposits that have settled on top of them. As a result, the Floridan aquifer system, contained in those old limestones, is present at ground level in some parts of Florida where younger sediments are lacking, but is deeply buried below younger sediments in other areas.

The Floridan Aquifer System. Figure 1-6 shows the area of the southeastern United States that is underlain by the Floridan, and Figure 1-7 shows other, "surficial," or "perched," aquifers that lie on top of it.

Most of Florida's groundwater circulates in the Floridan aquifer system. Thick layers of limestone and dolostone laid down within the last 66 million years comprise the system, which by now has become a huge, deep honeycomb of tunnels and caverns that are still growing larger. The Floridan holds many times more water than all of Florida's other aquifers together. Deep wells into it provide water to millions of people and hundreds of cities and municipalities.

As shown in Figure 1-7, the Floridan lies near the surface in central and north Florida and some of its limestones are exposed to view, but in

An **aquifer** is a subterranean body of water. Some aquifers consist of water filling the spaces among particles of sand, gravel, and clay. Other aquifers are large systems of water-filled tunnels and caves in limestone.

An aquifer that has a ceiling of impermeable sediment such as clay is a **confined aquifer**. An aquifer that has no such ceiling is an **unconfined aquifer**. Some aquifers are intermediate between the two and are called **partially confined aquifers**.

A **surficial**, or **perched, aquifer** is an aquifer perched atop a confining layer in deep sands or mixed sand, clay, gravel, or shells and shell fragments. It may be water held in a sandier layer of clastic sediments a few feet thick and a city block in area, or it may be tens of feet deep in sediments and a county or more in area.

The **Floridan aquifer system** is Florida's largest and most important aquifer system. It is the largest and deepest water-holding formation in the state, and one of the most productive aquifers in the world. It holds massive quantities of water because of its high permeability and porosity.

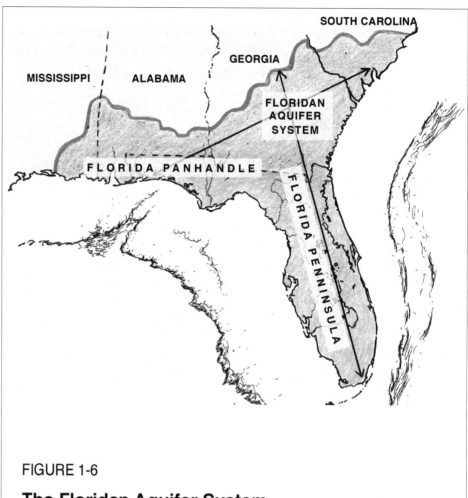

FIGURE 1-6

The Floridan Aquifer System

The Floridan aquifer system underlies all of Florida as well as parts of neighboring states, as shown. In many areas it is not at the surface as it appears here, but is overlain by many other aquifers as shown in the next figure.

the western Florida Panhandle and also in south Florida, the limestones dip far down into the ground below surficial aquifers. Beneath south Florida, the Floridan aquifer system lies more than a thousand feet down, so deep that it does not influence the Everglades, a huge wetland that is fed entirely by rain.[5]

Florida's Surficial Aquifers. As shown, many surficial aquifers lie "perched" above the Floridan. One surficial aquifer is the unconfined Biscayne aquifer southeast of Lake Okeechobee, where the Floridan aquifer system is too deep and salty to be useful as drinking or irrigation water. East coast communities subsist on fresh water from the Biscayne—a wedge of loose limestone, sandstone, and seashells that occupies the space from the surface of the ground down to 35 to 40 feet below it.[6] In some places, it is perched on top of a sequence of low-permeability clayey deposits about 1,000 feet thick that separates the Biscayne Aquifer from the underlying Floridan aquifer system.

Another large, surficial aquifer that holds significant water stores is the 2,400-square mile Sand-and-Gravel Aquifer, which lies near the surface

Taken all together, Florida's surficial aquifers are known as the **Surficial aquifer system**.

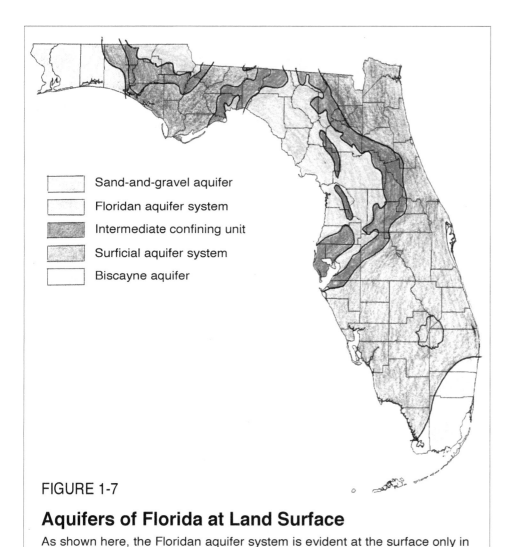

FIGURE 1-7

Aquifers of Florida at Land Surface

As shown here, the Floridan aquifer system is evident at the surface only in parts of the Florida Panhandle and the northern peninsula. Other, "surficial" aquifers lie above it everywhere else.

Legend:
- Sand-and-gravel aquifer
- Floridan aquifer system
- Intermediate confining unit
- Surficial aquifer system
- Biscayne aquifer

beneath the western Panhandle. This bed is underlain by layers of impermeable materials, which keep the water from seeping downward, but water can escape from it by seeping laterally. Such aquifers are common in Panhandle Florida west of the Choctawhatchee River. Other perched aquifers are scattered all over the state, but compared with the Biscayne (4,000 square miles), they are small, and all are small compared with the Floridan aquifer system.

Intermediate Aquifer System. An in-between system is often found underlying the Surficial aquifer system and on top of the Floridan. Known as the Intermediate aquifer system, it separates the two where the Floridan is not near the surface. It is composed of sand, shells, and limestone with clay confining units of low permeability within it. Many of Florida's surficial aquifers are perched upon it, and it confines the Floridan aquifer system below it. In most places, water very slowly percolates down from the surficial aquifer system above into the intermediate aquifer system below. Lateral flow is generally from high areas towards major surface water features and the Gulf of Mexico.

Florida native: Duckweed (a *Lemna* species). A duckweed is a tiny floating green plant with shoe-shaped leaves and a single root hanging underneath. Duckweeds occur in large floating mats in Florida's still or slow-moving waters. They are among the world's smallest flowering plants.

FLORIDA'S AQUATIC BIODIVERSITY

As just shown, there is water all over Florida and beneath it and around it. This is one reason why Florida is so rich in water bodies and water-adapted plants and animals. And for many reasons, Florida's waters contain tremendous biodiversity. Probably most important is that the peninsula juts south from the temperate zone in the north into the tropics in the Keys. North Florida boasts of the most flowing water habitats, with large whitewater (muddy) rivers containing species from the continent. North Florida has elevations up to 345 feet, which allow small ravine streams and creeks to form in the elevated clay and sand hills. Along the peninsula southward, elevations decline and aquatic habitats become increasingly slow-moving.

Florida's rivers are very diverse. There are sediment-laden muddy rivers in the Panhandle, acidic blackwater rivers in the peninsula and coastal lowlands, and near-neutral rivers flowing out of the Floridan aquifer system onto the top of the ground as crystal-clear rivers. Lakes and ponds also vary ecologically from north to south. Temperate plants and animals inhabit the northern waters; tropical or subtropical life abounds in the south.

The same temperate/tropical effects are manifest in the waters around Florida's coastlines. Northern coastlines support vast salt marshes and seagrass beds; whereas, in south Florida equally vast mangrove swamps abound. East of the Florida Keys lies one of the world's largest coral reefs and west of the Keys is a shallow offshore bay with its own unique biodiversity. Marine invertebrate communities vary hugely along the Atlantic coast in comparison with the Keys and Florida Bay, as well as in comparison with the southwest Florida shorelines and those of the Florida Panhandle. In short, Florida's waters may hold natural communities as biologically diverse as those on land.

The water bodies along Florida's coast are also diverse for yet another reason, one that is not obvious on ordinary maps: the Florida Platform is much broader than present-day Florida. Figure 1-8 displays the entire Florida Platform, both the parts that are now above water (the peninsula and the Panhandle) and the part that is under water (the continental shelf). Aquatic communities occupy all parts of that shelf and contribute to the great diversity of Florida's aquatic ecosystems. The Florida Natural Areas Inventory has identified 21 ecosystems in that category.[7] They are listed in the Appendix, which shows the alternative names some of them are given in this book. All of them are teeming with life.

NATURAL COMMUNITIES AND NATIVE SPECIES

An ecosystem is defined as a biological community of living organisms interacting with their environment. Each acts on the other, the environment determining the types of organisms that can best survive and reproduce there, and the inhabitants adapting to the environment in ways that will enable them to vie successfully with their competitors.

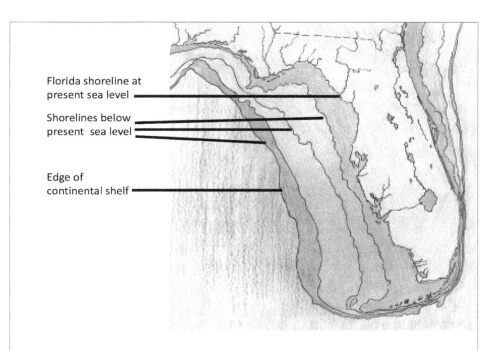

FIGURE 1-8

Florida's Varying Sizes and Shapes

The Florida Platform extends all the way to the continental shelf and at times the whole land mass has been exposed above sea level. Chapter 8 tells the story of Florida's fluctuating sizes and shapes over millions of years in the past.

The successive contours shown outside Florida's present shoreline are at 60, 120, 300, and 600 feet below sea level.

The continental shelf is 35 to 100 miles wide off Panhandle Florida, 150 miles wide west of Tampa, less than 5 miles wide at Miami, and about 60 miles wide at Jacksonville.

Source: Adapted from Fernald and Purdum 1992, p. 14.

The term *natural ecosystem* requires explanation. It means the same thing as natural community, the phrase favored by the Nature Conservancy. Natural communities are defined as those that are relatively undisturbed by human influence and that are still functioning largely as they did in pre-Columbian times. In truth, even before Columbus, the native people who inhabited Florida altered the land somewhat, but not to nearly the same extent as the Europeans and Africans who succeeded them. *Natural* is therefore an approximate term that represents a range of values.[8]

Natural communities are further distinguished from others in that they support resident populations of native species. These populations are genetically adapted to grow and reproduce in specific local settings and in concert with each other. They have evolved in those or similar settings over hundreds or thousands of generations and they are equipped to cope with both normal conditions and normal extremes. Moreover, they are self-maintaining. They require no power plants to provide their energy, no air-conditioning to regulate their temperature, and no garbage trucks to carry away their waste.

Common water-hyacinth *(Eichhornia crassipes)*, an invasive exotic pest plant. This noxious weed has one of the fastest growth rates of any known plant. It overwhelms water bodies and displaces native aquatic plants.

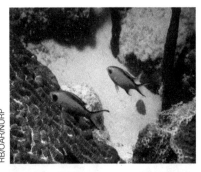

Native to Florida waters: Purple reeffish *(Chromis cyanea)*. These fish are swimming by a reef off the Florida Keys.

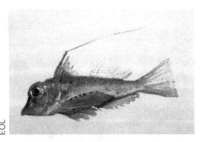

Florida native: Horned searobin (*Prionotus* [or *Bellatar*] *militaris*). This fish, which is less than five inches long, swims in the Western Atlantic from North Carolina to southern Florida and the northern Gulf of Mexico in the United States and south to the Yucatan in Mexico.

In contrast, nonnative species are not adapted in these ways. Some nonnative species exhibit extreme aggressiveness and may completely annihilate native populations. They are rightly called alien, invasive, or exotic. Some, such as ornamental garden plants, simply don't belong: they don't hurt anything but they don't help, either—they simply take up space. And some, such as agricultural crops, may require considerable assistance from humans to establish themselves at all in native territory.

Barring interference by nonnative species, the normal inhabitants of natural communities may be stressed near the extremes to which they are adapted, but they rebound at the first opportunity, provided only that repeated injuries are prevented. Often they can even recover after natural "disasters" which may appear at first to overwhelm them. Some communities promptly reassemble in the same places where they grew before. For example, lakeside plants regrow after high water levels decline. Others may regroup elsewhere as suitable new places become available. For example, a storm may change the course of a river and appear to denude its waters of all their plants and animals, but surviving seeds and larvae will soon repopulate the "new" river, which may in time become as rich in species as before. In short, natural communities tend to persist, provided that the physical stresses they encounter are within the limits that they are equipped to withstand.

Of course, many of Florida's waters are no longer natural. Native vegetation has been dredged away, stream courses and levels have been altered, lakes have been cleared of shoreline wetlands, and the waters may have been polluted by oil or fertilizer or industrial waste. At the coast, much of the shoreline, especially along bays, is today so densely populated that the natural communities have largely broken down. Although living organisms may still grow in them, their diversity is diminished, so that what remains is only damaged remnants of the original natural communities. To regain natural function these need more than management; they require restoration.

On a positive note, although few of Florida's aquatic environments are wholly natural any longer, some can be maintained in near-natural condition. Environmental benefits can be reaped by supporting and mimicking natural processes.

A Note on Species. It was said above that native species were well equipped to grow and reproduce in local settings. They are adapted to local conditions, including the presence of other native species; they have existed there for a long time; and they are contributing services of ecological value. Provided that its environment does not change greatly, a native species population can perpetuate itself over long spans of time without elaborate management efforts. Native species are the ones best suited to perpetuate the functioning of natural ecosystems. Native species are featured in photos throughout this book.

By definition, a species is a distinct group of organisms that reproduce their own kind. A single species may exist as several populations occupying

separated habitats, but for as long as the individuals readily breed with one another, they are considered to be members of one species. If two populations of organisms are similar but display no tendency to interbreed when brought together, they are distinct species.[9]

A species breeds true because every individual receives the same basic genetic blueprint. For example, every Barbour's map turtle inherits the information necessary to produce its distinctive shell pattern and to keep on producing new generations of Barbour's map turtles. The inherited traits may vary a little in detail due to genetic diversity, but the basic structures and functions are the same in all.

In these times of severe disruptions of natural ecosystems all over the planet, it is important to understand two other things about native species: that they did not arrive here overnight and that once extinct, they cannot be replaced. Except under extraordinary circumstances (such as laboratory manipulation), new species arise only by way of a process known as speciation, a process that in nature is usually slow. It begins with reproductive isolation. A single population may be split geographically into two subpopulations that remain separated for long times. Then, over many generations, the separated subpopulations may develop so many genetic differences that they become unable to interbreed if they come together again.[10]

Long times, perhaps on the order of hundreds of thousands of years, are required to produce new species of large animals such as sturgeon, whose generation times (to sexual maturity of the young) are on the order of several years to a decade or so. In plants and animals that produce one generation a year, speciation might take 20,000 years—still a long time. In animals that produce several new generations a year, it takes about 5,000 years. Extremely short times are needed for bacteria and other microorganisms, some of which can produce several generations in a day. In short, immense variation is the rule.

Over the more than three billion years since life first arose on Earth, hundreds of millions of new species have arisen on the planet. Nearly as many have also gone extinct. Until recently, however, the rate of production of new species has, on average, slightly exceeded the extinction rate, so that over the enormously long spans of time since the origin of life, net species gains over losses now add up to a total, for the world, of many millions of species—perhaps even ten million or more, no one knows. About 1.75 million species have been discovered and described. At least 8 million and probably more species remain to be discovered, mostly among invertebrates, plants, and other living things.

In this book's chapters, besides the photos, there are lists of the species that occur naturally in the various habitats being described. These are the species that evolved here, that are indigenous, the ones that "belong" in Florida. We need to get to know these species and respect them. They maintain the resiliency of natural ecosystems, and those systems are best equipped to keep functioning without costly inputs from human societies.

Names of Species. Every known species has a scientific as well as a

A **natural ecosystem**, or **natural community**, according to FNAI, is "a distinct and recurring assemblage of populations of plants, animals, fungi, and microorganisms, naturally associated with each other and with their physical environment."

Speciation is the process by which new species arise.

Native to Florida's offshore waters: A polychaete worm in the tropical Atlantic Ocean. Polychaetes are a major group of seafloor animals.

common name. Those featured in this book's photos are given both names in photo captions, but are given just their common names in the text. Every common name is an "approved" one, though: authorities have specified what it should be. Thus the bass species that swims only in the Ochlockonee and Suwannee rivers and whose scientific name is *Micropterus notius* is, in common parlance, the "Suwannee bass." Using the names assigned this way, all species discussed herein are listed in the Index to Species, which precedes this book's General Index, and the scientific name for each one is also shown. The Reference Notes and Bibliography list the authorities for the naming of species.[11]

Florida's Native Species. Florida's native species, taken together, number in the thousands. More than 3,000 species of trees, shrubs, and other flowering plants are native to the state including 100 species of orchids. Its ferns, numbering some 150 species, are the most diverse in the nation, and besides all these, there are many mosses, hornworts, liverworts, and algae. As for the animals, the list of all of Florida's native vertebrates numbers well over 1,000 species, and these are far outnumbered by Florida's invertebrates, of which there are about 30,000 species on the land and no one knows how many in the water. At least three other whole *kingdoms* of living things are required to account for other living things such as protists, bacteria, and fungi, many of which are aquatic organisms.[12] A scheme based on a five-kingdom array is shown below:

Five-Kingdom Scheme of Classes of Living Things

Kingdom Protista: single-celled organisms with true nuclei.

Kingdom Bacteria: simpler single-celled organisms with their genetic material not encased in nuclei.

Kingdom Fungi (FUNJ-eye): multicellular organisms that obtain their energy by breaking down dead organic material. Examples are molds, mildews, and mushrooms.

Kingdom Plantae: multicellular organisms that can perform photosynthesis. Examples are trees, herbs, and ferns. (Photosynthetic organisms are able to synthesize sugars using sunlight for energy and using the green pigment chlorophyll as a catalyst.)

Kingdom Animalia: multicellular organisms that cannot photosynthesize but obtain their energy by eating plants (or eating other animals that eat plants). Among the animals, vertebrates are animals with backbones and invertebrates are animals without backbones.

Note: In this book, "plants and animals" is a shorthand term that often refers to members of all five kingdoms. "Plants" refers to all organisms that can conduct photosynthesis: multicellular plants, multicellular algae, single-celled algae, and photosynthetic bacteria.

Florida's Endemic Species. Some of Florida's native species are widely distributed across the continent or the world, some are limited to smaller regions, some are restricted to individual river systems, and some are completely restricted to Florida. The latter species are known as Florida endemics. Among the endemic plants are about 300 vascular plants and many algae. Among the native invertebrate animals, more than 400

endemic species are known; and among the vertebrates, 40 or more are endemic to Florida. No one knows how many endemic species there are within the other three kingdoms.

Florida's native species, and especially its endemic species, are ours to protect or lose. An objective of this and the other volumes in this series is to make their value clear.

Florida's Species Today. Florida's species are among the most endangered in the nation. This is largely due to destruction of their habitats. When the last member of a species' last population dies out, the genetic information necessary to produce new individuals of that species vanishes forever. The total information available for making living things also diminishes. Upon extinction, the genetic blueprints assembled in a species over hundreds of millions of years is gone for all time.

It still takes approximately 5,000 years or more to produce a new species, on average, but worldwide species losses today, by current estimates, are amounting to dozens a day. Moreover, the extinction rate is accelerating.

Within Florida, the pace of species losses matches that of the rest of the world and also is accelerating. However, most of Florida's species have not gone, and need not go, extinct. If the people of Florida know and value local native species sufficiently, they will take what steps they can to protect and maintain local natural ecosystems.

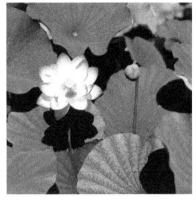

Sacred lotus *(Nelumbo nucifera)*, an introduced exotic pest plant. This lotus, an import from the Old World, occasionally escapes into the wild and displaces native-plants.

An **endemic species** is one that occurs naturally only in a limited region. Florida endemic species are naturally restricted to Florida.

* * *

The science of classifying living things has gone through many changes since 1735 when Carl Linnaeus first proposed only two kingdoms, Animalia and Vegetabilia. Today, with the direct study of genes through DNA analyses, as many as eight kingdoms have been proposed, but new discoveries are proceeding rapidly and there is no current consensus about how many kingdoms presently exist. For our purposes, animals, plants, bacteria, fungi, and protists are the most dominant—and visible—organisms of Florida's natural communities. We recognize, however, that new scientific insights are being made, especially about microbial life, but however many times their names may change, it is the living things that we celebrate in this book.

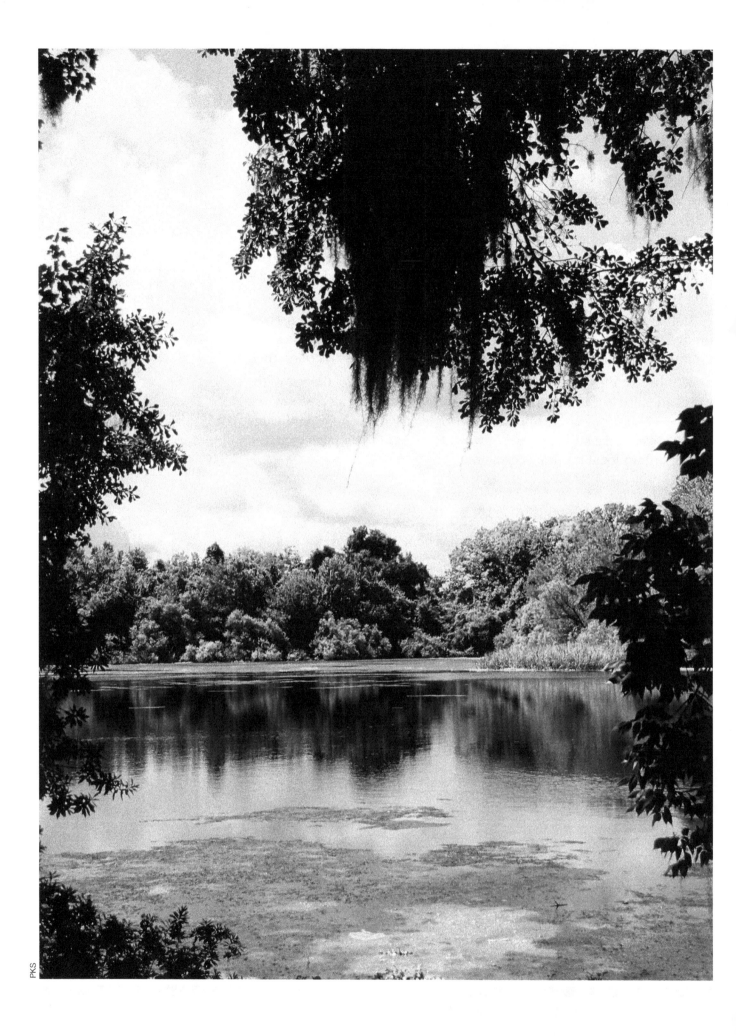

CHAPTER TWO

INTERIOR WATERS: LAKES AND PONDS

Fly over Florida in a rainy season and you will see the mirrorlike reflections of the thousands of lakes and ponds that occur wherever there are basins with open water in their centers—that is, water typically more than five feet deep. Figure 2-1 shows that lakes are especially numerous on level terrain that is deep in sand. The high, sandy uplands of the central peninsula are outstanding: four counties (Lake, Orange, Polk, and Osceola) account for more than a third of all of Florida's lakes. Lakes are also associated with the St. Johns River region, which is mostly low, sandy, and flat with many wetlands. Smaller lakes and ponds lie in sandy basins across all of Florida's flatwoods and nestle behind coastal dunes near the shore.

Although lakes are more numerous in some regions than in others, every region has at least some still-water bodies, and each has a character of its own. A given Florida lake or pond may be alkaline or acid, rich in nutrients or poor, clear or colored. It may have a sandy, silty, clayey, or organic bottom. It may have streams running into it, or out of it, or both, or neither. Some lakes and ponds hold water permanently, some temporarily; and all have fluctuating water levels. The surrounding soils and plant communities vary greatly and affect the water's chemistry. Lake water temperatures vary with the seasons, with the amount of shade afforded by encircling forests and swamps, and with the climate from north to south Florida.

Most of Florida's lakes and ponds tend to be shallow. Typically, most of them range from seven to about twenty feet in depth. Most formed as near-surface limestone dissolved, and the sediments above it slumped in. If viewed from above they are circular, and in cross section they are shallow bowls.

A few of Florida's lakes are other shapes. Some formed originally as saltwater lagoons behind sand bars or barrier islands when sea level was higher; then when sea level dropped, their salt water drained away and rain filled them with fresh water. Some are oxbows left behind by rivers; and a few lakes are circular but deep: true sinkholes, whose bottoms have fallen into limestone caverns underground. One type of pond is very shallow—the temporary pond described later.

A **lake** or **pond** is a permanent still-water body that is contained in a natural basin or depression and that supports a natural ecosystem. Lakes are greater than 10 acres in size; ponds are smaller.

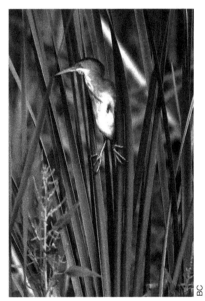

Least bittern *(Ixobrychus exilis)*. This is Florida's smallest heron, a common but shy bird that hides in lakeside vegetation and feeds on small lake animals and fish.

OPPOSITE: Lake Alice, Gainesville, Alachua County. This wild little lake, nestled on the University of Florida campus, is easily accessible to faculty and students for research and recreation.

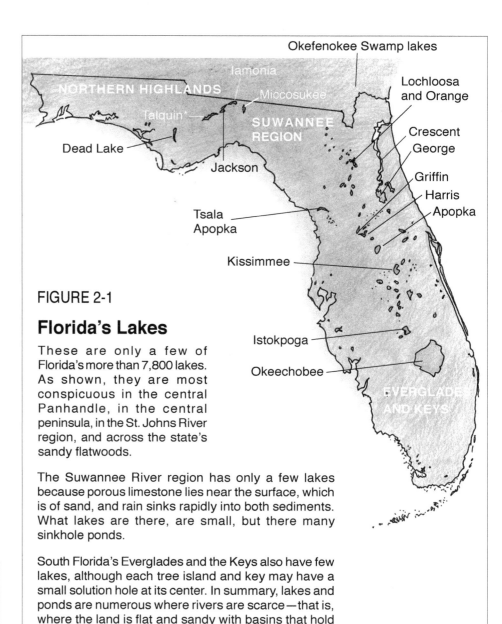

Okefenokee Swamp lakes

NORTHERN HIGHLANDS

Iamonia

Miccosukee

Lochloosa and Orange

Talquin*

SUWANNEE REGION

Dead Lake

Jackson

Crescent

George

Griffin

Harris

Apopka

Tsala Apopka

Kissimmee

FIGURE 2-1

Florida's Lakes

These are only a few of Florida's more than 7,800 lakes. As shown, they are most conspicuous in the central Panhandle, in the central peninsula, in the St. Johns River region, and across the state's sandy flatwoods.

The Suwannee River region has only a few lakes because porous limestone lies near the surface, which is of sand, and rain sinks rapidly into both sediments. What lakes are there, are small, but there many sinkhole ponds.

South Florida's Everglades and the Keys also have few lakes, although each tree island and key may have a small solution hole at its center. In summary, lakes and ponds are numerous where rivers are scarce—that is, where the land is flat and sandy with basins that hold water, and where the water does not flow overland to the sea.

Istokpoga

Okeechobee

EVERGLADES AND KEYS

*Lake Talquin is an impoundment in the Ochlockonee River. Lake Seminole (not shown) is an impoundment in the Apalachicola River north of the Florida-Georgia border.

**LIST 2-1
Classification of
Florida lakes
(in order as in this
chapter)**

- Clayhill lakes
- Sandhill lakes
- Swamp/floodplain lakes
- Flatwoods/prairie lakes
- Coastal dune lakes
- Temporary ponds
- Coastal rockland lakes
- Sinkhole lakes[a]

Lake terminology varies. The Appendix lists other terms applied to lakes.

[a]Sinkhole, or karst, lakes are treated as parts of the groundwater system in Chapter 4.

Lakes can be classified in a variety of ways. This chapter describes the first seven types itemized in List 2-1, leaving sinkhole lakes to Chapter 4. In truth, however, Florida's lakes are more diverse than this brief survey may seem to imply. One study of Florida's lakes identified 47 regions within the state, each with lakes of a different character.[1] Figure 2-2 offers one example of the contrast among lakes, comparing a clayhill lake with a sandhill lake.

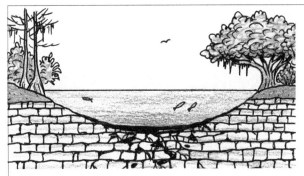

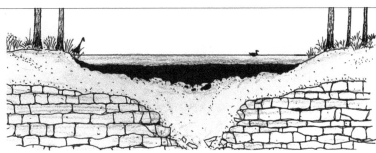

Clayhill lake. In the past, when an ancient stream cut away the clayey sediments overlying the limestone, the Floridan aquifer system, no longer confined, was forced upward by hydraulic pressure to fill the lake basin. Then, over time, the lake's basin grew by collapsing sinkhole action and the lake valley widened. Today, during extensive droughts that cause the Floridan aquifer system to drop, most clayhill lakes drain down again through sinkholes in their beds.

Sandhill lake. A sandhill lake has a floor of sand, but organic matter accumulates on the bottom and largely retards downward percolation of the water. The surface of a sandhill lake often is continuous with the top surface of a local surficial aquifer. The lake's water comes only from rain and groundwater seepage and is lost by evaporation. Alternatively, the surface of a sandhill lake may be continuous with the top of the unconfined Floridan aquifer system and the lake rises and falls with the aquifer's surface.

FIGURE 2-2

Clayhill and Sandhill Lakes

Zones in Lakes

Naively, one might think of a lake as homogeneous, presenting a single environment to its inhabitants. On the contrary, however, the living things in lakes and ponds occupy several different underwater zones. Consider one example of a productive, natural lake, the kind that would attract a fisherman—say, a clayhill lake surrounded by marsh vegetation.

Natural lakes are bordered by wetlands—that is, marshes or swamps. These are natural communities in their own right, and are described in Volume 2 of this series, *Florida's Wetlands*. Wetlands are so intimately connected with lakes and ponds, however, that they appear repeatedly in this volume as well.

Within the lake, zones offering different habitats are arranged by depth (see Figure 2-3). Each zone supports a different kind of life. The shoreline (littoral) zone, from zero to about five feet deep, is a fringing wetland that may be either a swamp or a marsh, depending upon the system's past history and the depth of the water. A swamp usually occupies the shallower waters of a shoreline. A marsh lies in somewhat deeper water and gives way directly to a clear, open-water zone.

The clear, open-water (limnetic) zone is the well-lit, open surface water of a lake where there are no emergent or floating plants. Submerged aquatic plants may occur in the shallower parts of this zone, but the lake

A **wetland** is a land area whose soil is frequently or continuously saturated or inundated with water, a condition that requires plants to have special adaptations to survive and grow. Marshes and swamps are the commonest kinds of wetlands.

A **marsh** is a wetland dominated by herbaceous vegetation, usually rushes, sedges, grasses, and other forbs.

A **swamp** is a wetland dominated by shrubs and trees.

Technically, the shoreline zone is called the **littoral zone** and the clear, open-water zone is called the **limnetic zone**.

LIST 2-2
Plants common in Florida lakes (examples)

Floating plants
Duckweed
Mosquito fern

Mat-forming plants
Frog's-bit
Marshpennywort
Primrosewillow species
Southern watergrass
Spikerush species
Waterhyssop

Emergent plants
American lotus
American white waterlily
Big floatingheart
Broadleaf arrowhead
Rushes (several
 species)
Spatterdock
Watermeal species
Watershield
Waterspider bog orchid

Submersed plants
Bladderwort, 3 species
Carolina fanwort
Hornwort (several
 species)
Carolina fanwort
Hornwort (several
 species)
Parrot feather
 watermilfoil
Pondweeds, 2 species
Stream bogmoss

Source: Adapted from
Guide 1990, 45-51.

The "plants" referred to in this book actually include members of three kingdoms: plants proper, algae, and photosynthetic bacteria.

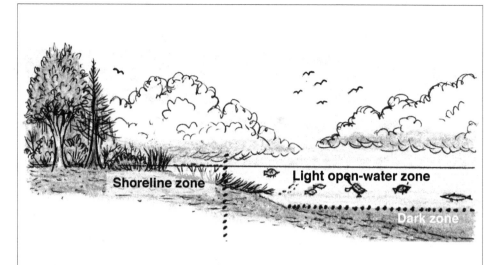

FIGURE 2-3

Zones in a Productive Wild Lake

The border of emergent wetland plants around the edge to a depth of about five feet is the shoreline or littoral zone. It may be a swamp of cypress and gum trees or a marsh of grasses and forbs, or both—that is, a swamp grading into a marsh. Large animals such as fish, amphibians, reptiles and macro-invertebrates (for example, crayfish) thrive in this zone thanks to the hiding places created by submerged roots, stems, and litter.

Beyond the edge of the marsh is the open-water or limnetic zone. Submersed plants grow where the sunlight reaches the bottom, but where the water is dark, the bottom sediments are barren of rooted plants. Where sunlight penetrates the water column of the open-water zone, myriad single-celled algae flourish. Because of their great numbers, even though microscopic, they form the largest contribution of living matter in most lakes. Where it is dark, dead organic matter (peat) accumulates and supports an indwelling community of microscopic organisms such as bacteria.

bottom soon becomes too deep and dark to support rooted aquatic plants. Rather, this zone is occupied by a variety of phytoplankton consisting of algae and cyanobacteria, as well as zooplankton, small crustaceans, and fish. Paradoxically, although from above all a viewer can see is open water, most photosynthesis takes place in this part of the lake. Microscopic phytoplankton are so abundant that the oxygen and food that support the life systems of the entire lake are in the limnetic zone.

Because the lake is shallow, wind can create turbulence that reaches to the bottom and aerates all of the water. This means there are no pockets of "dead water," and thus fish and other animals can live everywhere. Fish food is abundant: Plants are growing on the bottom, and small organisms are living on the plants and in the bottom sediments.

Microscopic animals (zooplankton) eat these plants and each other. All these tiny living things may drift into the shoreline zone and become other creatures' lunches, or they may spread into deeper parts of the lake, where they will finally drop out of the sunlight, die, and feed the cycle of decomposition at the bottom. Few fish inhabit the light open-water zone, because it offers them little food or shelter.

In the deepest part of the lake, the dark zone, bacteria and fungi feed on organic matter that drifts down to them. In the process, they free nutrients into the water, which become available again for life along the shore. Although decomposition depletes the oxygen supply, the deep water offers a temperature-stable environment to a few specially adapted fishes such as freshwater eels, catfishes, and chubsuckers, all of which feed on benthic organisms such as snails, crayfish, insect larvae, some plant material, small fishes, and even carrion.

The sediments of the lake floor contain a community of microorganisms, worms, mollusks, crustaceans, insect larvae, and the larvae of other animals. When healthy and well developed, this community (known as the *benthos*) is highly organized. Distinct groups of organisms live at different depths and different species are abundant at different seasons. The benthic community is especially rich beneath beds of rooted aquatic plants where oxygen and plant litter are available.

For simplicity's sake, this description was of a smoothly conical lake, but of course real lakes may be much more complex. Where a lake has a deep hole near the edge, a dark zone may interrupt the border of water weeds. Where a peninsula extends into the middle, or where an island stands, another shoreline zone will be present. Lakes may have bumpy bottoms and hold interesting structures such as rocky outcrops, springs, and fallen trees. From the point of view of a fish, a lake with a complex bottom offers many kinds of food and many places to hide from predators, making an excellent homesite.

PLANTS IN LAKES AND PONDS

The still water of lakes and ponds permits floating and suspended, as well as attached, vegetation to develop. Microscopic algae and photosynthetic bacteria may flourish in a healthy lake in full sun, both floating and attached to aquatic plants. Microscopic plants are the basic foodstuffs in the lake food web. To illustrate their diversity, Figure 2-4 depicts a few of the microscopic plants found in Florida lakes.

Exactly which species of microscopic plants will grow in a given lake or pond depends on the nature of the bottom sediments, the water chemistry, season, and the other plants and plant eaters present. A single lake may have a dozen or more main species, and all of Florida's lakes and ponds taken together hold hundreds of species of floating and attached algae and cyanobacteria.[2]

Large aquatic plants are also diverse in Florida lakes, thanks to the long growing season and the mostly shallow water. List 2-2 presents a sampling and Figure 2-5 illustrates a few.

ANIMALS IN LAKES AND PONDS

Given the still water of lakes, it might seem that animals could live a relatively tranquil life in them since they can stay in place without having

Two types of plants grow in water.

Wetland plants are **emergent plants**, rooted at water depths of about five feet or less. Their topmost tissues spread on or extend above the water's surface.

Aquatic plants are either **submersed plants**, rooted at depths of f ive or more feet with their topmost tissues completely under water, or **floating plants**, whose roots do not reach the bottom.

LIST 2-3
Types of fish found in Florida lakes

Florida's fish include two families of cartilage-skeleton (holost) fishes (gars and bowfins) and eleven families of bony-skeleton (teleost) fishes.

Catfishes (bullheads/
 madtoms)
Gars and bowfins
Killifishes (topminnows/
 mosquitofishes)
Minnows (shiners)
Perch and darters
Pikes/pickerels
Pirate perch
Shad
Silversides
Suckers/chubsuckers
Sunfishes/bream/
 crappies/bluegills/
 warmouth[a]

Note: [a]Technically, the largemouth bass is a sunfish, too, albeit a big one.

Source: Eddy and Underhill 1978.

Plankton are passively floating or weakly swimming, tiny (mostly microscopic) plants and animals in a body of water. The plant members of this community are the **phytoplankton** (FYE-toe-plank-ton); the animals are **zooplankton** (ZOH-oh-plank-ton).

Algae include both single-celled and multicellular forms.

Single-celled and small multicellular algae are **microalgae**. Many secrete silicon-based outer shells and are called **diatoms**.

Large multicellular algae are **macroalgae**.

One category of microorganisms, which used to be called blue-green algae, are actually bacteria that can photosynthesize. They are now known as **cyanobacteria**.

CYANOBACTERIA

Merismopedia *Aphanizomenon* *Scytonema* *Microcystis*

MICROALGAE

Isthmochloron *Micrasterias* *Aulacoseira*

 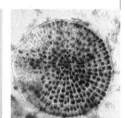

Scenedesmus *Desmidium* *Coleochaete*

The microscopic plants in lakes are of two main kinds: cyanobacteria (formerly called blue-green algae), and algae. These are only a few of hundreds of species that inhabit Florida's fresh waters. Each grows under different conditions.

Among cyanobacteria (top row):

Merismopedia hangs suspended in the water.

Aphanizomenon forms surface scums and bundles of strands visible to the naked eye.

Scytonema forms woolly clumps in the shoreline zone of lakes.

Microcystis species produce surface scum, and may form large "algal blooms."

Among algae (bottom two rows):

Some species of *Isthmochloron* occur in dark water that is rich in organic matter, some floating, some suspended, and some on the bottom.

Micrasterias lives suspended in acidic lakes with low nutrient levels. Aulacoseira forms chains that grow on lake floors where light is available. *Scenedesmus* colonies are common floating plankton in many Florida freshwater bodies and become overly abundant in nutrient-rich waters.

Desmidium filaments often grow in the littoral zone among submerged aquatic plants in low-nutrient, soft, acidic water bodies.

Coleochaete colonies occur in all types of freshwater habitats, attached as periphyton to submerged aquatic plants and emergent vegetation such as cattails and reeds.

FIGURE 2-4

Microscopic Plants in Lakes

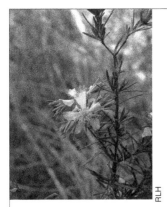

Sandweed (*Hypericum fasciculatum*)

Eastern purple bladderwort (*Utricularia purpurea*)

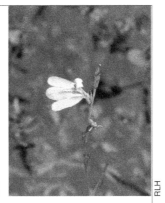

Endemic: Pineland waterwillow (*Justicia angusta*)

FIGURE 2-5

Plants Found Naturally in Florida Lakes

Skyflower (*Hydrolea corymbosa*)

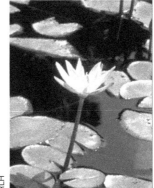

Tropical royalblue waterlily (*Nymphaea elegans*)

to fight moving water. However, lakes present unique challenges to their inhabitants. Oxygen is limited below the surface of still water bodies, so animals must either stay near the top or have special ways to carry oxygen with them while under water. Light becomes dim below the surface and deep waters are always dark. Plants cannot grow without light, and neither sight nor color is useful to animals in a lightless world.

To those that can meet its challenges, however, life in water offers some advantages over life on land. Sound travels well in water, gravity is not a problem, and except at the surface, temperatures change slowly and more moderately than in air. Florida's surface waters hold surprisingly rich natural ecosystems.

Two groups of animals have achieved predominance in lakes: invertebrates that dwell in the bottom sediments, and fish that, of course, predominate in the water. A productive lake's sediments are full of bottom-dwelling worms, clams, mussels, crustaceans (isopods, crayfish, amphipods), insect larvae, and myriad microorganisms such as bacteria, protozoans, algae, and numerous other living things. The fecal pellets

> The sediments on the floor of a water body and the organisms that live among them are known as the **benthos**, or **benthic community**.

Ebony jewelwing *(Calopteryx maculata)*, a damselfly. Damselflies have swarmed around lakes every spring since 300 to 350 million years ago. Their eggs and larvae develop in the bottom sediments and are important links in the aquatic food web. The decline of a lake's damselflies signifies decline of the lake's water quality.

dropped by these animals and by fish serve as fertilizer for rooted plants and as food for decomposer organisms. The number and variety of creatures that dwell in the bottom sediments reliably indicate a lake's health.

Many winged insects (for example, mayflies, caddisflies, midges, and damselflies) start their lives as larvae in the water and bottom sediments, then metamorphose and emerge as winged adults. The more insects you see flying around a lake in the spring, the more larvae must be present in the water, and the more fish you can expect the lake to produce later on. Nature writer Shelley Franz advises, "Those fortunate people who live around the lakes in Florida can look forward to the emergences of the [flying insects].... Don't be alarmed by the large numbers that accumulate on your window screens; view this spectacular natural event as a sign of a healthy lake ecosystem."[3]

The other predominant animal group in lake environments is fish. Given high-quality water, freedom from infestation by nonnative weeds and exotic fish, a minimum of shoreline disturbance, and healthy bottom sediments, a Florida lake may offer a bounty of healthy foods to many native game fish. The ever-so-popular largemouth bass and other sunfish species find feasts in healthy Florida lakes.

Many lake fish are of the several kinds called bream (or sunfish, because their discoid bodies are coated with metallic scales that flash in the sun). Two of these are shown in Figure 2-6. Many others, such as catfish, are bottom feeders. List 2-3 names the many types of fish that are native to Florida lakes and ponds; they account for some 40-odd species.

A fisherman can sing you a litany of the game fish to be found along a healthy lake shore, and fishermen who know the fishes' habitat preferences can cast their lures in just the right places. Are you fishing for bream? Fish in five-foot deep water bordering the shallow zone and cast your weedless lures near underwater hiding places such as fallen trees or aquatic plants. Are you fishing for bass? Cast your flies on the shore, wiggle them into the shoreline vegetation, and reel them back through the thickest cover.

Bluespotted sunfish *(Enneacanthus gloriosus)*

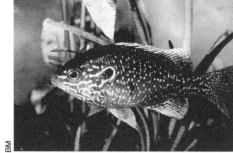

Dollar sunfish *(Lepomis marginatus)*

FIGURE 2-6

Two Native Sunfishes that Occur in Florida's Lakes

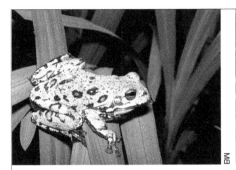

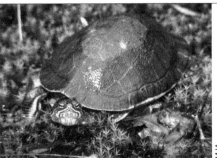

Barking treefrog *(Hyla gratiosa).* Like all North American treefrogs, this animal comes to ponds to breed.

Chicken turtle *(Deirochelys reticularia).* This turtle prefers small ponds. If one pond dries up, the chicken turtle will travel far over land to find another.

Greater siren *(Siren lacertina)* is a large salamander. It has a body up to 30 inches long with short front legs and no hind legs. To obtain oxygen, it has both gills for use under water and lungs for use in air. A wholly aquatic animal, the siren burrows into bottom sediments when its habitat dries up.

FIGURE 2-7

Other Animals in Florida Lakes

Figure 2-7 displays three representatives of other animal groups that are found in and around lakes. And nearby there are many birds and mammals that drink the water and fish in the lakes.

DIVERSITY OF FLORIDA'S LAKES AND PONDS

The next few paragraphs briefly describe each of the seven types of lakes itemized at the start of this chapter (leaving sinkhole lakes for Chapter 4). Lists that accompany these sections demonstrate various aspects of the species diversity they support, focusing on the plants in some lakes and the fish in others.

Clayhill Lakes. Clayhill lakes of varying shapes, depths, and slopes are scattered in depressions all across north Florida's highlands. Their shorelines vary greatly; some are grassy, some shrubby, some forested with swamp trees. Conspicuous within the water are about a dozen species of aquatic plants, and there are some two dozen species of fish (see List 2-4). About 30 other kinds of animals are observed in and around these lakes including alligators, turtles, snakes, birds, beavers, and otters.

Pristine clayhill lakes are rare today. The lakes that most travelers see from highways have been greatly altered by human settlement, destruction of lakeside vegetation, and pollution.

Sandhill Lakes. Sandhill lakes are found in ancient sand deposits that now lie inland. The typical sandhill lake is a big, round lake bathed in sun, with a smooth, sandy bottom that is underlain by limestone. The water is slightly acid from vegetation in the surrounding sand, is low in minerals, and supports sparse populations of water plants and fish. Even so, it is an important breeding place for local amphibians and insects.

Because they are so shallow, usually less than ten feet deep, sandhill lakes expand and shrink dramatically with seasonal rains and droughts. They even dry out completely every 20 or 30 years.

LIST 2-4
Fish species in clay-hill lakes (examples)

Black crappie
Bluegill
Bluespotted sunfish
Bowfin
Brook silverside
Chain pickerel
Flier
Florida gar
Golden shiner
Golden topminnow
Ironcolor shiner
Largemouth bass
Least killifish
Lined topminnow
Okefenokee pygmy
 sunfish
Pirate perch
Pygmy killifish
Redear sunfish
Redeye chub
Swamp darter
Threadfin shad
Warmouth
Western mosquitofish
Yellow bullhead

Scientific names of these and all other species named in lists are in the Index to Species.

Source: Guide 2010, 209

Some sandhill lakes are ringed by narrow borders of aquatic plants, others by broad bands of shrubs. Some are clear throughout, others have submerged aquatic plants dominating much of their area. Floating plants cover much of the surface in some cases (see List 2-5). Insects swarm around them, feeding on the plants and using them as perching, hiding, and breeding places. Many of the insects are unusual and some are endemic. Because insects thrive, animals that eat them are numerous too.

A number of long-legged birds wade along the shore, dipping for fish, frogs, and salamanders. Ducks visit to eat the aquatic vegetation, and many birds court, breed, feed, and nest nearby.

Swamp Lakes and Floodplain Lakes. Swamps are defined as wetlands whose emergent plants are trees and shrubs. The swamp part is that under the tree canopy. Swamp lakes may have open water—that is, aquatic habitats—in their deeper centers. Trees such as cypress, gums or tupelos, and others around the edges of these lakes produce a deep shade in the shoreline zone. Examples of the plants, fish, amphibians, and reptiles are in List 2-6 and List 2-7, and besides these, numerous birds visit the lakes including herons, egrets, ibises, wood storks, belted kingfishers, and water-loving mammals such as beavers and otters.

Some swamp lakes lie in river floodplains, others lie in depressions in flatwoods. Flatwoods lakes are low in minerals, but decomposing vegetation produces abundant organic acids which make the water acidic and stain it brown or black in color but otherwise clear, like tea. These characteristics give them the alternative name, blackwater lakes.

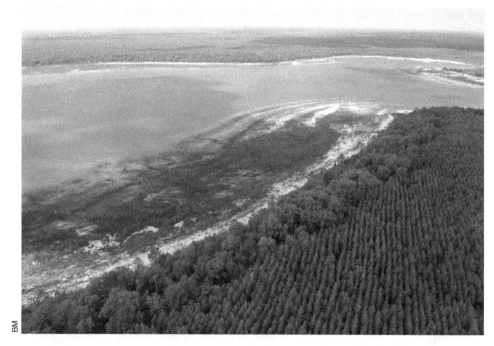

Part of Big Blue Lake in Washington County, a typical sandhill lake showing 1) a gently inclined shore with wetland plants in the foreground, and 2) steeper shores in the distance with white sandy beaches. Where the bottom of the lake is white sand, sky-blue light is scattered; the darker areas are shadows of clouds.

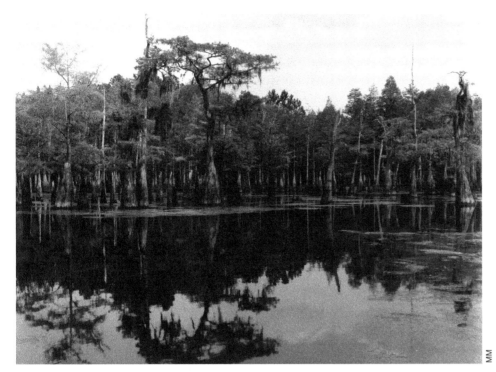

A swamp lake in Leon County.

Shoreline of a swamp lake.

The water level in all basins rises and falls with the rainy and dry seasons. In the case of basin lakes in river floodplains, the water flows during high-water stages, then is trapped when river levels fall. Lakes in the floodplains of high-discharge rivers may have their contents completely swept away once or twice a year, but life quickly returns from bottom sediments and from upstream waters.

Flatwoods and Prairie Lakes and Ponds. Lakes in Florida's flatwoods and prairies may be surrounded by sparse prairie plants or by dense shrubs. Often, saw palmetto encircles them above the high-water line. Within the water are numerous emergent plants: varieties of yelloweyed grass and spikerushes along with maidencane and creeping primrosewillow. Many animals live in these lakes and many others visit them to feed or breed (see List 2-8). As with swamps, flatwoods and prairie lakes in the wet season may become basin marshes in the dry season.

Among flatwoods ponds are cypress ponds, which lie in small, roughly circular depressions that have formed all over Florida's coastal lowlands wherever limestone has dissolved below the ground. Some are ringed by cypress and are called cypress donuts; others have cypress throughout and are called cypress domes. Other trees may grow among the cypresses if the pond is water-filled for long enough to maintain peat. Sweetbay, swamp bay, loblolly bay, and sometimes slash pine can grow in peat beneath cypresses if the water level remains shallow and fairly constant. If the water level fluctuates greatly, however, then cypress may be the only tree species present.

Florida's largest prairie lake is Lake Okeechobee, in the southcentral peninsula. Lake Okeechobee receives huge influxes of water from the

LIST 2-7
Animals in river floodplain lakes and swamp lakes (examples)

Fish
Bluegill
Bowfin
Brown bullhead
Flier
Florida gar
Golden shiner
Golden topminnow
Lake chubsucker
Largemouth bass
Pirate perch
Pygmy killifish
Redfin pickerel
Spot
Swamp darter
Tadpole madtom
Taillight shiner
Western mosquitofish

Amphibians
Alabama waterdog
Bullfrog
Mole salamander
Sirens
Southern cricket frog

(continued next page)

LIST 2-7
(continued)

Southern leopard frog
Two-toed amphiuma

<u>Reptiles</u>
American alligator
Banded water snake
Common musk turtle
Common snapping turtle
Eastern mud turtle
Florida cooter
Florida softshell turtle
Mud snake
Plainbelly watersnake
Yellow-bellied slider

A **cypress dome** is a roughly circular depression that holds water for some or most of the year, and in which cypresses grow with the tallest in the center.

A **cypress donut** is a cypress dome with open water in the center.

Kissimmee River in the rainy season and releases the water over its southern rim into the Everglades. When Marjory Stoneman Douglas first saw Lake Okeechobee nearly a hundred years ago, it was pristine. Numerous tree islands dotted the lake and every tree held nesting water birds. She described it with rapture:

> [The lake was] one of the greatest nesting places in the world. [The trees] were covered with acres of stick nests of egret and glossy ibis and heron of every kind. . . . At sunset with full crops they would move in their white thousands and tens of thousands, with the sound of great stiff silk banners, birds in flocks, birds in wedges, birds in wavering ribbons, blue and white crowds, rivers of birds pouring against the sunset.[4]

Later, Lake Okeechobee attracted hundreds of fishermen and became the speckled perch capital of the nation, supporting a $22 million a year fishing industry. Duck hunters found it a paradise, too, and even with all the human activity, the lake supported 12,000 alligators, uncountable millions of frogs, and other water animals. Today, although greatly changed, the lake still holds an abundance of tree islands, bird colonies, and multitudes of fish.[5]

Coastal Dune Lakes. Coastal dune lakes are shallow, usually elongate, lakes in coastal communities. Dune lakes are far more stressful environments than inland lakes, because they are subjected to much more variable weather conditions. Sometimes storms and hurricanes push surges of salt water into them. Then heavy rains may fill them with fresh water. At other times the sun practically dries them up; then salt water may intrude from underground. When water is present, it is hot, and dark with decayed vegetation. Few species can survive in such environments. Whereas in the clayhill lake described first, there were 25 species of fish, in the coastal dune lake there are two (see List 2-8) There are six species of turtles in clayhill

A prairie lake in Paynes Prairie, Alachua County. During wet times, a sinkhole that drains the prairie becomes plugged, rainwater accumulates, and parts of Paynes Prairie become marsh lakes.

A prairie lake. Lake Okeechobee, Florida's largest lake, occupies 690 square miles in Glades, Hendry, Highlands, Martin, Okeechobee, and Palm Beach counties.

lakes; here there is one: the mud turtle. Clayhill lakes have five species of snakes, but here there may be only one: the banded water snake.

Although life is sparse in coastal dune lakes, it is abundant nearby. Birds, reptiles, and rodents that live in the surrounding ultra-dry terrain come to these lakes to drink when the water is fresh. Many insects, which form the base of numerous food chains, spend their larval lives in lakes.

Temporary Ponds. Among the types of lakes described to this point, some can be quite small (one-tenth of an acre to an acre or two) and shallow (one to five feet deep). These ponds dry down completely at times: their hydroperiods range from weeks to a few years, and they never or rarely have fish.

Literally thousands of such small, isolated water bodies exist and make a very important contribution to Florida's wetland biodiversity. No fewer than 30 species of amphibians and reptiles require these ponds to reproduce. In the case of amphibians (many species of frogs and salamanders), they need the ponds during their larval stages whereas among reptiles, five species of turtles and several snakes need the ponds as habitat in which to live while water is present. Two species of flatwoods salamanders, for instance, absolutely require temporary cypress ponds in flatwoods for their larval stages. Similarly, the striped newt prefers sandhill ponds for its larvae, as does the gopher frog, which is often found with it. Figure 2-8 shows three forms a temporary pond can assume in dry and wet seasons.

When temporary ponds dry down, aquatic life becomes concentrated in a smorgasbord for wading birds, snakes, and other predators. The federally threatened wood stork is specially adapted for feeding in these ephemeral wetlands.

A **temporary pond** (or **depression marsh** or **ephemeral pond**) is a shallow depression that holds water during rainy seasons and dries up completely between times.

A wetland's or lake's **hydroperiod** is the length of time during which it is saturated or inundated each year or series of years. The hydroperiod is a key factor governing what plants will grow there.

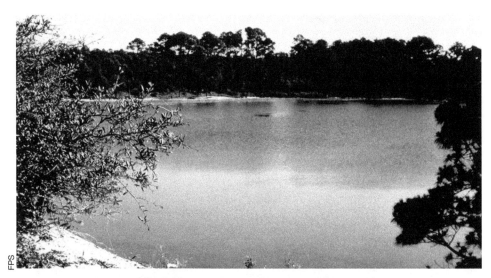
A coastal dune lake in Topsail Hill State Park, Walton County.

**LIST 2-8
Animals in coastal dune lakes**

Fishes
Western mosquitofish
Sailfin molly

Other animals
American alligator
Eastern mud turtle
Saltmarsh snake

Source: Guide 2010, 211.

**LIST 2-9
Animals in coastal rockland lakes**

Florida Keys sheepshead
 minnow
Florida Keys sailfin molly

Source: Guide 2010, 213.

Coastal Rockland Lakes. South Florida has one other type of still-water body: a coastal rockland lake. These lakes differ from the others treated in this chapter because they have limestone walls and floors and alkaline water. Each rockland "lake" is actually just a tiny, deep solution hole hidden within a tropical hammock in the Florida Keys. Acid from disintegration of plant matter eats into the underlying limestone to form these holes, and then they fill with rain. Their fresh water floats as a thin lens on top of salty groundwater. The lens is often and easily depleted; then the coastal rockland lakes turn salty throughout. List 2-9 shows that, as in coastal rockland lakes, only a couple of fish species are present.

Because of the stressful alternation of fresh and salt water in rockland lakes, few plants grow in the water, but algae are attached to the bare walls and floors. Small fish such as the sheepshead minnow and sailfin molly feed on these algae, and thirsty Florida Key deer and other animals from the surrounding hammocks and pine rocklands come to drink the water when it is fresh.

CYCLING OF FLORIDA LAKES AND PONDS

Despite all their differences, Florida's lakes and ponds have much in common. They are all still-water, as opposed to flowing-water, environments. Except at times of overflow, the only movements of water in them are upward evaporation, downward percolation, and occasional stirring by wind.

All lakes experience seasonal and long-term variations in area and depth—that is, "pulses." Florida lakes do not freeze, so they lose water to evaporation at a quite constant rate the year around, but their water levels fluctuate greatly with rainfall. Seasonal rains may cause a lake to rise and fall from two feet for some to more than 20 feet for others. About 80 percent of Florida lakes fluctuate by five feet or more in a year, and a five-foot change in depth makes for a much greater change in area. On flat land, a foot or two added to the depth of a shallow lake may expand its margin by 100 feet or more. A foot or two lost may shrink it drastically.[6]

Temporary pond in the dry season. Because it completely dries up each year, the pond supports no fish.

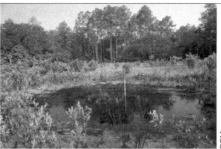
Same pond during a winter rainy season. The pond now measures about 75 feet across.

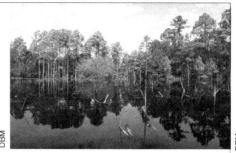
Same pond in 100-year flood. Now 500 feet across, it is still free of fish, and safe for small aquatic animals.

FIGURE 2-8

A Temporary Pond in Three Different Seasons

Expansion and contraction of a lake's area profoundly affect shoreline life. When a lake expands, terrestrial vegetation becomes submerged and dies back around the newly flooded margin. Then rotting plant materials—muck and peat—accumulate in the water. In contrast to the rooted vegetation, though, aquatic plants thrive. Fish and other water-loving wildlife expand their ranges and population sizes. Each rain increases the acidity of a lake temporarily by flushing dead plant matter into it.

When a lake dries down, its plant matter oxidizes and disappears. Fires often burn through surrounding marshes and the organic lake bottom itself may even burn. While the shoreline and bottom are dry, the seeds of many nearby plants quickly colonize the newly available soil, and plants whose seeds have been lying dormant under water grow and flower and reseed quickly. Unusual species may bloom in profusion in dry lake beds, then go dormant again for many years while under water. An observer of lake cycles in the Panhandle reports seeing two such flowers only a few times in 50 years: Kral's yelloweyed grass and Panhandle meadowbeauty, both endemic to north Florida's sandhill lakes.

When the rains return, low-oxygen conditions keep the fresh crop of seeds dormant until once again the lake dries and they become able to sprout.[7] After drying, a lake basin can refill with rain water or water overflowing from other water bodies. Then it becomes habitable again by aquatic plants and animals. Once refilled, a lake may regain its fish from eggs that have lain dormant in the bottom sediments or fry that have survived in deep holes. Overflow from other water bodies may carry animals in, and occasionally wading birds fly in, bringing fish or salamander eggs stuck to their legs.

Just as terrestrial plants seem to disappear when a lake bed is full of water, lake animals seem to disappear when the lake goes dry. Then during the next rainy season, lake animals grow and mature quickly, breed, and lay their eggs or release their young. Anyone who has heard the

Halloween pennant dragonfly (Celithemis eponina). Like all dragonflies, this animal spends its larval life in lakes.

sudden calling of frogs in the first rain that terminates a drought knows how promptly these animals respond to the arrival of water. Once mature, they live on land, hide by day, and come out at night.

When lakes shrink, the adult aquatic animals that have lived in them become more and more crowded, making them easy prey for other animals. Predators devour them and thrive in their place—a population shift in response to the lake's seasonal changes. Lakes vary year by year, too. About once every ten years, a third less rain falls than the average.[8]

The surface of all of Florida's lakes is at the same level as that of the local water table. In the larger lakes of central and north Florida, it is the great Floridan aquifer system itself that is exposed. In other lakes, especially those that lie on sands that rest upon a dense layer of relatively impermeable clay over limestone, the water that supports a lake may be a local surficial aquifer perched on the clay beneath the sand.

Water tables rise and fall over time, and all lakes undergo periodic natural cycling that reflects these changes in level. When water levels fluctuate only a little, peat builds up in lakes, making them shallower. A 25-foot-deep lake might completely fill in with peat over a 5,000-year period. However, during a drought when the water table falls, the peat dries out and normally, upon being exposed to air, decomposes. Dry peat is also vulnerable to fires, which rapidly reduce it.

It must be clear from the foregoing that both short- and long-term flux governs much of the forms and functions of Florida's lakes. When they first form, or as they are forming, they are dominated by water and are largely aquatic habitats. Then, if peat builds up sufficiently, a lake may become a marsh with emergent herbaceous vegetation rooted in the peat. If this process continues, the marsh becomes a swamp (a wetland dominated by trees). However, many factors interact and these processes start and stop, causing long-term and short-term fluctuations in the lake basin ecology. All of these stages are normal and produce viable and valuable ecosystems at any stage.

Changes in Florida's lakes that have negative impacts are almost always caused by man. Sedimentation by runoff of sand, clay, and silt from human activities in adjacent uplands can settle on the bottoms of lakes and smother the vibrant benthos. Heavy metals and toxic hydrocarbons and other chemicals that run off roads, parking lots, subdivisions, and agricultural fields accumulate in the peat of bottom sediments. And heavy loads of nitrogen, phosphorus, and other elements nutrify lakes and stimulate unnatural algal, bacterial, and fungal blooms in the water. This eutrophication process depletes oxygen levels so much that fish and other lake animals undergo major die-offs. Worse, when lakes are dewatered by drought and human-induced draw-downs, the toxins that have been sequestered in the bottom sediments are released into the water or flushed into streams to wreak more havoc.

An impoverished lake community signifies the lake's lost health and a need for restoration. Guidelines for the monitoring of Florida lakes are available.[9]

VALUES OF LAKES AND PONDS

Besides providing habitats for resident animals, lakes are important to visiting animals. Water birds prey on fish, and the more fish are in a lake, the more water birds will be there. To sustain the life of a lake, keep its shoreline wetlands natural and undisturbed so that fish and fish-eating birds will be numerous. Visiting birds might include bitterns, herons, eagles, rails, wrens, and grackles, among others. Animals also come to lakes from the surrounding land for fresh drinking water. Wild turkeys gobble at dawn from the swamps around lakes, and barred owls hoot at dusk. Deer, bear, raccoon, opossum, bobcat, and other animals visit lakes from nearby wildlands. Lakes are also stopping places for migratory birds, which need healthy lake vegetation and aquatic organisms to feed on. The birds in turn enrich the variety of life there.

In their original, pristine condition, all of Florida's lakes were outstanding water bodies. The Indian names of Florida's lakes and ponds— Tsala Apopka, Tohopekaliga, Weohyakapka, and the others—testify that they have always attracted people to their shores. Today, many have changed greatly due to human impacts. Lake Okeechobee is in the heart of south-central Florida's agricultural area. Lake Apopka (in Orange County) is surrounded by citrus groves and farming operations where lake muck and peat are collected for use as fertilizer. Lake Jackson (in Leon County) has been engulfed by residential development—and so forth. Similar stories relate the fates of virtually all Florida lakes.

Like all plants, those that grow in lakes and ponds require nitrogen, phosphorus, and other nutrients to grow, and up to a point, the more nutrients are present, the more abundant the plants will be. However, a superabundance of nutrients running into a lake can lead to the growth of so many algae that the lake cannot support its other aquatic organisms. As algae pile up in the water, some sink out of the sunlight and die; this leads to overgrowth of bacteria, oxygen depletion of the water, and death of the lake's fish and other animals. The progression of this process to the extreme, known as eutrophication, presents a major hazard to Florida's lakes. Broadleaf cattail, which is native to Florida, becomes an invasive weed when a lake turns eutrophic.

Lakes and ponds are vulnerable to altered land uses around them. The quality of a lake's water depends on the quality of the basin in which it lies. If the forests and wetlands surrounding a lake are disturbed (removed or drained), as many are today, pollutants may flow in and end up in the bottom sediments, never to be washed away. Lake restoration and, especially, lake protection are vital to the future of Florida's lakes.

Seminole killifish (*Fundulus seminolis*).

Eastern mosquitofish (*Gambusia holbrooki*).

Lake waters may be **dystrophic, oligotrophic, or eutrophic.**

Dystrophic waters are low in nutrients and/or acidic and support little growth of plants.

Oligotrophic waters have moderate nutrient levels.

Eutrophic (yew-TROH-fic) waters have abundant nutrients and produce abundant plant life.

Eutrophication (YEW-tro-fi-CAY-shun) is the process by which a lake becomes more eutrophic, and can lead to death of the lake's living things.

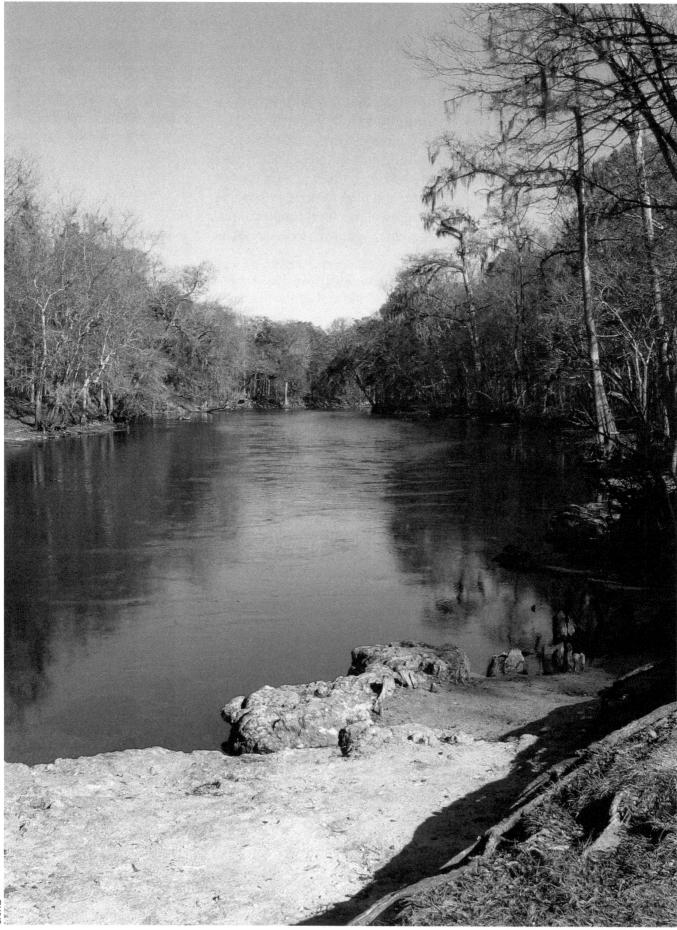

CHAPTER THREE

ALLUVIAL, BLACKWATER, AND SEEPAGE STREAMS

In 1867, while traveling through Florida, John Muir commented that "Most streams appear to travel through a country with thoughts and plans for something beyond. But those of Florida are at home, do not appear to be traveling at all, and seem to know nothing of the sea. . . . No stream that I crossed today appeared to have the least idea where it was going."[1] And indeed, Florida has some of the flattest streams on the continent. To be sure, across north Florida, some streams run down slopes out of clayey uplands, but peninsular Florida streams arise in lowlands where the land is nearly level. These waterways make hairpin turns and reverse them, traveling as much sideways as forward. A walker on the bank of a typical, flat Florida stream can easily keep up with it—the average flow is only 1 mile per hour. The very flat St. Johns River, 150 miles from its mouth, flows at only a third of a mile per hour. And while the St. Johns flows north, the Kissimmee, which is parallel to it, flows south through essentially the same terrain.[2]

Still, streams do flow, however slowly, and this makes them altogether different from the lakes and ponds of the last chapter. Anything that lives in a stream, plant or animal, has to be able to cope with and take advantage of a constantly moving environment. Plants must be rooted on the bottom, or, if floating, must circulate in eddies off the main stream. Animals must anchor themselves in bottom sediments, seek quiet backwaters, swim constantly against the current, or alternately swim upstream and drift downstream, perhaps at different times in their life cycles. Mullet jump repeatedly on their way upstream.

It is a common misconception that a stream is just the flowing water in a surface channel. It is that, of course, but many Florida streams are also part of much larger, hidden water bodies that are flowing underground. In sandy and karst areas, streambeds are permeable and the surface portions of streams exchange water with the ground along their banks and floors. Some streams flow underground for some miles and then come to the surface in springs. Some flow underground all the way to the coast, and then emerge from holes on the ocean floor offshore.

All natural, flowing, fresh-water systems are **streams**. Thus all **rivers** and **creeks** are streams. Canals are manmade and, although they may flow, are not considered streams.

Blackbanded sunfish (*Enneacanthus chaetodon*). This small fish swims in lowland streams all along the U.S. east and Gulf coasts.

OPPOSITE: The Santa Fe River, a major blackwater tributary to the Suwannee River. The river flows through terrain that is rich in limestone and has exposed the outcrop seen in the foreground. The photo was taken in Gilchrist County, looking toward Columbia County.

In another sense, too, to correctly understand a stream, one must realize that it flows, not in just one channel, but in two. There is a high-water channel as well as a low-water one. The low-water channel is what most people are familiar with because it is the purely aquatic portion that is confined between two discrete channel banks. The high-water channel is the floodplain, which is often much wider. Along the Apalachicola River, for example, the high-water channel can be five miles wide between the river valley sidewalls.

The low-water channel meanders over time from one side of the river valley bottom to the other as the faster flowing water of the outside bends cuts into the bank sediments and deposits those sediments on inside bends as point bars. The low-water channel "snakes" from one side to the other across its high-water channel that receives overflow waters during high water events. While this chapter describes the aquatic environment of rivers and streams, the river dynamics and wetlands of the high-water portions of rivers are described in Chapter 5 of Volume 2 (*Florida's Wetlands.*)

In sum, streams in Florida are of many kinds; no two are alike. However, they are grouped here into four idealized types, of which three are treated in this chapter: alluvial, blackwater, and seepage streams. (Those of the fourth type, spring-run streams, are treated in Chapter 4, together with the aquatic caves with which they are connected.) Finally, to demonstrate the complexity that exists in real streams, one of them, the Suwannee, is described in more detail.

Figure 3-1 identifies several dozen Florida streams. None is large in comparison with the world's greatest rivers. Compared with the Amazon, for instance, even the Mississippi is small, and Florida's largest stream, the Apalachicola, is smaller still. But Florida's 1,700-odd streams move water across thousands of miles of terrain. Taken together, they carry an enormous volume of water because they drain regions of such high rainfall. Florida has more than a dozen major rivers—that is, rivers that drain areas greater than 500 square miles each—and the 55 to 70 inches of rain that fall each year on 500 square miles add up to an awesome pile of water.[3]

DIVERSITY OF FLORIDA'S STREAMS

As indicated by the definitions in the margin, Florida's streams carry water from various sources in all kinds of terrain. Some streams are muddy, some colored with organics, some clear. Some are acid and rich in iron, some are alkaline and rich in calcium and magnesium, some carry other salts or sulfur, and some are nutrient poor. Some vary much more in volume and temperature than others. Some are long and have many tributaries, others are short and have none.

Streams vary in volume over the year, some much more than others. Some streams flow through areas that are impervious to water such as the clayey highlands of north Florida. Their streambeds are almost impermeable to water, and the extents to which these streams rise and fall depend almost entirely on rainfall. They vary many-fold in volume from

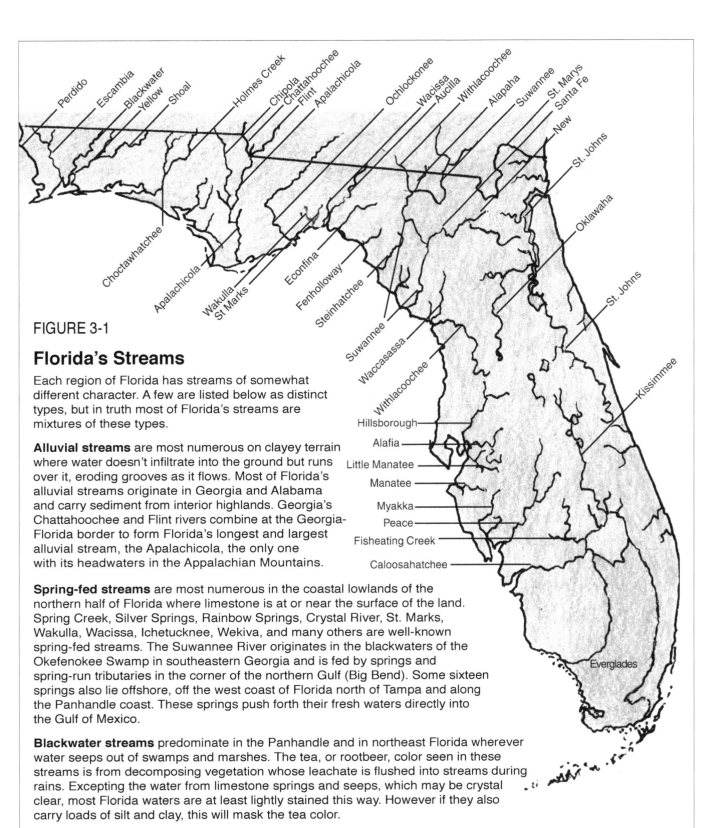

FIGURE 3-1

Florida's Streams

Each region of Florida has streams of somewhat different character. A few are listed below as distinct types, but in truth most of Florida's streams are mixtures of these types.

Alluvial streams are most numerous on clayey terrain where water doesn't infiltrate into the ground but runs over it, eroding grooves as it flows. Most of Florida's alluvial streams originate in Georgia and Alabama and carry sediment from interior highlands. Georgia's Chattahoochee and Flint rivers combine at the Georgia-Florida border to form Florida's longest and largest alluvial stream, the Apalachicola, the only one with its headwaters in the Appalachian Mountains.

Spring-fed streams are most numerous in the coastal lowlands of the northern half of Florida where limestone is at or near the surface of the land. Spring Creek, Silver Springs, Rainbow Springs, Crystal River, St. Marks, Wakulla, Wacissa, Ichetucknee, Wekiva, and many others are well-known spring-fed streams. The Suwannee River originates in the blackwaters of the Okefenokee Swamp in southeastern Georgia and is fed by springs and spring-run tributaries in the corner of the northern Gulf (Big Bend). Some sixteen springs also lie offshore, off the west coast of Florida north of Tampa and along the Panhandle coast. These springs push forth their fresh waters directly into the Gulf of Mexico.

Blackwater streams predominate in the Panhandle and in northeast Florida wherever water seeps out of swamps and marshes. The tea, or rootbeer, color seen in these streams is from decomposing vegetation whose leachate is flushed into streams during rains. Excepting the water from limestone springs and seeps, which may be crystal clear, most Florida waters are at least lightly stained this way. However if they also carry loads of silt and clay, this will mask the tea color.

In any case, the term blackwater is applied to streams that are usually otherwise clear. The Perdido, Blackwater, New, and Aucilla rivers are classic blackwater streams in the Florida Panhandle. In the peninsula, those that do not have spring-run components, including the St. Marys and St. Johns, are largely blackwater streams.

Seepage streams arise from groundwater that seeps out of the banks of sand hills. Valley wall seepage also is an important source of the water in the Choctawhatchee, Ochlockonee, Suwannee, and Apalachicola rivers.

Steephead streams are a special class of seepage streams. They seep from the bases of steep-sided, sandy ravines.

Sources: Heath and Conover 1981, 115; Johnson 1996

Striped bass *(Morone saxatilis)*. The striped bass is one of several fish species that enter streams on both the Atlantic and Gulf coasts to spawn.

Ocean fish such as sturgeon, striped bass, and shad, which come into freshwater streams to spawn, are known as **anadromous** (an-ADD-ro-mus) fish.

American eels and hogchokers, which leave freshwater environments to spawn in salt water, are **catadromous** (ca-TAD-ro-mus) fish.

wet to dry seasons. In contrast, on land that is permeable to water such as Florida's sand hills and karst lowlands, groundwater exchanges readily with stream water, replenishing it during droughts and accepting it after rains. As a result, the seepage streams and spring runs found in these areas vary only a little in volume. Blackwater streams are maintained by base flow from seepage along their banks, but small blackwater streams may dry up altogether during dry times. Their flow may vary more than a hundredfold over the year.

Fluctuations in a stream's volume affect the life it supports. Because alluvial streams receive large influxes of fresh nutrients and water during heavy rains, the ecosystems they support are the most diverse. Because spring runs vary only twofold or less in volume, they offer a nearly constant environment for a rich assemblage of plants and animals. Blackwater streams, which often almost dry up, place stringent limits on the plants and animals that can grow there. Variations in stream volume also affect estuaries as described in Chapter 5.

Florida's streams also vary in the topography of their banks and bottoms and in the amounts of light and shade they receive. Thanks to these variations, different streams are home to different sets of algae, rooted plants, bottom microorganisms, fish, and invertebrate animals. Florida's streams provide habitat for some 100 species of strictly freshwater fishes and another 100 species of saltwater fishes that swim off the coast but make their way up freshwater streams to forage or to spawn (release their eggs and sperm for fertilization). Eels and hogchokers do the reverse: they spawn in the ocean and live out the rest of their lives in interior waters.

To complicate matters still further, the various reaches of a single stream differ from each other. The first- and second-order streams near the headwaters offer habitat for different assortments of plants and fish than do the downstream reaches. List 3-1 shows how the fish populations of the

Yellow River in the western Panhandle change along its course. The many variations seen in streams make them tremendous reservoirs of wetland and aquatic biodiversity.

ANIMAL SPECIES ENDEMIC TO STREAM SYSTEMS

Just as an island or continent may be the permanent home of endemic land plants and animals, so a stream system may be the permanent refuge of endemic freshwater species. Land animals can wander long distances, and saltwater plants and animals can swim all over the ocean. But freshwater animals, especially small ones, may be restricted to only one stream system. If a freshwater animal travels too far from the waterways it inhabits, it will die of exposure to dry conditions, and if it is washed out to sea, it will die of salt exposure.

Moreover, compared with lakes, which typically persist for only a few thousand years, streams can be millions of years old, allowing time for new species to evolve in them. Not surprisingly, then, streams flowing out of Florida's northern highlands, which have been above sea level for tens of millions of years, have distinct species of animals. These animals are not endemic to Florida alone, but to whole stream systems that flow through Florida from Alabama and Georgia.

In some cases, neighboring stream systems share endemic species. This reveals that when sea level was lower, the streams joined on the outer continental shelf before they reached the ocean. Then the marine waters rose and swamped the junction. Now each stream runs directly into salt water, but may still have endemic species in common with a neighboring stream. Figure 3-2 presents examples of fish species endemic to distinct stream systems.

Many of Florida's stream systems, those that run from origins in the peninsula, are relatively young: they have been completely drowned by the ocean within the last three to five million years. However, those streams that flow out of the northern highlands are very old, and their upper reaches in the Appalachian Mountains have been above sea level for more than 65 million years. The old stream systems are, in a sense, like islands. They have been isolated from other stream systems for so long that some of the animal populations in them have evolved to become distinct species. Dozens of species of freshwater fishes occur in the old stream systems. So do many turtle species—and for that matter, snails, mussels, clams, and other aquatic animals.

The most diverse array of endemic freshwater fishes occurs in the Apalachicola River: 83 species. It and the Suwannee and Escambia rivers harbor most of those that are endangered, threatened, and rare. Three bass species are localized in the Suwannee and neighboring rivers west of it.

Many of Florida's diverse species of freshwater turtles, too, are restricted to one or a few stream systems. Two of them are mostly endemic to Florida, ranging only a short way upriver into Alabama and Georgia—Barbour's map turtle and the Suwannee cooter.

LIST 3-1
Fish habitats along the Yellow River

Small creeks at the river's origins are home to small darters and shiners. Larger creeks downstream hold other mixes of fish, each different.

Numbers represent percentages of total fish in each habitat. For example, of the fish in small creeks, 18 percent were sailfin shiners. Only the five most numerous fish are listed for each habitat.

Small creeks
Sailfin shiner (18)
Weed shiner (15)
Flagfin shiner (14)
Blackbanded darter (9)
Longnose shiner (6)

Larger creeks
Weed shiner (23)
Blacktail shiner (18)
Longnose shiner (16)
Blackbanded darter (9)
Blackspotted
 topminnow (7)

Main channel
Weed shiner (30)
Blacktail shiner (21)
Blacktail redhorse (6)
Bluegill (6)
Longear sunfish (4)

Swamps and backwaters
Pirate perch (15)
Weed shiner (14)
Warmouth (8)
Brook silverside (8)
Bluegill (7)

Tidal swamp and marsh
Bluespotted sunfish (22)
Coastal shiner (13)
Ironcolor shiner (12)
Redear sunfish (10)
Spotted sunfish (10)

River mouth and bay
Rainwater killifish (34)
Coastal shiner (24)
Gulf pipefish (13)
Redear sunfish (7)
Inland silverside (6)

Source: Adapted from Bass (D. G.) 1991.

Suwannee cooter *(Pseudemys con-cinna suwanniensis)*. These turtles often bask in groups on logs along streams. This population is distinct from other river cooter populations and is endemic from the Suwannee to the Ochlockonee river systems.

Detritus (de-TRY-tus) is the finely divided material that results from the partial decomposition of organic matter and is an important source of energy in wetland and aquatic ecosystems.

LIFE IN ALLUVIAL STREAMS

Alluvial streams are turbid. They carry clay, silt, sand, and detritus, especially during floods. Water volumes and temperatures vary with seasons and rainfalls. Stream beds are muddy; berms and levees are sandy. These factors define the aquatic habitats.

Plants are not numerous in alluvial streams. Too little sunlight penetrates the cloudy water to support growth below the surface, and any plants that manage to take hold in the loose bottom sediments are uprooted and swept away by each year's powerful floods. Quiet backwaters in large, wide, slow-moving streams may harbor some plankton. One reference names 22 different genera of plankton found in alluvial streams—not many compared with the hundreds of species in lakes, but more than might be expected.[4]

Alluvial streams offer diverse habitats to animals that can cope with their varying flows and temperatures. They have sandy to muddy bottoms and banks, fast-flowing currents around outer bends, and quiet inner curves. And every year when streams overflow their banks, their floodplains, too, become aquatic habitats. Then fish, frogs, turtles, water snakes, and others swarm all over the floodplain feeding, breeding, and leaving behind eggs and young fish to start their next generations. During droughts, ponds remain in floodplain swales and are important reservoirs for many species. Some of those that frequent alluvial stream habitats are shown in List 3-2.

An important habitat in flatter portions of the floodplain is the slough, a quiet part of a former channel off the main channel. Sloughs are sometimes water-filled, sometimes muddy. They are an ideal place for tiny animals to be born and live their early lives. Because they are connected to the stream at intervals, sloughs do not trap fish as ponds do. They permit maturing fish to move out into the larger aquatic world when the water level rises and the young fish are ready.

The bottom sediments of alluvial streams house a rich and varied, little-known life. Who but a specialist in bottom-dwelling organisms would know that Florida's alluvial stream bottoms include at least 60 species of clams? Some 40 of these are in the Apalachicola River, and three are endemic to just that river's watershed. The Apalachicola also has 20 snail species, of which five are endemic. Only if you were to scoop up buckets of sediments from the bottom and sift them would you find these mollusks, with their distinctive sizes and shapes and variously colored shells. Yet they have dwelt there for hundreds of thousands of years, evolving adaptations to the particular chemistry and biology in the sand, silt, and clay in that particular stream. The same is true of other bottom dwellers even more obscure: worms, crustaceans, and others. They, too, are numerous, varied, and specialized.[5]

Mussels in stream-bottom sediments are of special interest to biologists because they are indicators of the health of an aquatic ecosystem. Mussels clean the water they are in; they have been called "silent sweepers of the stream."[6] Where mussels are abundant, water quality is excellent; where

A Escambia River: Crystal and Harlequin darters.

B Santa Rosa County: Blackmouth shiner.

C Okaloosa and Walton counties: Okaloosa darter.

D Apalachicola-Chipola River: Shoal bass, Bluestripe shiner, and Barbour's map turtle.

E Ochlockonee to Suwannee rivers: Suwannee bass.

F Ochlockonee to Suwannee rivers: Suwannee cooter.

G St. Johns River: Shortnose sturgeon and Southern tesselated darter.

FIGURE 3-2

Native Fish Species Endemic to Specific Stream Systems

Sources: Bass (Gray) 1987; Suwannee River Task Force 1989; Mount 1975.

they are scarce, there is likely to be pollution or smothering by eroded silt and clay. If its mussels die, an entire aquatic ecosystem may become unable to support its normal biodiversity.

Mussels face the challenge of resisting the force of the river, which tends to sweep them out to sea. Only if they can seed their offspring high up near the source, can they keep the whole riverbed populated. Figure 3-3 shows how mussel larvae attach themselves to fish and thus gain transport upriver.

A few mussels endemic to the Apalachicola and Ochlockonee stream systems have an especially effective knack of attracting fish, especially bass,

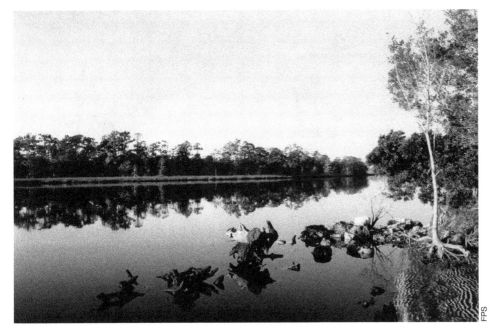

The Ochlockonee River, a mixed blackwater and alluvial river in the mid-Panhandle. Viewed during the fall dry season, the river is relatively clear.

LIST 3-2
**Plants and animals
in and around
alluvial streams**

<u>Plants</u>
 <u>Along quiet stretches:</u>
 Waterlily species
 Pondlily species

 <u>Fringing the banks</u>
 Cattail species

 <u>Along the banks</u>
 River birch
 Silver maple

<u>Fish</u>
American eel
Bluegill
Crappie species
Darter species
Gizzard shad
Madtom species
Pirate perch
Redbreast sunfish
Speckled chub
Striped bass
Warmouth

<u>Amphibians</u>
Alabama waterdog
River frog

<u>Reptiles</u>
Alligator snapping turtle
American alligator
Brown water snake
Common musk turtle
Common snapping turtle
Eastern mud turtle
Florida cooter
River cooter

<u>Birds</u>
Belted kingfisher
Lousiana waterthrush

<u>Mammals</u>
Beaver
North American
 river otter

Source: Guide 2010,
213.

with tempting lures (see adjacent photo). Each lure is actually a large package of the mussel's larvae arranged to look like a small, wiggling worm or fish. The predator who takes a bite of the lure unwittingly ingests dozens of mussel larvae, but obtains nourishment from only a few of them. Most attach to the fish's gills and fins for a free ride upstream.[7]

It is no accident that bass are the chosen hosts for these mussels' offspring. Bass are big, strong swimmers that can distribute the young mussels to the habitats in which they will develop best. The relationship between bass, their rivers, and the mussels has developed over hundreds of thousands of years and supports the opinion, expressed by one fish researcher, that the first fishermen were females—female mussels.[8]

Above the bottom sediments, the stream's flowing water offers other habitats. For example, fast-moving water on the stream's outer bends undercuts trees so that their roots are exposed and the trees fall in. Currents that eddy around these obstacles scour out holes in the banks. Exposed roots and branches offer holdfasts for filter feeders such as insect larvae and these in turn attract small grazing animals and fish. On some outer bends the river undercuts the bank, forming underwater caves in which large fish and other animals can hide. In the Apalachicola River, such caves may cut as deeply as 40 feet into the river's banks. Beavers use them as homes in preference to building their own dens.

LIFE IN BLACKWATER STREAMS

Blackwater streams differ as habitat from all other streams. They emerge from wetlands, mostly marshes, bogs, and swamps, which slowly release

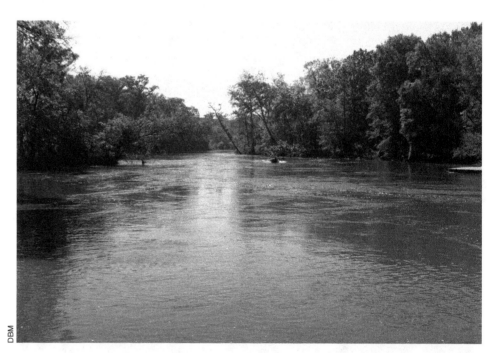

The Choctawhatchee River, brown with alluvium, flows south into Panhandle Florida from the red clay hills of middle Alabama. All of Florida's alluvial rivers are muddier than in presettlement times because they receive large amounts of silt and clay from agricultural runoff in Alabama and Georgia.

How Mussel Larvae Attach to Fish

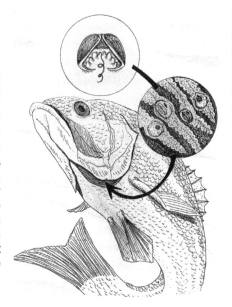

Mussels are descended from marine ancestors that entered from bays and headed upstream, perhaps attached to fish. Today, each species of mussel depends on one or more particular fish species briefly but absolutely during the larval stage. The mussel larva attaches to the fish's gills or fins for just long enough to obtain the oxygen needed for its rapid metamorphosis into a mature mussel. Then it drops off, buries itself in gravel, matures, and filters its food from the passing water. Without their host fish, mussels cannot disperse, and so may lose much of their territory.

Source: Adapted from Conover 1998.

accumulated rain water into stream channels. The stream water is often stained amber by organic acids leached from decaying plant matter in adjacent wetlands. It is variably acidic, carries little or no sediment, and is translucent, like tea. Temperatures and volumes fluctuate with seasons. Streambeds are typically sandy with a thin layer of detritus, sometimes underlain by limestone which may form outcrops in places.

Plant life in a blackwater stream is limited by the dark, acidic water. Submerged aquatic plants cannot grow for lack of sunlight, but emergent and floating plants such as goldenclub, smartweed, and various sedges and grasses may occupy shallow, slow-flowing stretches where the banks are not too steep and water levels not too variable. Blackwater streams have only one species of mollusk, perhaps because their waters contain too little calcium for building shells or because mollusk shells are weakened by acid water. Snails are not numerous either: they prefer clear water where algae can grow. But crayfish seek out black water and are represented by many species, especially in the Panhandle's flatwoods streams. The list of other animals associated with blackwater streams is long (examples are in List 3-3).

LIFE IN SEEPAGE STREAMS

Seepage from streamside banks makes important contributions to many Florida streams, and some streams consist primarily of seepage water. They are cold (around 70 degrees Fahrenheit), clear or lightly colored, and usually somewhat acidic. Their beds are always sandy, although they may have minor accumulations of clay, gravel, or limestone depending on exposure of underlying formations.

The streams in steephead ravine walls are a special case of seepage streams. Steephead ravines are notched into high sand hills which, long ago, were offshore barrier islands with high dunes. Now the sand hills are

Bass lure created by a mussel. A female mussel, buried out of sight at left, has packaged dozens of her offspring in a strand of glutinous material that wiggles in the stream like a small, shiny fish, the perfect lure for bass. When the bass attacks the lure, the offspring are not ingested, but take advantage of the bass (see Figure 3-3).

This mussel, the shinyrayed pocketbook *(Lampsilis subangulata),* is endemic to the Apalachicola and Ochlockonee stream systems.

Mud snake *(Farancia abacura)*. This large snake makes its home in many Florida freshwater habitats. By day, it hides in dense vegetation or other cover; at night it prowls.

stranded inland and groundwater lies in perched aquifers within them. Water from the aquifers percolates down through the sand and runs out from the bottom of the ravine walls onto the floor of each ravine as shown in Figure 3-4.

Steephead streams are crystal clear, and they flow swiftly through dappled shade over flat sand bottoms. Many small fish, salamanders, frogs, turtles, and snakes are adapted to the various niches steephead streams provide. List 3-4 names a few of them.

An unusual plant community occurs partway down some of the larger steephead streams in Okaloosa and Santa Rosa counties where sun exposure is maximal. The water in the center runs clear, but dead leaves and other plant parts catch along the sides and hang in the water. They decay slowly, half floating, half sinking, turning the water acid, and forming a bed of loose, flocculent peat that is inches to several feet thick. Within this bed of peat, pitcherplants take root and bloom by the thousands in continuous sun, floating and swaying in the water.

The fish are especially interesting, and many are beautiful (see Figure 3-5). To survive in a variously lit, fast-flowing, shallow stream, fish have to be small, so that they can hide under fallen leaves and twigs. They

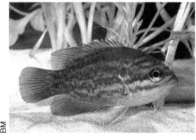

Mud sunfish *(Acantharchus pomotis)*. This small fish easily hides in the dark water in which it swims.

Origin of a blackwater stream. Water seeping out of this swamp collects into a stream, which merges with others to become the Blackwater River in Santa Rosa County.

have to be camouflaged: many are speckled or striped and blend in with the water's ripples. They have to be strong enough to stay abreast of the current and nimble enough to dart forth and pick worms and insect larvae out of the fast-moving water. Among fish with these adaptations, minnows, topminnows, and darters are numerous in the steephead streams of the western Panhandle.

Darters have evolved to become many different species in different north Florida stream systems. They lack the gas bladders that make other fish buoyant, so they can sink to the bottom and use their fins to hop along rather than swim. Many, such as the harlequin darter of the Escambia River, have beautiful rainbow colors on their fins and scales during the breeding season. Each bears the color markings best suited to its particular habitat—the combination of shade, light, depth of the water, and background colors and textures. One species, whose protective coloration makes it nearly indistinguishable from the sand over which it swims, is the Okaloosa darter, Florida's only federally endangered fish species. Altogether, 12 different species of darters occupy Panhandle rivers in Okaloosa and Walton counties alone. Another tiny, endemic fish, the blackmouth shiner, occurs only in a tributary creek of the Blackwater River near Milton. Many other Panhandle streams possess their own animal species, and doubtless many remain to be discovered and described, for hardly anyone has even looked in the bottom sediments to see what burrowing animals are there.[9]

The foregoing descriptions help to distinguish among general types of streams, but to reiterate, no Florida stream conforms strictly to any of these types; each has its own special character. To help convey the true diversity and uniqueness of Florida's flowing waterways, Figure 3-6 presents examples of streams not previously described, and the next section provides a closer look at a single famous, long, and varied Florida river, the Suwannee.

THE SUWANNEE, A RIVER OF MANY PARTS

The Suwannee changes character many times along its length. Each segment of the river supports a different balance of aquatic life. The river originates as black water overflowing from the Okefenokee/Pinhook Swamp, the huge blackwater swamp in southeast Georgia/northeast Florida from which the St. Marys River also takes its blackwater character. Meandering 165 miles before it empties into the Gulf, the Suwannee cuts in places between 40-foot-high banks, crosses numerous flowing springs and sinks, develops rapids on limestone bedrock, and winds through massive floodplain forests before reaching the ocean. It drains 10,000 square miles, half in Georgia, half in Florida, but it is relatively small at the Florida-Georgia border. It picks up an enormous quantity of water from springs and tributaries thereafter and is comparable to the Apalachicola in discharge at its mouth. At least 50 springs feed it, nine of them first-magnitude springs, so even during droughts when the swamps are dry, the Suwannee keeps flowing.

The upper Suwannee River, above White Springs, flows fast and narrow between high, steep banks over densely packed sand and limestone. With

LIST 3-3
Animals associated with blackwater streams (examples)

Fishes
Banded sunfish
Banded topminnow
Bannerfin shiner
Black crappie
Blacktail shiner
Chain pickerel
Channel catfish
Chubsucker
Darters (several species)
Dollar sunfish
Everglades pygmy
 sunfish
Flier
Gizzard shad
Ironcolor shiner
Mosquitofish
Mud sunfish
Pygmy killifish
Redbreast sunfish
Redfin pickerel
Spotted bass
Spotted gar
Threadfin shad
Weed shiner

Amphibians and Reptiles
Alabama waterdog
Alligator snapping turtle
American alligator
Brown water snake
Common musk turtle
Common snapping turtle
Florida cooter
Peninsula cooter
Redbelly watersnake
Spiny softshell
Suwannee cooter

Mammals
Beaver
River otter

LIST 3-4
Animals in steephead streams (examples)

<u>Fish</u>
Blackbanded darter
Brown darter
Creek chub
Sailfin shiner
Speckled madtom

<u>Amphibians</u>
Alabama waterdog
Apalachicola dusky
 salamander
Bronze frog
One-toed amphiuma
Red salamander
Two-lined salamander

Source: Adapted from
Guide 1990, 54.

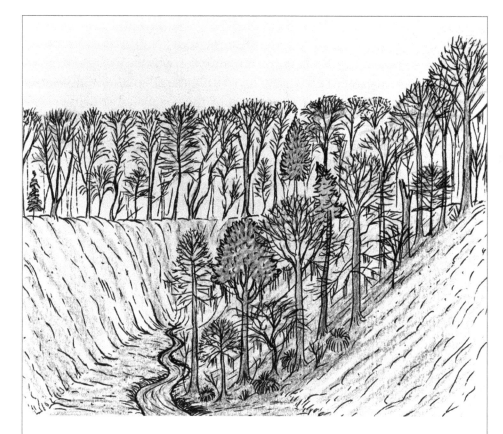

FIGURE 3-4

Seepage Stream Flowing from a Steephead Ravine

The terrain shown here is composed entirely of sand, in which a steep-sided ravine has formed. Rain water falling on the ravine does not run down the slopes and erode them, as in clay hills, but percolates down through the sand and runs out from beneath the hill, carrying sand away. Over time, the ravine migrates headward as the stream carries more and more sand away. Notice how water runs out from beneath the sandy slopes through which it has percolated, rather than from the top of the ravine.

Steephead ravines are found along Sweetwater Creek, a tributary that flows through deep sand into the Apalachicola River from the east. Other steephead streams are found on other stranded, ancient barrier islands: on Eglin Air Force Base in Santa Rosa and Okaloosa counties; by the Econfina River north of Panama City; by the Ochlockonee River along Lake Talquin; and along Trail ridge in Clay and Bradford counties.

Source: Means 1991 (Florida's steepheads).

every major rainstorm, the water rises rapidly and sweeps the sandy banks clean, preventing debris accumulation and limiting diversity. Because it is acid at this point, with water low in minerals, it supports few clams and mussels, which depend on alkaline, mineral-rich water for formation of their shells. The fast flow keeps plants from rooting and supports no significant masses of algae, so there are few alligators, wading birds, or water mammals. Few large bottom animals can withstand the swift current, but small burrowing types such as crayfish thrive in the bottom sediments, and these serve as food for 41 species of fish.[10]

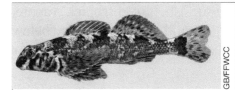

Harlequin darter *(Etheostoma histrio)*. Harlequin darters swim over sand and gravel, usually near snags, in fast-running water. Once common from west Florida to Texas, this fish is now threatened.

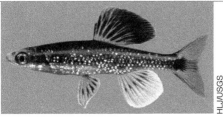

Bluenose shiner *(Notropis welaka)*. This beautiful, two-inch long fish roams the bottoms of many north Florida streams and others around the Gulf coast to Texas.

Coastal darter *(Etheostoma colorosum)*. Coastal darters are common in small Panhandle creeks.

Southern tessellated darter *(Etheostoma olmstedi)*. These now occur only in the Oklawaha River drainage system.

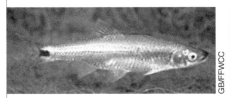

Blacktail shiner *(Cyprinella venusta)*. Relatively large for a shiner, this fish is fairly common in Florida's streams.

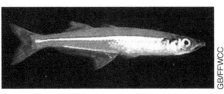

Brook silverside *(Labidesthes sicculus)*. This fish is widespread in Florida streams and is an important forage fish for bass and other larger fish.

Blackspotted topminnow *(Fundulus olivaceus)*. This fish swims in shallow shoreline areas of streams and backwaters.

FIGURE 3-5

Small Fish Native to Florida Streams

Fish in the upper Suwannee must be able to make use of the few plants that can grow there. Some of them, such as the bowfin (which locals call the mudfish) move into the Okefenokee Swamp to spawn; then the young swim back to grow up in the river. Where the waters eddy around tree roots along the banks, pirate perch, warmouth, and flier hide and feed. The upper river's living community is not showy, but it is stable, self-sustaining, and able to withstand the river's great variations in water level, current velocity, and shifting sands.[11]

Farther down the Suwannee, the Alapaha and Withlacoochee bring in more minerals from springs. These feed more abundant plant life, enabling

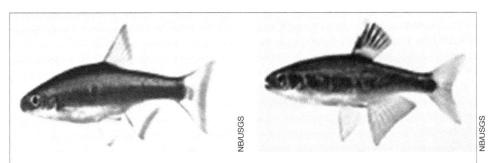

At left is the Flagfin shiner *(Pteronotropis signipinnis)*, from Alligator Creek. At right is the Sailfin shiner *(Pteronotropis hypselopterus)*, from Tenmile Creek. Both creeks are in Okaloosa County.

additional species of fish to thrive: spotted sunfish, bluegill, black crappie, and others. In the Withlacoochee, the striped mud turtle swims, and below it, Suwannee bass first appear. They seek out flowing spring waters over rocky shoals and feed on bottom crayfish.[12]

Still farther downriver, the waters slow down. Sand settles out, berms form and shift around, and sloughs behind the berms retain water, a habitat not found farther upstream and a home to many special amphibians and reptiles. Then the waters slow even more and deposit silt as well as sand. Nutrients accumulate along river bends, permitting lush growth of rooted plants such as lilies ("bonnets"), wild rice, fanwort, and others. These offer hiding, feeding, and egg-laying sites for snails, other invertebrates, and fish. At high tides, salt water moves up the river beneath the fresh, and several species of ocean animals move in and out of this environment, including eel, pipefish, mullet, red drum, and sea trout, as well as sturgeon and manatee. Finally, at its mouth, the Suwannee broadens into a vast, productive tidal estuary.

STREAM VALUE AND QUALITY

Florida's 1,700-odd streams offer unparalleled recreation opportunities. To travel them is to know why people have always been drawn to them. Thousands of years ago, the Indians, attracted by freshwater shellfish, snails, and other mollusks, rode the rivers in canoes and walked the banks and floodplains silently on foot. For the past several hundred years, Europeans and other settlers have used faster modes of travel, but canoers and hikers can, if they wish, still see many of the rivers as the Indians did.

Florida's streams are also diverse and important wildlife habitats. They serve as corridors, permitting aquatic animals to travel between interior waters and the ocean. They are important as biological refuges for many different constellations of aquatic life. They are a valuable economic resource. They serve as conveyor belts, constantly carrying water and nutrients from

Suwannee River: Big Shoals at low water. The river flows over clearly visible limerock outcrops. The river is impassable for boats, and moss on the rocks makes treacherous footing, but the plants and animals in and around the river are adapted to both high and low water.

Big Shoals on the Suwannee River in Columbia County. Big Shoals is the largest rapids in Florida.

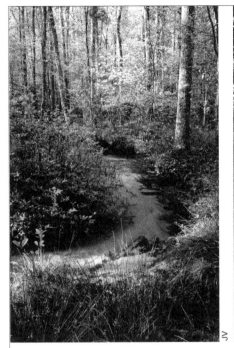

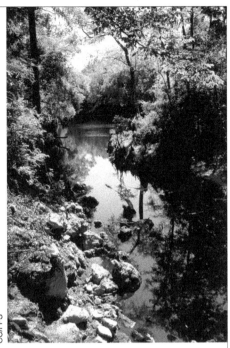

COOL, SWIFT, CONSTANT: This unnamed stream in Liberty County is a tributary to the Apalachicola River.

SUNNY AND ACIDIC: This is the Waccasassa River, a 29-mile-long, blackwater stream in Levy County.

LIMY, SHADY, AND COOL: The Aucilla is a 69-mile-long, part blackwater and part spring-fed river in Jefferson County.

BROAD AND PEACEFUL: The Tolomato is a tributary to the Guana River near the estuary in St. Johns County.

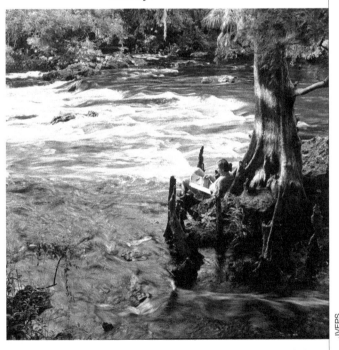

FAST-FLOWING WITH RAPIDS: This is a stretch of the Hillsborough River in Pasco County.

FIGURE 3-6

Diverse Florida Streams

upstream to estuaries. And wherever the surrounding floodplain wetlands remain unaltered, they help control both floods and droughts, cleanse and purify both surface and groundwaters, serve as storage reservoirs for fresh water, help recharge aquifers, and prevent saltwater intrusion into underground water supplies.

Common snook (*Centropomus undecimalis*). Ordinarily considered ocean fish, snook sometimes swim up freshwater streams. These were photographed at Homosassa Springs in Citrus County.

Survival of the aquatic communities in streams depends on two factors: the quality of stream waters, and the preservation of intact ecosystems around them. It is true that streams can purify themselves to some extent, unlike lakes and ponds, which accumulate all materials that flow into them. Fresh influxes of rain and groundwater dilute streams, and their sediments gradually work their way downstream. But most of Florida's streams are nearly flat and the cleansing process is slow. They can't handle much contamination without suffering a decline in their quality.[13]

Streams are also sensitive to runoff. If only ten percent of a stream's watershed becomes impervious (paved or built upon), measurable changes occur in the stream's high and low water levels, together with declines in habitat structure, biodiversity, and water quality.

To keep track of the health of streams, it has long been the custom to monitor their water chemistry. However, the shape of a stream, its shoreline vegetation, and its bottom sediments also are keys to its health. The best indicator of all is the actual presence of normal, living plants and animals. The healthy growth of water-cleansing microorganisms and the presence of robust aquatic vegetation reveal what researchers call a stream's biological integrity. Thanks to the structural complexity of

A stream's **estuary** is that part of the stream system where the stream flows out to sea. Its water is brackish: a mixture of salt and fresh.

Along Florida's Big Bend, in the corner of the Gulf of Mexico, where numerous streams run out to sea, estuarine waters extend all along the shore.

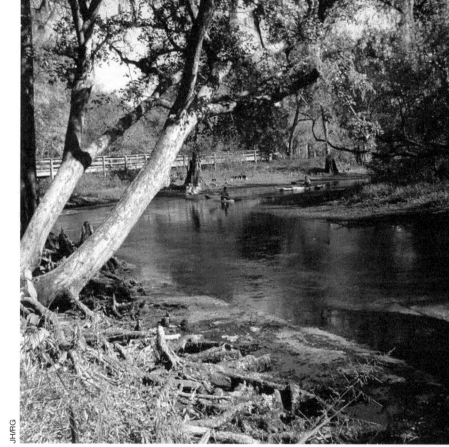

Suwannee River, mid-run. Clear, blue, mineral-rich water runs in from many springs along this stretch between Suwannee and Lafayette counties.

Part of the Suwannee River estuary. The river leaves its floodplain and mingles with the blue waters of the Gulf of Mexico in a vast tidal salt marsh.

Lower Suwannee River. Calm and slow at this point, between Levy and Dixie counties, the Suwannee grows ever wider, meanders across its broad floodplain, and finally exits the land through vast estuarine marshes.

Osprey *(Pandion haliaetus)*. Ospreys build their big, messy nests in the tops of trees near lakes, rivers, and the coast. They perch or hover high over the water, then plunge into the water feet first, to catch fish to eat.

their sides and bottoms, and to the abundant food in them, natural rivers associated with undisturbed floodplains hold more fish than other rivers that are stocked with fish.[14]

According to James Karr, stream quality assessor, the question to ask is not "How clean is the water?" but "How well does the stream support aquatic life?" The best way to answer that question is to evaluate the aquatic habitat with its plants and animals. How many surfaces are available for organisms to cling to? (When a stream bottom is dredged or choked with sediment, the number of "clingers" declines markedly.) How much food is there (leaves, twigs, detritus, and mineral nutrients) for organisms in the stream? How many native organisms, and of what kinds, live in the stream (phytoplankton, zooplankton, mussels, crayfish, fish, and rooted plants)? Chemical indicators used alone fail to reflect about half of the biological integrity of streams. To keep streams healthy, then, we must observe them intelligently and dedicate resources to their protection and management.[15]

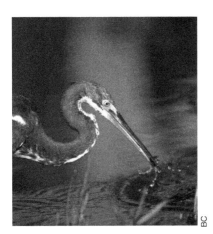

Tricolored heron *(Egretta tricolor)*, juvenile. This wading bird finds plenty of fish in a healthy river with flourishing native vegetation.

CHAPTER FOUR

AQUATIC CAVES, SINKS, SPRINGS, AND SPRING RUNS

Florida was appropriately named for its flowers ("La Florida"), but as already emphasized, it is also a watery place. Not only does it have numerous and diverse surface-water bodies and wetlands—lakes, ponds, streams, marshes, and swamps—it also has stupendous stores of groundwater, on which those surface-water features depend for their existence. Groundwater seeps into lakes and streams when water tables are high, and is recharged by lakes and streams when they rise from heavy rains.

The aquatic systems described in this chapter are even more closely connected with the groundwater. Aquatic caves do not exchange their contents with the groundwater; they actually contain it, and perfectly match its composition. Sinks also contain pure groundwater (to which rain makes periodic contributions), and when one peers into a sinkhole, one may see groundwater moving through it. In times of surface floods, water can travel down through sinks, which are then called swallets. The level of the water table below the ground determines whether the water will stay at a given level or flow up or down through a sinkhole. If it flows up and out, the sinkhole has become a spring, the starting place of a spring-run stream. This chapter deals with aquatic caves, then with sinks and springs, and last with spring runs.

AQUATIC CAVE SYSTEMS

Wherever there is livable space on this planet, there are living things, and Florida's underground aquatic spaces are no exception. Where a cave system intersects the water table or lies wholly below it, it is filled with groundwater and forms a dark, aquatic habitat. Divers have begun to explore and map some of Florida's aquatic cave systems.

Divers who swim into caves with lights report that some of the water-filled chambers and tunnels beneath Florida are huge, deep, and wondrously beautiful. Florida's largest limestone caverns are found under water. The famous cave system at Wakulla Springs, for example, has an entrance more than 200 feet below the water's surface (see Figure 4-1). Divers have

KC/FPS

Wood duck *(Aix sponsa)*. He sits above, she below, on a tree at Wakulla Springs, Wakulla County.

> *Reminder:* The **water table** in a given region is the level below which the ground is saturated with water.

OPPOSITE: Peacock Spring, Suwannee County. The ledges of limerock around the walls of this spring are clearly visible in the water.

Reminder: Most of Florida's groundwater resides in the Floridan aquifer system, described in Chapter 1.

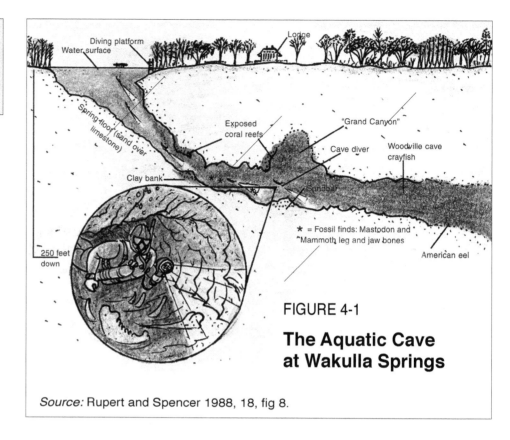

FIGURE 4-1

The Aquatic Cave at Wakulla Springs

Source: Rupert and Spencer 1988, 18, fig 8.

explored many branches of that labyrinth, following several tunnels leading upstream from the mouth. One cave, they say, is an immense, jug-shaped room almost 200 feet across. Such caves provide a huge physical space in which dark-adapted aquatic animals can conduct their lives. As a consequence, the number of aquatic cave-adapted species in Florida outnumbers cave-adapted species in the air-filled passageways of terrestrial caves.[1]

As with terrestrial caves, some animals use aquatic caves optionally, while others must spend their whole lives in these spaces. Beavers are an example of the former. A beaver family will dam a stream, if necessary, to create an impoundment and make the water deep enough for its lodge. (A beaver lodge must have an underwater entrance but an above-water interior where the pair can breathe air and raise their young.) However, if they find a ready-made cave with the needed proportions of above-water and underwater space, they prefer it to building their own. Caves in banks along some Florida streams are frequently used by beavers. (The animals are active mostly at night, so people seldom see them. There may be no detectable signs of their presence at all.)

Many wholly aquatic animals also use caves from time to time. Fish and others travel in and out of springs and caves and underground passageways, freely visiting both light and dark environments. Several species of catfish are at home in caves, where they use their well-developed chemical senses to find crayfish and other prey and carrion. Catfish have been found as far back from the entrance of a cave as 3,500 feet and as deep below the surface as 300 feet. Other fish include pirate perch, sunfish, gar, eel, and redeye chub. Visitors from the subterranean world swim freely in

Wakulla Spring, underwater view of sky. The water is so clear that one can see the blue of the sky, the clouds, the trees around the sink, and the fish, but not the water itself.

underground streams connected to the cave, so some of the fish that swim in the depths of streams are likely to be of the same species as those in the next sinks along the same underground passageway.

The American eel spends years deep in caves or in mats of vegetation at the bottoms of rivers and lakes. It feeds in the dark, and because it has a keen sense of smell it can easily find insects, worms, mollusks, crustaceans (especially crayfish), salamanders, and living and dead fish. Its mouth can hold prey, but it cannot bite; it spins its prey to subdue it, as crocodiles do. The eel matures slowly, becoming ready to breed at about ten years of age. Then it leaves its freshwater environment to go to the ocean. Its prodigious migrations to and from the Sargasso Sea, in the middle of the Atlantic Ocean, are described in Chapter 8.

Then there are animals that never leave caves (see List 4-1). Small invertebrate animals known as isopods and amphipods are numerous, and populations of cave crayfish live in deep, dark recesses. Each exhibits long-evolved adaptations to the cave environment. The Georgia blind salamander (which is actually known from more localities in Florida than in Georgia) spends its whole life in the dark. It swims in the water and walks about on the underwater floors and walls of aquatic caves and tunnels around Marianna. It is three inches long or less, has a flat head and broad mouth, and can feed efficiently by feel, like a deep-sea fish. It has no eyes, just the remnants of optic tissue deep beneath the skin, revealing that it must have evolved from a sighted creature that crawled into a cave long ago. Its long, skinny limbs permit smooth locomotion; and its strong trunk and tail facilitate fast escape from predators such as

LIST 4-1
Florida aquatic cave-dependent animals

Blind cave crayfishes
 (15 species)
Blind cave salamander
Cave isopods
 (4 species)
Cave amphipods
 (2 species)
Cave shrimp
Cave snail
Feather-duster worms

Sources: Guide 1990, 57; Wisenbaker 1994; USGS-LIST 13 March 1998.

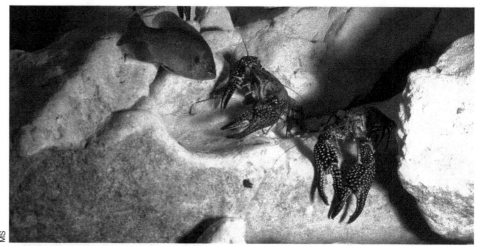

Visitors to a cave. A crayfish *(Procambarus spiculifer)* and a redear sunfish *(Lepomis micro-lophus)* hobnob in groundwater beneath Leon County.

eels and crayfish in the water. It has bushy external gills and specialized sense organs (neuromast organs) to help it detect minute disturbances of the water caused by prey or predators. It is known to eat tiny, aquatic cave-adapted crustaceans and their relatives, but nothing is known about its life history and breeding.[2]

Other aquatic-cave dwellers are the blind cave crayfishes, which roam the subterranean passageways of several Florida cave systems. They, too, are colorless and sightless, but use their exquisitely tuned senses of feel to tiptoe around on the cave walls and capture their prey or eat carrion.

Both the Georgia blind salamander and the cave crayfishes are endemic to small karst regions beneath Florida and nearby Georgia. Other isolated, endemic populations of cave-adapted animals occupy cave systems too. A cave shrimp exists only in Squirrel Chimney near Gainesville. A cave snail is found only in a cave near Econfina Creek in the Panhandle, where it feeds on wood carried in by beavers. Each endemic population is thought to have begun evolving from ancestors that crept into Florida's cave systems when their water first became fresh. Future study of these animals should bring to light many more interesting details about them.

Blind cave animals endemic to Florida. Left: Georgia blind salamander *(Haideotriton wallacei)*. Center: Blind cave crayfish *(Troglocambarus maclanei)*. Right: Florida cave amphipod *(Crangonyx grandimanus)*.

Woodville cave crayfish *(Procambarus orcinus)*. This colorless, blind cave crayfish is one of several endemic crayfishes, each of which inhabits a different cave system in subterranean Florida.

SINKS

In a sink, or sinkhole, one can see the groundwater—whether it be the top of the Floridan aquifer system or the top of a local surficial aquifer. Water levels in both types of sinkholes fluctuate as the aquifer fluctuates, so those that are connected to the vast Floridan aquifer system vary very little in level, whereas those connected only to local surficial aquifers may be very much influenced by local rainfall or drought.

Many sinkholes appear to be small and insignificant, but if they are connected to the Floridan aquifer system, they open up into vast underground tunnels in limestone. Water deep in a sinkhole connects with water flowing unceasingly downstream to the coast. Water levels in this type of sink are not much affected by local droughts and rains. Only long-term, region-wide depletion of the groundwater lowers the water table enough to dry such a sink; and only repeated deluges (for example, tropical storms) will raise its level.

Over centuries and millenia, of course, regional water levels do shift, as the ocean's level does. Some sinks that once held water in the distant past now lie well above the water table, and rain water flows down into them. Groundwater that flows in confining tunnels may encounter a collapse of the tunnel's ceiling due to sinkhole action. If the pressure on the water (hydraulic head) is great enough, the water flows up and onto the top of the ground, in the process that gives birth to Florida's beautiful springs and spring-run streams.

A wet sink. This diagram shows that aquifer water is visible at the bottom of this round hole in the ground. The land that fell in to form the hole now lies on the bottom in a cone-shaped pile.

SPRINGS

Some of Florida's springs are polluted today, and some are naturally dark with swamp water, but many of them still produce pure, hard water that is perfectly transparent. These crystal-clear springs and the streams that flow from them are in the spotlight for the rest of this chapter. They are swirling gems of crystal, emerald, and sapphire set in stone, and each one is different. Their bottoms are of gleaming white sand and limestone, partly free of vegetation, partly decorated with greenery like underwater gardens.

To gaze into an unspoiled spring is to view a world of deep blue, so vivid that it almost has texture. The sky-blue color results from the pure water's absorption of all but blue wavelengths of light. Once in the water, though, a diver floating above the bottom sees no color and seems to hang, suspended and weightless, in nothing at all.

Florida's springs are most numerous in the northern half of the state, where the underlying limestone is near the ground surface. The force behind springs is produced by pressure created by the great height of water entering the complex of tunnels inland. Confined by a tunnel, the water works its way down to openings near the coast and then bursts forth. (Figure 4-2 shows the source of a spring.)

Florida has more freshwater springs than any other area of comparable size in the world. There are now known to be at least 1,000 springs in the state, more per unit area than anywhere else in the world. Some springs give rise to clear, cold streams (spring runs) such as the springs at the origins of the Wakulla, Wacissa, Ichetucknee, Silver, Crystal, and Rainbow rivers. Other springs well forth from the bottoms of streams such as the Suwannee, Santa Fe, and St. Johns rivers, which have eroded their beds down to the limestone underlayer. And at least sixteen springs occur offshore in the Gulf of Mexico north of Tampa and along the Panhandle coast. The largest known spring in the world is just offshore at Spring Creek in Wakulla County.

Springs are classified by their discharge. The very largest, first-magnitude springs include Wakulla Springs, Spring Creek, and Silver Springs, each of which may flow hundreds of millions of gallons a day. Collectively, the springs of Florida discharge more than 7 billion gallons of fresh water each day, exceeding all current human water consumption in the state. List 4-2 names Florida's largest-discharge springs by county.

The flow of a spring is determined by the amount of rainfall in its watershed and the permeability of the surrounding limestone. Since a spring may lie in a watershed covering hundreds of square miles, a local shower or dry spell has little or no effect on its volume of flow. A spring will cease to expel groundwater only if droughts or withdrawals are so extreme and widespread that the groundwater level falls drastically all over a region. Then the spring becomes a swallet, through which newly falling rain may flow into the aquifer.

For the most part, the chemical composition of any single spring's water is extremely stable, but from one spring to the next, chemistry varies. Springs

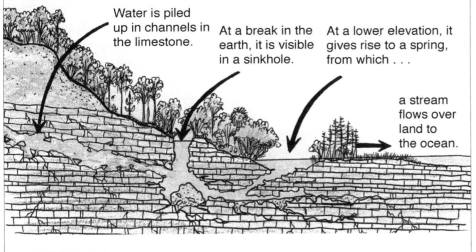

Water is piled up in channels in the limestone.

At a break in the earth, it is visible in a sinkhole.

At a lower elevation, it gives rise to a spring, from which . . .

a stream flows over land to the ocean.

FIGURE 4-2

The Source of a Spring

The height of a great volume of water in the regional landscape gives rise to a fast-flowing spring-run river down below.

LIST 4-2
First-magnitude springs of Florida

Alachua County
Ala 112971*
Hornsby

Bay County
Gainer

Citrus County
Chassahowitska
Homosassa
Kings Bay

Columbia County
Columbia
Col 61981*
Ichetucknee
Santa Fe Rise

Gilchrist County
Devil's Ear
Siphon Creek Rise

Hamilton County
Alapaha Rise
Holton Creek Rise

Hernando County
Weeki Wachee

Jackson County
Jackson/Blue

Jefferson County
Nutall Rise
Wacissa

Lafayette County
Lafayette/Blue
Troy

Lake County
Alexander

Leon County
St. Marks

Levy County
Fanning
Manatee

Madison County
Madison/Blue

Marion County
Rainbow
Silver
Silver Glen

(continued on next page)

discharge groundwater from both shallow and deeper layers of the aquifer. Some spring waters are high in calcium, magnesium, and bicarbonate ions. Some produce water that has been filtered by its passage through sand and limestone and is colorless and clean. A few springs, after rains, discharge brown, tannic acid-stained water that has only recently been flushed from the surface. Some spring waters are low in dissolved oxygen or high in sulfur, iron, or other minerals. Some springs that come from the deepest layers of groundwater, discharge briny salt water.

The water temperature of a given spring is constant and matches the temperature of the ground through which it has flowed, which in turn reflects the average annual air temperature. Panhandle springs have temperatures of 66 to 75 degrees Fahrenheit. South Florida springs are at 75 degrees or more.

The time that has elapsed since water flowing out of a spring was last on the surface can be determined by measuring several different chemical isotopes. The residence time can range from days to decades, with larger springs tending to discharge older water than smaller springs. In many cases, water that, today, flows out of the limestone cave or tunnel at the bottom of a spring may have spent several decades underground since it was last at the surface.

SPRING-RUN STREAMS

Because Florida's springs and spring runs provide constant water flow, temperature, and chemistry, and admit an abundance of sunlight, spring runs hold some of the most lush, biologically productive ecosystems in the world. They are home to the smallest species of fish in North America—

**LIST 4-2
First-magnitude
springs**
(continued)

Suwannee County
Lime Run Sink

Taylor County
Steinhatchee Rise

Volusia County
Volusia Blue

Wakulla County
Spring Creek
Wakulla

Note: *These springs
have not yet been given
names.

Source: Florida Springs
Task Force 2000.

the least killifish; and the largest reptile—the alligator; to endangered manatees; and to a spectacular assortment of wading birds and ducks. And not only does life abound in Florida springs and spring runs, much of it is also easy to see because spring water is so clear.

Spring-run floors vary. They may be covered by submerged flowering plants like pondweed, by mats of bright green algae, or by coontail and stonewort—large, dark green algae that look like complex plants. Some spring runs, largely free of vegetation, are floored with golden-white sand bars, a miniature landscape of hills and valleys, sparsely carpeted with green mats of stonewort and tiny black snails tracing spiral trails in the sand.

At the start of a spring-run stream, the water is bathed in sunlight and sun-loving plants can grow. Meadows of tapegrass carpet many Florida springs and spring runs, undulating and swaying endlessly in the current, their delicate white flowers blooming just below the surface. The water flows swiftly, so there are few floating plankton, but the tapegrass and other aquatic plants offer vast surfaces on which strands of green algae can attach and photosynthesize, forming the base of a complex and rich food web. Rocky outcrops present a coarse, multifaceted surface to which algae and other tiny plants also cling. A wader or swimmer in a clear, fast-flowing spring-run stream might expect the limestone rocks, having rough surfaces, to be easy to walk on, but if coated with algae, they may be extraordinarily slippery.

Strands of green algae also trail from logs, the shells of live turtles, and other hard surfaces. Altogether, more than 25 species of macroalgae grow in springs and spring runs. One study done in Silver Springs showed that the biological productivity of its algae and submerged aquatic plants exceeded that of many agricultural crops. The algae support huge populations of freshwater shrimp and their relatives, as well as freshwater snails, minnows, and aquatic insect larvae. Mayflies, caddisflies, dragonflies, damselflies, waterstriders, and diving beetles are everywhere, and their aquatic larvae serve as a major food source for larger animals.

Snails are extraordinarily numerous in springs and spring runs because the water is rich in shell-making calcium, algae on which they graze are abundant, and there are luxuriant aquatic plants on which they can lay their eggs. Of Florida's 100-odd species of freshwater snails, most occur in spring-run streams. Many species are restricted to ranges of only 20 to 30 feet around the mouth of a single spring. They must have diverged from other, related species at a distant time in the past and the springs where they reside have flowed constantly ever since. Many other snails are nearly as restricted in distribution, occurring only within single drainage systems.

Apple snails may be abundant on submerged spring-run stream vegetation. Apple snails are the largest native freshwater snails in North America, growing to more than three inches in diameter. They occur only in Florida and along the southern edge of Georgia. Canoeists find clumps of their pinkish-white eggs glued above the water line on streamside vegetation. Apple snails can take in oxygen both in and out of the water—using their

FPS

Greater flamingo *(Phoenicopterus ruber)*. Flamingos occur naturally only in extreme south Florida, but have been made welcome in this wildlife park at Homosassa Springs in Citrus County.

The origin of a spring-run stream, the Silver River (Silver Spring, Marion County). Concentric ripples on the surface (foreground) show the force with which the water shoots forth from the spring. Loose sand "boils" vigorously in the water around the spring opening.

gills when submerged and their siphons when at the surface. Apple snails are the primary food of the limpkin, one of Florida's rarest birds. They are also a major food of otters, mink, and raccoons.

The numerous insects and larvae of a spring run feed a host of small fish such as redbreast sunfish, which in turn are hunted by larger fish.

Snail eggs. The apple snail *(Pomacea palludosus)* lays its big, shiny, pink, pea-sized eggs on streamside vegetation and cypress trees just above the water line. When young snails emerge, they go under water promptly to escape predation. They graze on algae and other periphyton, visit the surface periodically, and during the dry season bury themselves in bottom sediments and go dormant.

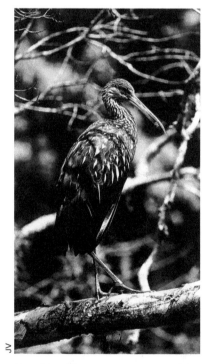

Limpkin *(Aramus guarauna).* The limpkin subsists largely on a diet of apple snails. Its curved bill probes deep into the snail shell to pull out the creature's soft body.

Schools of fish roam all over Florida's spring runs. Freshwater fishes include sturgeon, eels, gizzard shad, redeye chub, spotted suckers, catfish, sunfish, killifish, and largemouth bass. Large crayfish make an excellent food for large fish such as bass.

More saltwater fishes enter freshwater streams in Florida than in any other state. Springs and spring runs near the Gulf coast, especially Homosassa Springs and River, are visited by schools of saltwater species such as gray snapper, jacks, mullet, sheepshead, tarpon, pipefish, snook, mojarra, and many other marine fish. Juvenile hogchokers use springs and spring runs as their main nursery areas, where they feed on insect larvae. Some scientists believe that marine fish are attracted to hard water that is rich in ions, where they can most easily regulate their own body salts. Many fish are also drawn to the warmth of spring water, especially in winter when marine waters and surface fresh waters have cooled.

Some fish travel in and out often, others stay in springs all winter. Diver Doug Stamm says it is a thrill to view these fish at night:

> *Shining silver caravans of schooling mullet twist and swerve through the beam of a diver's light . . . Prolific blue crabs . . . wander spring floors . . . Unpredictable needlefish, elusive and skittish by day, become fleeting lances . . . American eels . . . arise from caverns and burrow and swim snakelike in search of prey . . . Gars' . . . archaic forms glide by . . .* [3]

Some marine fishes access springs by circuitous routes. The St. Johns River is primarily a blackwater stream, but some of its tributaries are spring runs. American shad travel 100 miles up the St. Johns to the Oklawaha and then follow the Silver River, to arrive finally at Silver Springs. Soon after spawning, they reverse their journey and travel 100 miles back downstream to the ocean again. Mullet and needlefish travel even farther to other springs. Stingrays visit springs, and juvenile flounder, only an inch long, may hide in bottom sediments. An important ecological principle is illustrated here. As with the fox squirrel and the wild turkey, a mosaic

Spotted gar *(Lepisosteus oculatus)* in Silver Run, Marion County. Gar swim up and down Florida's streams and often congregate in springs.

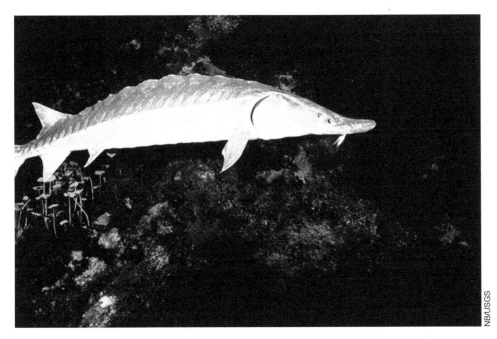

Gulf sturgeon *(Acipenser oxyrinchus desotoi)*. These amazing ancient fishes jump out of the water and make huge splashes that scare the dickens out of fishermen, and sometimes even accidentally kill boaters moving at high speed on the river. Gulf sturgeon can attain a length of about 15 feet, a weight of 800 pounds or more, and an age of 60 years. This animal was about five feet long.

of different habitats is needed for the survival of these fish. Many require several aquatic environments, including a stream's headwaters, middle reaches, and estuary, as well as the open ocean.

Two "living fossils," the gar and the bowfin, are common throughout southern waters but are most easily seen in springs. Gar are survivors of an ancient line of fishes that dominated the world during the age of dinosaurs some 250 to 65 million years ago. Gar are air breathers: they roll frequently at the surface to gulp air and will drown if kept submerged. Gar prey on fish, frogs, and crayfish.

Bowfin are even older. They are the sole living representatives of some of the most primitive fish in the fossil record. Like the earliest known jawed fishes and like their relatives, the gars, they have bony, armorlike scales as well as bony plates that cover a semicartilaginous skull. And like gar, they, too, gulp air.

The fabled sturgeon, whose eggs are prized as caviar, is another relic from the time of the dinosaurs, a 250-million-year-old species. Two subspecies of sturgeon occur in separate ranges that include Florida: one along the Gulf coast east to the Suwannee River or a little farther; the other along the Atlantic coast from Canada to the St. Johns River or a little farther.

Reptiles are also abundant in spring-run streams. Turtles are everywhere. The loggerhead musk turtle (not to be confused with the loggerhead sea turtle, a completely different species) secretes a vile-smelling musk if disturbed. It tends to sink rather than float and can absorb oxygen from the water through its skin, so it can remain submerged indefinitely. It is often

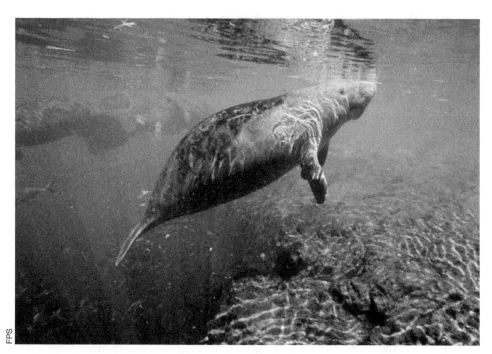

West Indian manatee *(Trichechus manatus)*. This big, gentle mammal was photographed in Homosassa Spring, Citrus County.

found deep in caves where other turtles could not survive. Other common spring-run turtles include the Florida cooter, common musk turtle, and the Florida softshell. They eat insects, plants, and the abundant snails of spring runs. Alligators are the dominant top predators, taking fish, turtles, and even the occasional unwary raccoon or deer at night.

Big, slow-moving manatees also visit Florida's springs. Florida manatees are marine mammals that range from the Carolinas to Louisiana grazing on coastal and river-mouth seagrasses. Manatees are tropical animals. They will die of pneumonia if exposed to water colder than 65 degrees Fahrenheit, and they could not survive in Florida were it not for the freshwater springs. During warm months, manatees feed, calve, and rest in the rivers; then when winter chills coastal and surface waters, they take refuge in the springs. They congregrate in large numbers in Crystal River on the Gulf coast and in Blue Springs in the St. Johns River, where they feast in the underwater pastures of eelgrass there. Each manatee can eat more than 100 pounds of vegetation per day. Several hundred manatees winter in these two spring systems, representing about 15 percent of the species' total population.

Florida's springs have been called the jewels in her crown. The state's Florida Springs Initiative of 2000 embodies the effort to preserve and protect them for future generations to enjoy[4]

Springs are the visible evidence of the groundwater's quality. A spring whose water is pure and clear reassures monitors that the underlying aquifer is, too. A spring whose water is polluted is a warning sign that groundwater quality is impaired.

The groundwater is vital to all living things in Florida. It supplies most of our drinking water, and, together with newly-fallen rain, it replenishes streams, rivers, ponds, and lakes as they evaporate or flow away. Trees sink their taproots into it to obtain a continuous supply. The groundwater even holds up the earth's surface by filling underground spaces. When the water table declines, the overlying earth may collapse as air replaces water. Air is compressible, but water is not. Cities, farm fields, forests, marshes, swamps, coastal bays, and estuaries all depend on groundwater. It behooves us, then, to protect and maintain our springs. Not only are they beautiful and important habitats for living things; they also are the guardians of our safety and health.

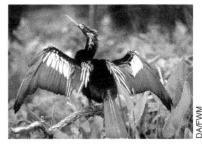

Anhinga *(Anhinga anhinga)*. This fishing bird's feathers do not repel water and as a result, the bird cannot float like other water birds. It swims with only its long head and neck above water, a practice that gives it the name snake bird. To catch fish, it swims altogether under water. Periodically it rests, spreading its wings in the sun to dry.

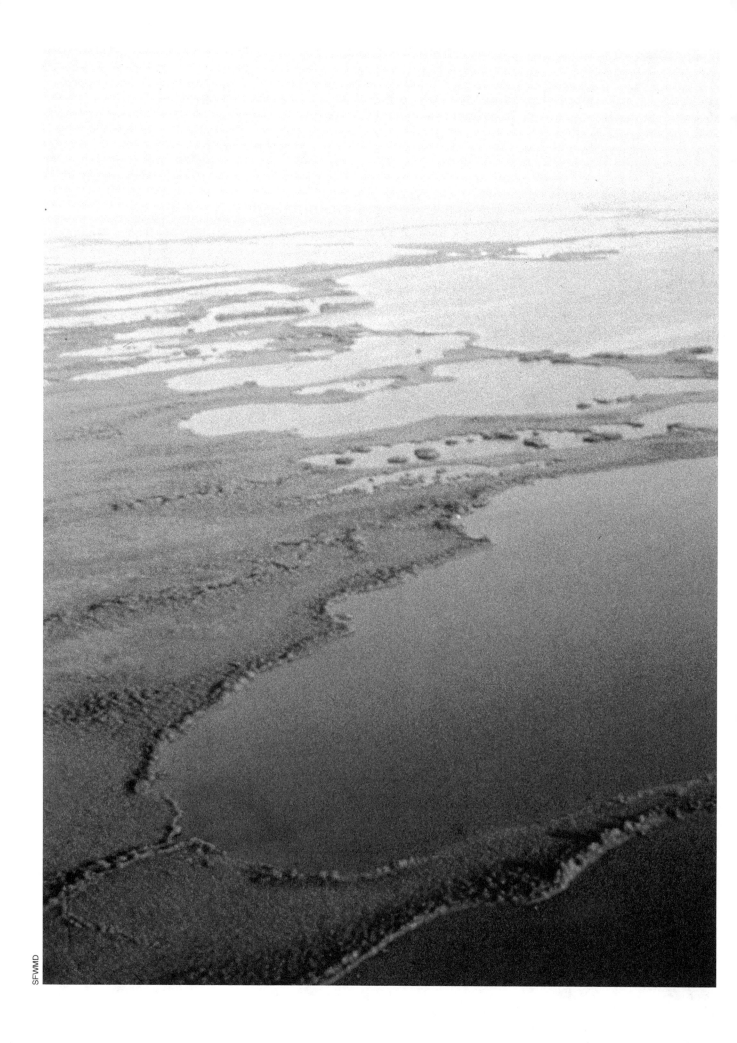

CHAPTER FIVE

COASTAL WATERS: ESTUARIES AND SEAFLOORS

This is the first of three chapters that explore the waters and seafloors of the continental shelf that surrounds Florida. The continental shelf extends at least five, and up to 200, miles offshore before it slopes down to the deep seafloor. Underwater habitats on that broad, productive terrain are varied and full of life. Even where the seafloor appears to be nothing but bare sand, mud, or marl, tens of thousands of animals and millions of microorganisms may dwell on and in each square yard of the seafloor. Still more living things are present where there are limestone outcrops on the shelf. And when, in turn, the living things form structures themselves, such as oyster or coral reefs or seagrass meadows, they become immense communities of great complexity.

Most of the communities described in these chapters occur in both estuarine (brackish) and marine (salt) water, although they may do better in one environment than the other. The Florida Natural Areas Inventory (FNAI) classifies only estuarine communities, and its scheme is followed in this chapter, which covers some representative groups of each type. FNAI sorts estuarine communities into three categories: mineral-based, plant-based, and animal-based. In mineral-based communities the foundation material is rock, sand, mud, or marl, and the community members dwell on or in this material. In plant-based communities, seagrasses and algae provide most habitats. In animal-based communities, mollusks, sponges, or corals build the structures among which the community members live.

List 5-1 shows FNAI's categories. This chapter deals with communities on mineral seafloors and with mollusk reefs and worm reefs. Chapter 6 continues with seagrass and algal beds, and Chapter 7 is devoted to sponge beds, limestone-based communities, and coral reefs. Figure 5-1 presents the coastal landmarks to which these three chapters refer, and Figure 5-2 highlights significant communities on the continental shelf.

Native to Florida waters: Margined sea star *(Astropecten articulatus).* This starfish lives on sand bottoms and in seagrasses in the northern Gulf of Mexico.

LIST 5-1
Natural communities in Florida's estuarine waters

Mineral Based
 Loose sediments
 Solid bottom
 (limestone)
Plant Based
 Seagrass beds
 Algal beds
Animal Based
 Mollusk reefs
 Worm reefs
 Octocoral reefs
 Sponge beds
 Coral reefs

Source: Guide 2010, 235-243.

OPPOSITE: Florida Bay. Shallow estuarine waters gently bathe mangrove swamps and seagrass beds from the coast of south and southwest Florida to the farthest Keys.

CHALLENGES OF LIFE IN ESTUARIES

Much of the water along Florida's shores is estuarine (brackish), consisting of salt water from the ocean that is constantly mixing with fresh water off the land. Typically, brackish water is found only in bays and inlets near the mouths of rivers. This is true along Florida's Atlantic coast; the estuaries are clearly bounded within Miami's Biscayne Bay, Sebastian Inlet, the Indian River Lagoon, and the mouth of the St. Johns River. Along Florida's Gulf coast, not all estuaries are semi-enclosed, as in bays. Brackish waters extend for miles along quiet shores even where not enclosed, and the water is brackish even far from streams. More than two million acres off the coasts of south and west Florida and the Panhandle are estuarine.[1]

No number can be assigned to the salinity of estuarine water; in fact, the distinguishing characteristic of an estuary is *variation* in salinity, both seasonally and daily. Plants and animals in some parts of estuaries may find themselves sometimes in wholly marine water and sometimes in nearly fresh water. Take, for example, an oyster reef near the shore. In seasons of drought, when only a little fresh water is running off the land, the ocean's salt water advances over the reef. Then in seasons of flood, rain water and river water pour off the land and nearly fresh water surrounds the reef. And every day, the water is most saline at high tide, when salt water is pushing into estuaries, and freshest at low tide, when salt water withdraws and river water flowing off the land predominates. To survive, the oysters and other reef dwellers must be able to tolerate not only the mixture of salt and fresh water, but wide swings between the two.

Another distinction marks estuaries: turbidity. Estuarine water is especially murky near the mouths of alluvial rivers that are delivering heavy loads of suspended fine clay and silt particles to the coast. Where fresh water forces its way out of a river, and marine water pushes in against it, the fresh water floats, forming a top layer, and the salt water sinks, forming a bottom layer. Such layering may not occur in shallow areas where winds keep the fresh and salt water well mixed, but in deep basins, it may be very pronounced. Where the water is layered, fine clay particles delivered by the river sink to the bottom of the fresh water, but when they arrive at the salt water layer, they can sink no further. The particles accumulate at the plane between the layers and clump into frothy aggregates, forming a dark ceiling below which neither light nor oxygen penetrates. Growth of both plants and animals is limited beneath that ceiling because plants can't grow in the dark, and animals can't live without oxygen. If winds stir the water enough to help return some oxygen to the depths, they also make it murkier.

A marine biologist encountered first-hand the daily alternation between fresh and saline, light and dark water that creatures in estuaries have to cope with. She took her class snorkeling in Saint Andrew Bay at Panama City after one January's hard rains :

Native to Florida waters: Red-footed sea cucumber *(Pentacta pygmea).* Sea cucumbers are members of the same phylum as starfishes, the echinoderms.

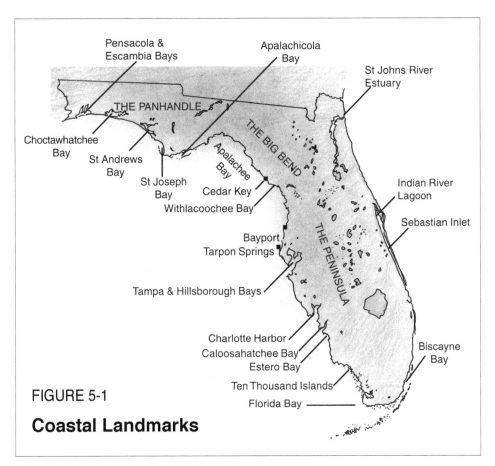

FIGURE 5-1

Coastal Landmarks

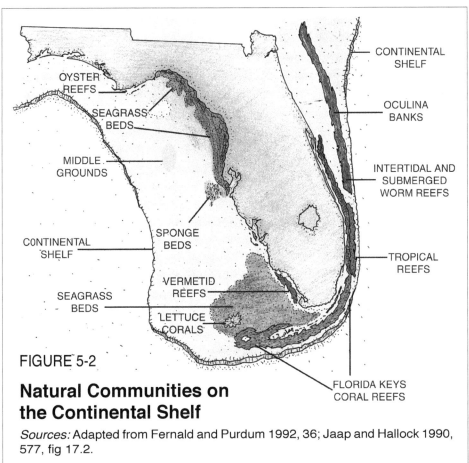

FIGURE 5-2

Natural Communities on the Continental Shelf

Sources: Adapted from Fernald and Purdum 1992, 36; Jaap and Hallock 1990, 577, fig 17.2.

The normally clear salt water in the bay had been flooded out by fresh water off the land. The boat basin was filled with opaque, black water and looked like a cypress swamp. What is lovely in a cypress forest was a problem here, though. Visibility was zero.

I didn't think we'd find anything today, but having come so far, we launched the boat anyway and ran out to a line of jetties offshore to have a look. And as we left the lagoon, the black swamp water abruptly gave way to the usual green and blue sparkle of salt water. A wavy boundary separated the two different worlds of swamp and ocean. The water over the jetties was clear. We could dive after all. . . .

As we swam along the base of the jetties, it was obvious that the swamp water had been here earlier. The sea urchins, which fare best in salt water, had been hit hard by the freshwater flood. Normally they cover the rocks by the thousands where they graze on seaweed. Now, the spines of the victims littered the sandy bottom.

Then the tide began to fall. As it did, a wall of black swamp water advanced down the channel, replacing the retreating salt water. There was almost no mixing. A line of foam marked the boundary—one side was black, the other was clear. It passed our anchored boat and enveloped the rocks. . . . Every day, it seemed, the sea urchins we'd seen got a few hours of relief from the fresh water at high tide and then got nailed again when the tide turned.[2]

Oscillations in salinity and light pose a great challenge to organisms in estuaries. There are wide swings in temperature, too. In summer, shallow coastal water may be very hot at low tide; then as the tide rises, the flux of incoming sea water cools it. In winter, the opposite is true: the water may be extremely cold at low tide; then the rising tide warms it. Some plants and animals can withstand all these stresses of life in estuaries; many cannot; and some, such as oysters, can thrive for long times only in estuaries, as explained later.

Despite the stresses in them, estuaries produce a tremendous mass of life. They are biological factories that support huge crops of plankton, thanks to the massive flows of detritus and mineral nutrients from inland rivers and tidal wetlands. And plankton are the raw material for estuarine productivity.

ESTUARINE PRODUCTIVITY: PLANKTON

Plankton occupy every cubic inch of ocean water. They are a fascinating mixture of peculiar-looking, tiny plants and animals that float or weakly swim in the water. Some are single-celled and remain microscopic all their lives. Others are fertilized eggs at first and develop into larger plants and animals in time. By the time they take up their mature lives, they have become an incredibly diverse assortment of living things and they comprise most of the life in the sea. Some become sponges and form large colonies on the seafloor. Some turn out to be worms that burrow in bottom sediments. Some become jellyfish, squid, shellfish, or fish. Most never grow up at all, because they become food for other creatures. Figure 5-3 displays some plant members of this enormous community, and Figure 5-4 shows some of the animal plankton, the largest ones, at their actual sizes.

DN/GSML

Native to Florida waters: A nudibranch. Although it doesn't look like a snail or clam, this animal is a bottom-dwelling mollusk.

Diatoms (an *Actinocyclus species*).

Diatoms (a *Pleurosigma species*).

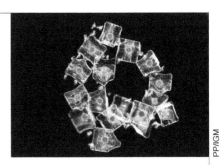
Chain diatom. This is a chain of singlecelled algae. The nuclei within the cells are clearly visible.

FIGURE 5-3

Ocean Plants: Phytoplankton

All three of these species are diatoms—single-celled algae with cell walls that are made of a silicon compound. These plants and their relatives are at the base of the food chain on which virtually every animal in the ocean depends.

The phytoplankton, that is, the plant members of the plankton, are the staple commodity in the food web that supports all of the life in the ocean. These tiny plants, by the millions of tons, derive their life from the sun that shines down on them in surface waters, and from nutrients that run down to them off the land. Then, when consumed, they pass on their energy and substance to support the growth and development of millions of tons of animals, from tiny zooplankton to great whales. The phytoplankton known as diatoms are among the most numerous organisms in the oceans, and it is through their activities that the oceans trap carbon from the atmosphere and offset excessive warming of the planet.

Diatoms and other plankton are hardly a household conversation topic, but their work is vital to all life on earth. As phrased by Gulf of Mexico scholar Robert H. Gore, "The small, the nondescript, and the numerous will always support . . . the few and the large."[3] Again and again, the chapters to come refer to "filter feeding"—the ways aquatic animals nourish themselves by straining plankton from the water.

Plankton are more numerous in estuaries than in any other part of the sea, and it is thanks to their presence that the estuaries can produce immense quantities of shrimp, crabs, oysters, fish, and other seafood. Nearly all of the animals that swim over the continental shelf start their lives in estuaries; it is not an exaggeration to say that Florida's estuaries are the birthplace of most of the sports and commercial fish and shellfish that fishermen catch around Florida. Other animals, too, depend on estuaries. Manatees, sea turtles, and wading birds forage in the grassbeds and marshes; ospreys and bald eagles dive there for their prey. These large and well-known creatures thrive thanks to the thousands of small, obscure marine species that flourish in the estuaries. But before going on to look at them, an overview is needed. Each Florida estuary is different from all the others, and areas within estuaries are diverse too.

FIGURE 5-4

Ocean Animals: Zooplankton

The majority of plankton are microscopic; the ones shown here are giants relative to most others. The true sizes of these animals are shown in the center of the figure.

A An arrow worm, 9 mm long, species unknown. A voracious eater, this animal can seize others with its grasping spines and devour them. It does not hesitate to eat its own kind.

B A crustacean, 10 mm, species unknown. This is a crab-to-be, although at this stage it resembles a shrimp.

C A nudibranch, 10 mm, *Phylliroe bucephala*. This planktonic swimming mollusk, when alive, is brightly bioluminescent.

D A rock lobster larva, 6.5 mm, *Palinurus* species.

E An octopus, 4.5 mm, species unknown. Visible are two small fins at the back of the head, and the large eyes, positioned at the base of the tentacles.

F A polychaete, 5 mm, species unknown, with its proboscis out. (The proboscis is a muscular organ that can be turned inside out to grasp prey, and then pulled back inside.)

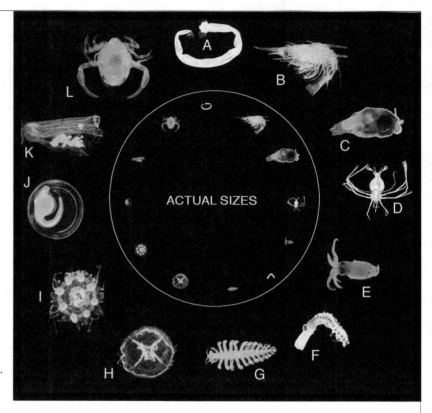

ACTUAL SIZES

ALL PHOTOS: MAB

G A polychaete, 3.6 mm

H A medusa, 7 mm, species unknown. Its four oral arms are loaded with stinging cells with which it can paralyze its prey. Then it pulls the victim into its mouth (in the center of the bell).

I A medusa, 3 mm, a *Nausithoe* species. The round, yellow structures on its underside are its gonads.

J A fish egg, 3.1 mm. The developing fish's head, tail, and yolk sac are clearly visible.

K A tunicate, 4 mm, species unknown. The tunicates are chordates, members of the phylum to which the vertebrates (fish, amphibians, reptiles, birds, and mammals) also belong.

L A crab, 5.7 mm across, species unknown. All the appendages including well-developed claws are clearly visible.

FLORIDA'S MAJOR ESTUARINE SYSTEMS

This survey begins at the state's western border, progresses across the Panhandle and down the peninsula, then continues around its tip and up the Atlantic coast. Pensacola Bay, at the west end of the Panhandle, is the first estuary we visit, and it has some features that no other Florida estuary shares. The bay is deep, because it formed on a part of the coast where the slope into the Gulf is steep. Its circulation is driven by tides, currents, and freshwater inflows, and is limited by a long, straight barrier island (Santa Rosa Island) that isolates it from the Gulf. Its waters are layered. The top layer is largely fresh water from rivers, rainfall, and sheet-flow runoff; the bottom layer is a salt wedge that penetrates beneath the fresh water of the rivers to a few miles inland from their mouths. The quality

of Pensacola Bay's waters reflects the influences of three main rivers (the Escambia, Blackwater, and Yellow rivers) and many creeks. Tides bring in different amounts of waters that flush the bay at different times in the two-week tide cycle.

Escambia Bay, which is part of Pensacola Bay, serves as an example of the diversity within estuaries. Its circulation pattern, shown in Figure 5-5, creates many different habitats for living communities. To a tourist crossing a bridge, the waters of a bay or estuary may look monotonous, but to its residents, they are highly diverse and challenging.

The next major estuary to the east, Apalachicola Bay, presents a contrast. Like Pensacola Bay, it is confined behind barrier islands, but it is shallow. It receives a larger volume of alluvial river water than any other Florida bay, and its inhabitants enjoy long periods of low salinity that keep marine predators away. Its waters are often turbid and darkly colored, so bottom-rooted plants are uncommon. Phytoplankton, which have access to the sun by floating, are the major photosynthesizers in Apalachicola Bay. Nearly half of the bay supports oyster bars on a mud floor, and these provide habitat for many other organisms. Of all of Florida's estuaries, Apalachicola Bay is the richest in both detritus and minerals.

The next estuary is Apalachee Bay, which lies in Florida's Big Bend region (shown earlier in Figure 5-1). Apalachee Bay presents another contrast. It is not bounded by barrier islands; in fact, no physical features visible on the map reveal where its boundaries are. It consists of all of the shallow water offshore that lies on the broadest part of the continental shelf. Its calm, brackish waters reach far out into the Gulf, and even 8 to 10 miles offshore the water is only about 60 feet deep. Apalachee Bay extends all the way from the Ochlockonee River almost to Tampa Bay and receives freshwater flows from sixteen rivers (see List 5-2). Still, Apalachee Bay receives less total river water than does Apalachicola Bay, and with lighter loads of minerals and detritus, so it is both more saline and less turbid than Apalachicola Bay and produces fewer phytoplankton. Sunlight penetrates deeper into the water, and the shores and seafloors hold vast marshes and grassbeds. Marsh and sea grasses are both the main habitat and the main source of nutrients for the bay's fish and other animals.

South of the Big Bend are many more estuaries. Major rivers feed into the Gulf in Tampa Bay, Sarasota Bay, Charlotte Harbor, Caloosahatchee Bay, and Estero Bay. Each has its own character. They vary in salinity and nutrient load, and each is complex. As an example, Tampa Bay is a subtropical estuary with a bottom consisting largely of soft sediments dominated by calcium carbonate and oyster shells. Streams carrying little or no sediment deliver clear, alkaline water. The bay is less than ten feet deep and is protected from the ocean's influence by the surrounding land. Frequent rains cleanse the bay at intervals, and where the shorelines have been left natural, fringing marshes and forests filter runoff flowing in off the land. Groundwater also feeds into the bay from springs and underlying aquifers, helping to keep its water composition constant and suitable for estuarine organisms. Oysters are numerous in the bay, although

LIST 5-2
Rivers feeding into Apalachee Bay

From west to east:

Ochlockonee
St. Marks
Aucilla
Econfina
Fenholloway
Spring Warrior
Steinhatchee
Suwannee
Waccasassa
Withlacoochee
Crystal
Homosassa
Chassahowitzka
Weeki Wachee
Pithlachascotee
Anclote

Note: Figure 3-1 (page 39) shows the locations of most of these rivers.

Source: Livingston 1991.

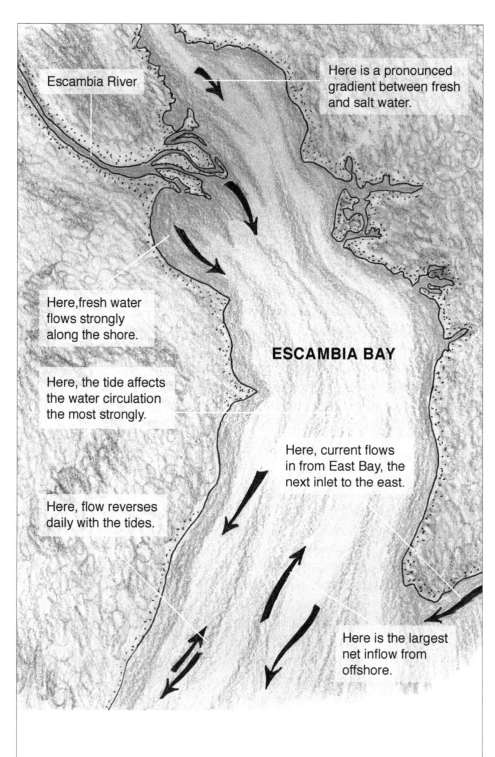

Escambia River

Here is a pronounced gradient between fresh and salt water.

Here, fresh water flows strongly along the shore.

Here, the tide affects the water circulation the most strongly.

Here, flow reverses daily with the tides.

ESCAMBIA BAY

Here, current flows in from East Bay, the next inlet to the east.

Here is the largest net inflow from offshore.

Native to Florida waters: Bonnethead shark *(Sphyrna tiburo).* This small shark dwells inshore in bays and estuaries, feeding on fish. It grows to a final size of about 3 to 4 feet.

FIGURE 5-5

Flow Patterns in Escambia Bay

Escambia Bay is one part of Pensacola Bay. Flows and salinity vary greatly, as shown.

Source: Jones and coauthors 1990, 19, fig 7.

less so than in past times, and oyster reefs support attached macroalgae and marine animals.

The tremendous diversity of organisms produced by Tampa Bay is apparent from the numbers in List 5-3. Note how many kinds of phytoplankton there are. Note that the zooplankton have not even been counted.

On the southwest coast of Florida, sheet flow of Everglades water supports yet another great estuary in Florida Bay, which lies inside the Florida Keys and extends far westward into the Gulf. Swirling eddies off Florida's southwest coast keep estuarine water circulating throughout the whole area and the estuarine floor holds vast seagrass beds.

Continuing around the Florida peninsula, the continental shelf narrows to a mile in width off Palm Beach. Because the east coast has higher-energy shores than the south and west, most of the shelf is bathed in marine water. Farther north, it is broader, but major estuaries lie only within enclosed bays and inlets, notably the Indian River Lagoon, Sebastian Inlet, and the mouth of the St. Johns River. Each estuary holds a large, complex, unique ecosystem. The Indian River lagoon, for example, has a dozen species of seagrasses and other plants, to which 41 different species of algae are attached like epiphytic plants on trees. There are numerous species of small seagrass-associated animals, several hundred species of mollusks, and many other groups. Just that one lagoon has 700 species of fish, and those in its low-salinity portion are unique for North American waters. At least five of its fish species may have no other North American breeding populations.[4]

Clearly, Florida's estuaries are wonderfully rich communities. However, most of those on the Atlantic coast have experienced profound impacts from human activity and industry, and only a few natural areas of any significance remain. The Gulf coast estuaries, in contrast, especially along the Big Bend, are among the most nearly pristine coastal waters along the lower 48 states, and they receive most of the focus in the rest of this chapter.

ANIMALS ADAPTED TO ESTUARIES

Given such wide swings between extremes of salinity, light, and temperature, one might expect that no animals could survive in estuarine environments. Indeed, only a few species live permanently there: diversity is much lower than in pure salt water. However, for those that can cope, the rewards are generous. Floods reliably deliver heavy loads of nutritive material from the land every year. Groundwater flows out constantly, delivering minerals from underground springs. Tides repeat predictably, bringing fresh nutrients from the ocean. Plankton are everywhere in the water. With relatively few species competing, and with this endless superabundance of foodstuffs, those animal species that can reside in estuaries can thrive by the billions.

Not even these populations thrive at all times, however. When they are stressed, individuals may die by the billions, but the species

LIST 5-3
Biodiversity in Tampa Bay

Phytoplankton, including diatoms, 272 species
Microalgae in bottom and on plants[a]
Macroalgae, 221 species
Seagrasses, 7 species
Tidal marsh plants[a]
Mangroves, 3 species
Riverine wetland plants, 409 species
Zooplankton[a]
Benthic animals[a]
Invertebrates[a]
Fish, 253 species
Birds, about 80 species
Marine mammals, 2[b]

Notes:
[a]These organisms have not been counted, but there are known to be hundreds or thousands of species.

[b]The mammals are the bottlenose dolphin and manatee.

Source: Lewis and Estevez 1988, 55-97.

"Nose"

"Tail"

Native to Florida's offshore waters: Clearnose skate *(Raja eglanteria)*. The black "purse" is an empty egg case. The newly hatched skate is almost perfectly concealed in the sand to its right (see circles)

Native to Florida's near-shore waters: Gulf toadfish *(Opsanus beta)*. Florida's productive, shallow, near-shore waters are ideal for this fish, whose prey include crustaceans, annelid worms, mollusks, and fishes. The toadfish rests on the bottom, often hiding in seagrass or near rocks or reefs, then snaps up its prey and chomps them with its powerful jaws.

populations are able to bounce back quickly. They are as adapted to natural disturbances as are weeds on land. Oysters exemplify their resilience. In the fall of 1985, two hurricanes destroyed more than 90 percent of Apalachicola Bay's major oyster bars—yet by late spring of 1987, they were back in greater abundance than before. Two factors permitted their dramatic recovery. The surviving oysters produced great clouds of offspring; and other species, unable to cope with the stresses of estuarine life, failed to compete for their attachment sites.[5]

For most species, however, estuaries pose too great a challenge to overcome. If any freshwater animals blunder into estuaries, they die. As for marine species, the overwhelming majority of those present at any given time are just passing through or visiting for a spell. A few of these transients and visitors are described in the next paragraphs; then the rest of the chapter is devoted to permanent estuarine residents and communities.

Transients Crossing Estuaries. Imagine being a fish or a crab attempting to swim or crawl from the open ocean across a river estuary to get into the river. Look again at the map of Escambia Bay in Figure 5-5. The turbulence, the low visibility, and the changing currents, salinity, and temperatures present formidable barriers. Still, many animals cross estuaries repeatedly throughout their lives. Sturgeon, gar, eels, and others pass through estuaries during breeding migrations. Flounder and needlefish make their way from the ocean across the Suwannee River estuary and up the river to springs miles from the coast. Mullet, flounder, blue crab, and others make prodigious migrations 100 miles up the St. Johns River to Silver Spring. Most people are familiar with the feats of the salmon that leap up rapids and waterfalls to go to their spawning grounds at the heads of mighty rivers on both coasts of North America, but Florida's freshwater animals make equally perilous transits across Florida's estuaries, and they are equally well adapted by long periods of evolution to manage their journeys.

Visitors to Estuaries. Currents and waves bring some visitors into estuaries daily. Many fish and invertebrates use the reversing tidal currents to ride in and out of the shallows, moving inshore to feed on rising tides and drifting back offshore on falling tides. Other visitors enter estuaries monthly, timing their spawning efforts to coincide with the highest high tides as described earlier, so that extra-strong currents will transport their planktonic larvae over wide areas.

Many animals visit estuaries at longer intervals—for certain seasons of the year, or for parts of their life cycles. Seasonal visitors stay when the habitat is right for them and move out when conditions change. For example, many fish feed and grow in north Florida's shallow coastal estuaries all summer; then, as the first strong cold front of fall chills the water, they pour out into the Gulf's warmer waters in waves. They spawn there, producing their tiny larvae out at sea, where salinity and temperature are more constant than in estuaries. The young start their lives as plankton, and the next year, as young fish, they ride ocean currents to the shore and enter the estuaries to forage and grow. Similarly, along south Florida's shores, many shrimp, crabs, and lobsters flourish and feed in estuaries in

Native to Florida's near-shore waters: Gulf flounder *(Paralichthys albigutta)*. Flounder swim in towards shore on the rising tide, following small fish, and conceal themselves in the sand to ambush prey. Only the outline of this fish can be seen (its mouth is near the magenta bryozoan at left).

summer and remain until the water turns cold in midwinter. Then they depart, to spawn over lime rocks in the reliably warm, calm waters of the continental shelf. At the depths where these rocks lie, the brief three-month winter chill doesn't penetrate. White shrimp feed in estuarine marshes in summer; then move out to barrier island beaches in fall and return the next spring. Pink shrimp, as juveniles, feed in seagrass beds on the west coast during summer; then migrate west, far beyond the Florida Keys, to spawn in the Tortugas. Stone crabs, as juveniles, grow up in Apalachee Bay and other estuaries along southwest and south Florida, either in seagrass beds or among shells or rocks. As they mature, they move to deeper water and burrow in soft sediments or hide in seagrass.[6]

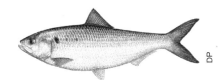

Native to Florida's offshore waters: American shad *(Alosa sapidissima)*. This fish lives in salt water offshore, but crosses estuaries to make a late winter spawning run up Florida's east coast rivers, notably the St. Johns. The young remain in fresh water until they are 2 to 4 inches long, then move out to sea, feeding on plankton. Shad reach a mature weight of 2 to 3 pounds, sometimes 5 pounds.

Blue crabs use estuaries in a distinctly different way. They do mate there in summer. Fertilization takes place internally, so the newly fertilized eggs are protected from fluctuating estuarine conditions. Blue crabs wander all over the continental shelf down to a depth of more than 100 feet, but they are considered estuary-dependent, because they reproduce there. Figure 5-6 features the blue crab.

Among the most conspicuous visitors to estuaries are large fish, including those that fishermen like to catch. Some feed on the bottom, some forage above it over bare floors, in seagrass beds, and especially around structures such as oyster reefs. The Figure 5-7 captions describe the ways in which a few fish use estuaries.

From these few sketches, it must be clear that Florida's estuaries are, for the most part, grand central stations where populations are changing constantly. Some populations pass across the estuaries into rivers and later cross back to return to the ocean. Others visit the estuaries for a spell and then turn around and go back to the ocean. Each species has its own timing. There are, however, some organisms that reside in estuaries throughout their lives, and the next sections turn to these.

RESIDENTS ON MINERAL FLOORS

Some estuarine floors are of sand, some of mud, and some of marl. Along the western Panhandle, where the waves are energetic, seafloors are largely of sand. In Apalachicola Bay, where the waves are gentle because of offshore barrier islands, there remain finer sediments from alluvial rivers and the bottoms are muddy. In Florida Bay, the bottom is marl laid down by microscopic algae mixed with shell hash, the broken-up remains of seashells. A different assortment of creatures lives within the bottom sediments of each of these areas, and these creatures near the base of the food web influence the rest of the life that is present there.

As an example, consider the floor of Apalachicola Bay, where the water is usually turbid. Although visible plant life is severely limited by lack of light, tons of fine mineral particles and tons of detritus yield phytoplankton that become food for an extensive living world. In such an environment many a hungry animal resorts to filter-feeding, either by straining the water for food or by vacuuming food off of sediment grains. In the top

When fertilized eggs are released by aquatic species, they are called **spawn**. The act of release is called **spawning**. In most aquatic species, spawning and fertilization take place at the same time. The eggs and sperm are released into the water, fertilization takes place, and the spawn promptly disperse.

For a few species, such as the blue crab, fertilization is internal and the female stores the fertilized eggs for a time. Spawning occurs later, when the eggs hatch and the female releases the larvae.

FIGURE 5-6

Blue Crab *(Callinectes sapidus)*

The blue crab occurs along both coasts of Florida. On the Atlantic side, a different crab population occupies each major estuary. They mate in the estuary; then the female moves near the mouth of the estuary carrying the fertilized eggs attached to her body. She buries herself in the bottom and remains there until the following spring. Then, when the fertilized eggs are ready to hatch, the female releases her larvae to float as plankton in near-shore waters on the continental shelf.

On the Gulf side, mating also takes place in every estuary, and the females bury themselves over the winter, but a migration takes place in the spring. When it is time to release their young, the females migrate north, looking for shallow muddy and sandy bottoms and seagrass beds. Some swim several hundred miles to Apalachee and Apalachicola bays.

The blue crab is adapted to the murky water of estuaries. The female blue crab, when ready to mate, releases a chemical attractant into the water. The male, once he detects the chemical, orients into the current and follows the odor gradient upstream. He will find the female, even though he may never see her.

Source: Livingston 1991.

inch of the sediment, crustaceans, worms, and shelled amoebas that are too small to be seen obtain their nourishment by ingesting whole grains of mud or sand and digesting off the coatings of still tinier living things. Then they excrete the sediment grains, now clean and ready to grow a new crop of food. The concentration of these tiny creatures, the microfauna and meiofauna, can range from 50,000 to a million individuals per square yard of seafloor. Below the top inch of sediment in which these creatures are concentrated, life is sparser, except where larger infaunal species pump oxygen down from the surface.

The larger animals in the sediments, the macrofauna, are big enough to see, but they live in burrows. Their lifestyle centers on straining their nutrients from the water. They have peculiar bodies (peculiar, that is, to people who are familiar only with land animals) and they obtain their food in ways that seem bizarre. A clam buries itself in mud and secretes strands of sticky mucus that flow across its gill tissue and then into its stomach, carrying trapped food items somewhat as sticky tape picks up lint. Another innova-

Goliath grouper *(Epinephelus itajara).* The largest of the groupers and mostly a south Florida fish. This fish may grow to an age of 30 to 50 years and a weight of nearly 800 pounds. It stays inshore, swimming in estuaries and especially around oyster bars, where it feeds on crustaceans and fish.

Sheepshead *(Archosargus probatocephalus).* Young sheepshead up to 2 pounds swim inshore around oyster bars, near seawalls, and in tidal creeks, feeding on fiddler crabs and barnacles. They spawn near shore in late winter and early spring, and the adults swim offshore, reaching 8 pounds in weight.

Florida pompano *(Trachinotus carolinus).* In warm seasons, this fish swims near shore along sandy beaches, around oyster bars, and over grassbeds. It feeds on mollusks and crustaceans, especially mole crab larvae. It moves in and out with the tides, often in turbid water. In cold seasons it moves to water as deep as 130 feet. It usually weighs less than 3 pounds when caught.

Atlantic sharpnose shark *(Rhizoprionodon terraenovae).* This shark can thrive inshore, even in surf. The young grow up in bays and estuaries, feeding on small fish and crustaceans. Mature when 2 to 4 feet long, the adults swim offshore.

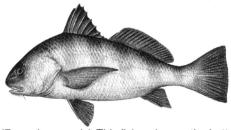

Black drum *(Pogonias cromis).* This fish swims on the bottom both in and off shore, often around oyster reefs. It spawns near shore in late winter and early spring. It feeds on oysters, mussels, crabs, shrimp, and occasionally fish. It lives to 35 years and commonly attains a weight of 30 pounds.

Atlantic croaker *(Micropogonias undulatus).* The young of this species grow up in central and north Florida estuaries along both coasts. Mature at 2 to 3 years and weighing 1 to 2 pounds, adults move to deep offshore waters in winter, but return to bays and estuaries in warmer seasons.

Sand seatrout *(Cynoscion arenarius).* Mainly a Gulf species, this fish feeds on small fish and shrimp inshore in shallow bays and inlets and spawns inshore in spring and early summer. Mature when nearly 1 pound in weight, the adults move offshore in winter.

Ladyfish *(Elops saurus).* This fish lives in bays, estuaries, tidal pools, and canals, sometimes in wholly fresh water, but spawns offshore in fall. It feeds predominantly on fish and crustaceans and attains a mature weight of 2 to 3 pounds.

FIGURE 5-7

Fish that Use Florida's Estuaries (Examples)

Source: Anon. c.1994 (Fishing Lines); drawings by Diane Peebles.

tive clam cultivates single-celled plants in gardens that grow inside its own tissues. The throngs of invertebrates in bottom sediments have no common names, but to specialists, their scientific names evoke associations of form, growth habits, and behavior, just as to a gardener the names chrysanthemum and geranium bring pictures instantly to mind. Each of them, *Corophium, Ampelisca, Grandidierella,* and all the others, have distinct ways of eating, mating, producing young, and maturing to repeat the life cycle.

Native to Florida waters: Jingles *(Anomia simplex)*. This bivalve may be up to 1 1/2 inches long. Its shells often break apart at the hinge and are commonly found singly, typically near shore in shallow water.

The **infauna** are animals that live in burrows they create within the bottom sediments. They strain their food from the sediments and water. The tiniest are **microfauna**, those that are barely visible are **meiofauna**, and those that are easily seen are **macrofauna**.

Polychaete (POLLY-keet) and **oligochaete** (OH-lee-go-keet) worms are members of the segmented-worm phylum, whose most familiar members are the earthworms.

Plumed Worms. Among the small burrowers on estuarine floors are polychaete and oligochaete worms—by the millions. They are a highly varied group and many are surprisingly beautiful; a few of the polychaetes are shown in Figure 5-8. They are also versatile: they can travel at will, produce energy, obtain oxygen, and dispose of waste efficiently, giving them an enormous range of lifestyle options. Some polychaetes are stationary; some swim; and some eat their way through the seafloor sand or mud as fast as coquina clams dig in the surf. Polychaetes are among the most common animals in the sediments of all coastal environments and about 80 species are found along the Florida coast. Wash several shovelfuls of sand or mud through a screen, and you will almost always find several of these important worms as well as other burrowing species. In a healthy estuary, these busy animals are pumping water through their bodies around the clock, filtering food from it while remaining hidden from predators. The burrows they make often serve later as habitats for other animals.

Because they occur in such enormous populations, marine worms are a major food resource for thousands of species of fishes and crustaceans. In shallower parts of soft mud bottoms, birds also feast on these bottom dwellers. If the marine worms disappeared, thousands of other species that depend on them for food would also disappear.

Clams and Other Mollusks. Many species of mollusks also live in bottom sediments and filter feed. Mollusks have been mentioned before, but because they are so important in estuaries, they are given special attention here. When we think of mollusks (if we do at all), we might think of clams or oysters or the snail slugs we see in the garden: "lowly" or "primitive," shelled crawling creatures, but this is a major misconception. Mollusks are the second most successful group of animals on earth: their basic body plan is found in some 125,000 different species. Only the arthropods (insects, spiders, crabs, and other animals with jointed external skeletons) outnumber them, with 1 million or so described species. How could we be so unaware of this mind-boggling assortment of living animals? The answer is that most are in the ocean. The world's snails number 75,000 species, and two-thirds are marine. The clams amount to some 25,000 species, and nine-tenths are marine. And of the other mollusks, all are marine, so most people never see them. The next section devotes a little more space to these remarkable creatures.

Mollusks: Soft Bodies with Hard Shells. There are known to be some 125,000 species of mollusks. Of those, 75,000 are species of snails; 25,000 are species of clams. To put these numbers in perspective, the group that includes all of the vertebrates numbers only about 50,000 species. That group includes all of the fishes, frogs, lizards, turtles, birds, and furry mammals, all of the forms that are displayed in our zoos, and humans as well. About half of the vertebrates are fishes, and even among those, the majority of fish species are (no surprise) in the ocean. Yet we arrogantly classify animals into "vertebrates" and "invertebrates"—that is, animals with backbones and everybody-else-lumped-together. This makes no more sense than if a resident of tiny Sopchoppy, Florida, were to divide the world

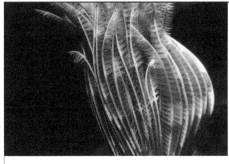
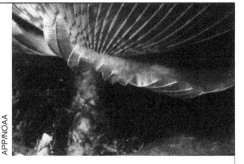

A polychaete worm on a Keys reef. At left, the fine, featherlike structures that enable the worm to filter volumes of water can be seen. At right, the tube, into which the worm can retreat, is buried, with only its top portion visible.

A group of polychaetes with their tubes buried in coral rubble on the seafloor.

A feather-duster worm mounted on a coral in the Keys reefs.

Red scaleworm (Levensteiniella kincaidi). This worm has left its old burrow and will make a new one elsewhere.

FIGURE 5-8

Polychaete Worms

into two equal parts: Sopchoppy versus the rest, with "the rest" including not only Miami but India as well.

The mollusks include snails, clams, octopuses, squids, and several other groups. Why are they classed together? What does a hard-shelled clam buried in the mud have in common with a jet-propelled rainbow-colored squid? Most of them have soft bodies that, on the inside, contain the internal organs, and on the outside secrete shells of calcium carbonate. The soft parts are folded into a variety of body shapes, ranging from the spiral shapes of snails and the flattened shapes of clams to the streamlined, tentacle-bearing shapes of octopus and squid. (Octopus and squid also have the shells, but only remnants that they conceal inside their bodies to facilitate rapid movement.) The history of the phylum Mollusca is one of endless efforts to balance the mass of the heavy protective shell with mobility.

Among the most thickly armored mollusks are the snails, or gastropods, animals with a single shell (such as snails and conchs) that can move by virtue of a muscular "foot" that they can protrude from the shell and use to creep along the seafloor. Thanks to the heavy shell, they can survive being pounded by sand and surf and thanks to the foot, they can scour the seafloor for food and move to new areas when it gets scarce. The success of the combination is reflected in the huge number of species that are alive today. Figure 5-9 shows photos of some gastropod shells commonly found on Florida beaches.

Another big group of mollusks is the bivalves, those with a pair of hinged shells. The bivalve shells of clams allow them to burrow smoothly through sediments, buried and out of reach of many potential predators. Scallops, which lie visible on the surface in seagrass, can, if threatened, "fly away" through the water by rapidly clapping their shells together. Margin photographs through the rest of this chapter display some of the extraordinary variety of bivalves that inhabit Florida's coastal and offshore environments.

Shell collectors comb Florida beaches, seeking treasures to take home as reminders of the beauty of the sea. Most of the shells they find are mollusk shells—cockles and scallops, predatory conchs, olive shells, pink-striped sunray venus clams, and many more. Those most numerous in Florida's estuaries are the mussel and, especially, the oyster. These animals are reef builders and their reefs attract many other creatures, forming communities.

Oyster Reefs and Others. Oysters have built extensive reefs around Florida. At least one large population of oysters occurs in purely marine waters of the Gulf of Mexico near Anclote Key (Pinellas County), but most are in estuaries, to which they are extraordinarily well adapted. They flourish best in water less than 30 feet deep with a firm bottom of mud or shell, notably among the mangroves of the Ten Thousand Islands, in some parts of Tampa Bay, and on the floor of Apalachicola Bay.

The oyster is the quintessential example of an animal that can thrive in an estuarine environment. Oysters filter their food from the turbid, dark water; they don't have to find it by sight. They build their hard shells from the minerals and their soft bodies from the organic materials, in the water. They don't have to see to mate, either, because they spawn; that is, the males and females release their sperm and eggs into the water and

Native to Florida's offshore waters: Flamingo tongue snail *(Cyphoma gibbosum).* This inch-long marine mollusk eats corals: this one was photographed on a sea fan in the Florida Keys coral reefs. Its shell is actually opaque and white, but the snail extrudes a thin skin of tissue that both covers it and serves as gills, obtaining oxygen from the water. When threatened, it pulls this tissue into its shell and "turns" white.

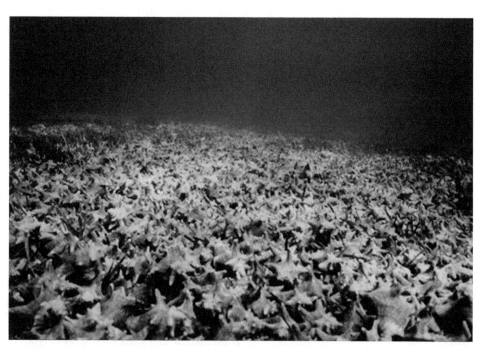

Conchs on the move. A whole population of conchs move across the seafloor, scouring the sediments for food.

fertilization takes place there. The oysters' tiny, planktonic larvae (known as spats) float in the plankton for a while, and then lodge on a hard or soft seafloor. On arrival, each oyster attaches to the estuary floor by the center of one of its two bowl-like shells; that way, most of the sediment particles that drift by with the current will slide beneath the lip of the shell, rather than smothering the oyster. If the water gets choppy and stirs up the sediment, the oyster claps shut.

It takes only a few spats to start a new oyster community. The reef or bar it forms keeps growing year after year, as spats settle out of the plankton and attach to the shells of older animals. An oyster can live for years, completely covered by other animals, then see the sea again when a chunk of the colony breaks off in rough waters. But over time, those that are farthest down in the aggregate are smothered and die, while living oysters are concentrated on the outer surfaces of the pile. Currents shape the oyster bars or reefs into narrow, linear structures, and the individuals themselves also grow long and narrow. Their shells open toward the food-bearing currents that pass across the bar. Each oyster "inhales" water through one siphon and filters its food, plankton and nutrients, from suspended sediments. Then it ejects the sediments through another siphon.

If exposed above water, oysters can close their shells, so they can occupy intertidal areas. Intertidal, "coon" oysters are usually stunted, because they can ingest food only when submerged at high tide, but if transplanted to deeper subtidal sites where they can feed continuously, they grow larger.

The **gastropods** are a class of mollusks. Many gastropods have heavy, single shells with a single opening. Through that opening they can extend both the muscular "foot" that they use to pull themselves along, and the body parts that they use to eat with. A child might say "they eat with their feet" (*gastro* means "stomach" and **pod** means "foot").

Bivalves are mollusks with paired shells connected by a hinge.

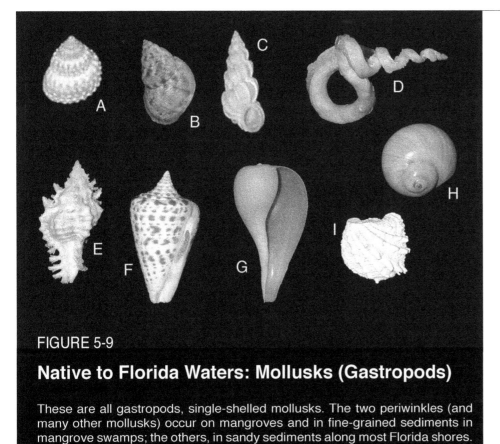

FIGURE 5-9

Native to Florida Waters: Mollusks (Gastropods)

These are all gastropods, single-shelled mollusks. The two periwinkles (and many other mollusks) occur on mangroves and in fine-grained sediments in mangrove swamps; the others, in sandy sediments along most Florida shores.

A. Beaded periwinkle (*Tectarius muricatus*), 1" long.

B. Angulate periwinkle (*Littorina angulifera*), 1" long.

C. Wentletrap (an *Epitonium species*), 1" long.

D. Worm seashell (*Vermicularia knorri*), up to 4".

E. Lace murex (*Chicoreus dilectus*), up to 2.5".

F. Alphabet cone *(Conux spurius)*, up to 3.5"

G. Paper fig seashell *(Ficus communis)*, up to 4"

H. Shark eye or moon snail (*Polinices duplicatus*), up to 2"

I. Spiny jewel box (*Arcinella arcinella*), up to 1.5"

Native to Florida waters: Angel wings *(Cyrotopleura costata)*. This bivalve buries itself in mud flats about one to two feet below the surface. It grows up to six inches long.

Native to Florida waters: Blue mussel *(Mytilus edilis)*. Mussels grow on some hard bottoms in Apalachicola Bay.

When the tide goes out, coon oysters snap shut and squirt their water out; people walking along the shore as the tide goes out can see them "spitting." Figure 5-10 features a colony of coon oysters and a handful of oyster shells from a reef.

Oysters use the water to convey several chemical signals. Mature oysters release a chemical into the water, and this attracts spats that are searching for attachment sites. Thus the oyster bar grows and the colony stays together. When one male spawns, he releases another chemical into the water. The surrounding males and females detect it, and spawning is triggered in the whole population. This ensures that plenty of eggs and sperm are present simultaneously and makes fertilization efficient, producing large numbers of larvae. The oyster colony also adjusts its sex distribution constantly to ensure that there will always be enough individuals of both sexes to reproduce. After the males have shed their sperm, they slowly turn into females; after the females have released their eggs, they may revert to being males.

Oysters can tolerate both marine and nearly fresh water equally well, but in salt water, marine predators can attack them. Their worst enemy is the oyster drill, a mollusk that bores into their shells and digests the oysters. In Apalachicola Bay, when the river's flows are average, fresh water dilutes the salt water enough to drive out or kill the oyster drills, but with abnormally low river flows, the water becomes salty and the marine predators stay alive, killing oysters. Thus, high river flows are protective. Major rainstorms and floods, which may not be welcome to people on land, are necessary to cleanse the bay and support its ecosystems. Withdrawals of water from the river system can severely impact the oyster fishery.

Oysters filter up to eight times more sediment from the water than would settle out due to gravity alone. As a result, they efficiently turn turbid water clear as it flows over them. After using the nutrients they need to build their soft bodies and hard shells, the oysters drop clean sediment particles on the bottom, laying down a broad, flat floor and releasing clearer water to the seagrass and algal beds that lie farther out in the estuary. In clear water, seagrasses and algae can obtain enough sunlight to thrive.

Like every intricate living structure, an oyster reef provides hiding and attachment places for many other species. Among the several dozen species of animals that find habitats on oyster reefs are mussels, boring clams, barnacles, shrimp, polychaete worms, anemones, burrowing sponges, lightning whelks, and many kinds of crabs. Populations of one tiny mud crab on oyster bars can reach densities of 1,000 per square yard.

For completeness' sake, it should be mentioned that there are other kinds of reefs in some of Florida's coastal zones. In north Florida's Apalachicola Bay, mussels have built reefs on some hard-bottom areas. Around south Florida, worm reefs occur on the soft floors of several shallow, intertidal zones. The worms make a protein that cements sand grains together into tubes, and these build up, one upon another, as new worm larvae settle on

them. Because they are in shallow water and can add material only when submerged, worm reefs grow mostly horizontally, forming broad, rocklike platforms that attract lobsters, fish, and other animals. Other reefs (called vermetid reefs, pronounced VER-me-tid) were built by a species of wormlike mollusk on sediment floors outside the Ten Thousand Islands. They are no longer active, but their rocky structure attracts juvenile and adult stone crabs and sometimes some fish. The reefs tend to catch floating debris and may form the nuclei of new islands.[7]

PERSPECTIVE ON ESTUARIES

This relatively brief overview of Florida's estuaries only hints at the huge arrays of plant and animal species they support. There are many more: we don't even know how many. We know that among the fishes alone, more than 1,000 species occur in near-shore habitats around Florida. We know that of these, 30 percent have populations only in, or mainly in, Florida, and that these represent about one-fourth of the fish species recorded for the entire western hemisphere north of the equator. According to a state committee on biodiversity, "Indications are that the fish [diversity] of this state [is far greater] than that of any comparable area in either North or Central America."[8]

As for invertebrates, consider just the oligochaete worms. Some 350 species of oligochaetes occupy coastal environments off eastern North America. More than half of these are found off Florida's shores. Or take the crustaceans: about 900 species are known all along the Atlantic coast from Florida's tip to northern Canada. Of these, more than 700 are found in Florida waters, and 35 are probably endemic. Thus, Florida's near-shore waters are a major biological resource. They deserve respect, preservation, and where needed, restoration.[9]

Eastern oyster *(Crassostrea virginica)*. These are "coon" oysters in the intertidal zone. They are stunted, because they are growing in a less-than-ideal site, but they are otherwise normal. They attract throngs of shorebirds.

Native to Florida waters: Sunray venus *(Macrocallista nimbosa)*. This is a large clam, up to 5 inches long, that buries itself in sandy bottoms beneath shallow water.

CHAPTER SIX

SUBMARINE MEADOWS

This chapter continues the series about natural communities on the continental shelf around Florida. Chapter 5 dealt with estuarine communities on mineral floors and with mollusk and worm reefs; this one describes grassy realms where sunlight penetrates the water far enough to reach the bottom, and where seagrasses and large algae can attach, grow, and spread. Numerous other organisms then find habitats on and among the plants and form communities of great complexity.

To a small invertebrate animal, a meadow of seagrass is a wonderland of different kinds of foliage and a forest of blades on which to feed, hide, mate, and travel from place to place. To carnivorous fish and shellfish, it is a jungle in which to find abundant prey. To the sea turtles and manatees for which two of the seagrasses are named, a seagrass meadow is a luxuriant pasture in which to feed to the heart's content. And to tiny travelers such as shrimp and small fish, seagrass meadows provide safe passage across the ocean floor.

SEAGRASSES AND MACROALGAE

Vast meadows of seagrasses blanket some estuarine and marine seafloors. Florida's two largest seagrass beds lie in Apalachee Bay and off the peninsula's southern tip in Florida Bay (shown earlier in Figure 5-2, page 69). The beds in Apalachee Bay occupy some 750,000 acres; those in Florida Bay almost 1,250,000 acres. These underwater meadows spread in a wavy band from just beyond the freshwater outflows of rivers up to 70 miles offshore, and in south Florida, they grow luxuriantly along tidal channels in mangrove islands.[1]

Seagrasses are true flowering plants. They bloom just as land plants do. They release pollen, and it drifts through the water, cross-pollinating other plants. They produce seeds that may take root and spread, and they also spread by growing long, horizontal rhizomes that put up new shoots from every node. Thus they can colonize increasingly broad sand and mud seafloors and come to dominate large areas. List 6-1 names the seagrasses

Seagrasses are not true-grasses but aquatic flowering forbs that evolved long ago from terrestrial ancestors.

Algae may occur as single cells, as filaments, as thinsheets, as calcified crusts, or as bushy, leaf-shaped forms.

Tiny algae, or **microalgae,** are single-celled and small multicellular plants that float among phytoplankton and grow on sediments, rocks, and plants.

Leafy-looking, large multicellular algae (**seaweeds or macroalgae**), hold to rocks, hard bottoms, corals, or sea-grasses, or float free.

Native to Florida waters: Pipefish (a *Syngnathus* species) from near-shore waters off Florida's Big Bend. Pipefishes are closely related to the fishes called seahorses. Their slender shape and mottled color enable them to hide easily in seagrass beds.

OPPOSITE: A seagrass meadow beneath the blue waters of the Gulf of Mexico.

87

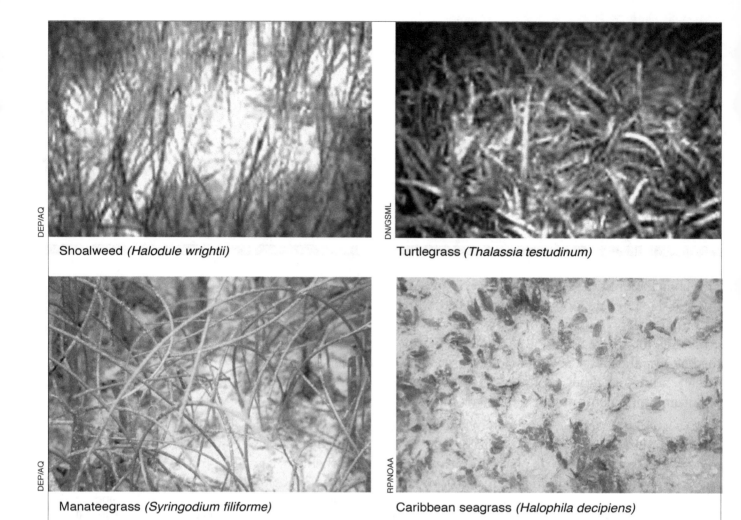

Shoalweed *(Halodule wrightii)*

Turtlegrass *(Thalassia testudinum)*

Manateegrass *(Syringodium filiforme)*

Caribbean seagrass *(Halophila decipiens)*

FIGURE 6-1

Estuarine and Marine Seagrasses Native to Florida Waters

**LIST 6-1
Native Florida
seagrasses**

Turtlegrass
Manateegrass
Shoalweed
Tapegrass species
Widgeongrass

. . . and numerous
epiphytic algae attached
to the seagrasses.

Source: Guide 2010,
247.

that are common along Florida's shores and Figure 6-1 shows those that dominate Florida's estuarine and marine floors down to about 100 feet of depth.

Each seagrass has a different habitat preference. Just as each tree species in a forest grows best at a certain elevation along a slope, each seagrass dominates a different part of the seafloor. Shoalweed grows closest to the shore and around the mouths of rivers; it withstands low salinity the best, so it can tolerate the fresh water running down rivers and runoff from rain along shores. It can also tolerate exposure to the air during low tide, hence its name. It is a pioneer, the first to colonize newly available areas or to recolonize disturbed areas.

Shoalweed has brittle, cylindrical leaves that break off easily, but its root-rhizome system branches prolifically and stabilizes the sediment, so like its terrestrial relatives on dunes, seaoats, shoal grass expands its own territory. Once shoalweed has begun to grow, sediment accumulates around it, forming mounds and ridges and enabling other seagrasses to take hold. Thus, shoalweed paves the way for other aquatic plants.

Turtlegrass lacks some of shoalweed's adaptations, but has others of its own. It dies if exposed to the air for more than brief periods, but it is a tough seagrass with broad leaves and branching roots and rhizomes that firmly stabilize the sediment in which it grows. It can form dense stands just below the low-tide mark and down to about ten feet of depth. Beyond ten feet, it can still grow, although more sparsely, all the way down to about thirty feet if the water is clear. Turtlegrass cannot tolerate low salinity, though, so shoalweed remains dominant near shores and near the outflows of rivers.

Other seagrasses often grow with turtlegrass in mixed beds. Manateegrass may grow mixed with turtlegrass, or may assume dominance in waters more than ten feet deep. Like turtlegrass, manateegrass grows only below the low-tide line and does not tolerate exposure to the air. Because its broad blades enable it to catch light efficiently, another seagrass, Caribbean seagrass, grows as an understory plant beneath the taller blades of turtlegrass and manateegrass and also occupies the deepest, most dimly lit parts of seagrass meadows out to a depth of about 100 feet. Several other species grow mixed with, or around the fringes of, these seagrasses.

Seagrasses grow well on muds and mucks, the sorts of sediments that accumulate in relatively quiet waters. They prevent the current from stirring up the bottom, so while they are flourishing (during the growing season) the water remains free of turbidity, permitting maximal light to reach them. When winter arrives along the northern Gulf coast, the seagrass blades may die back and slow down wave action less effectively. Then the water grows too turbid to allow much light to penetrate, but the plants' metabolism has slowed and they no longer need as much light. In spring, they grow back from their subsurface roots and rhizomes and again the water becomes clear.[2]

Seagrasses exhibit many other adaptations. Those that grow in shallow water have flaccid leaves that lie flat at low tide, so they remain immersed even when the water is low. Those that grow in deeper water have stiffer, more erect leaves, which are less likely to bend in the current, so they can reach higher for light under prevailing conditions.

Like phytoplankton, salt marsh grasses, and mangroves, seagrasses deliver to other organisms much of the energy they capture from sunlight. Some energy they yield up directly to herbivores, notably sea urchins, sea turtles, and manatees, but most they release as detritus, which feeds organisms both within and beyond the seagrass beds. Because they grow fast—up to half an inch a day in strong light and clear, warm, slowly moving water— seagrasses are prolific producers of both green tissue and detritus. During the day, while photosynthesizing, they may release oxygen so fast that it is easy to see bubbles escaping from their leaf margins. They also pump up nitrogen from bottom sediments, where bacteria are always binding ("fixing") nitrogen into compounds that are usable by other living things. The seagrasses release some of this usable nitrogen through their leaves into the water, where other organisms have access to it. Some fixed nitrogen washes out to sea and becomes available to other communities.[3]

Seagrasses add structure to the underwater environment, and as in all ecosystems, the more surface area that is available, the more hangers-on

can attach. A square inch of "bare" mud or marl on the seafloor may hold 5,000 organisms, but a few leaves of seagrass growing on that square inch may hold several hundreds of thousands: single-celled algae, bacteria, invertebrate grazers, filter-feeders, and predators on these. Moreover, seagrass beds have many nooks and crannies that can accommodate huge numbers of swimming plant cells (dinoflagellates); phytoplankton; long filaments of attached algae; and even large, free-floating clumps and cylinders of drift algae that roll along the bottom. Feeding on these are zooplankton, shellfish, small fish, and many others. Descriptions of food webs based on seagrass beds quickly grow long.

The several hundred species of single-celled algae that grow on seagrass blades are a microscopic lawn that feeds a multitude of tiny animals, providing nutrients that make fast growth possible. Some single-celled algae fix nitrogen as bacteria do in bottom sediments. Some make skeletons or coats of calcium salts from the sea water. More than 30 species of tiny snails and dozens of species of barely visible shrimp and other crustaceans roam over seagrass leaves and partake of their algal coating. These animals find such nourishment in the lawns of algae on seagrass blades that they live out their entire lives there and grow a thousandfold in size from newly hatched larvae to adults. When seagrass washes up on the beach, people step aside to avoid its slimy, gritty coating; they call it "seaweed," but it is in fact a grand pastureland for grazers and the "grit" is evidence of their presence.

Some underwater meadows are composed of large algae (macroalgae) in greater numbers than seagrasses. These algae, or seaweeds, are not vascular plants—that is, they do not have internal vessels to circulate their fluids, and they do not have true roots that can absorb nutrients or take firm hold in soft sediments. However, in deep water, macroalgae can grow as tall as trees, and they can attach to rocks with creeping, rootlike structures called holdfasts. Limestone seafloors, limestone outcrops, oyster reefs, and mussel reefs may be cloaked over many acres with macroalgae—either thick algal mats or tall, leafy, swaying, green filaments.

Some large algae make skeletons of calcium carbonate and when they die, add them to the sediments (limestone is still forming on the seafloor, just as it has done for millions of years past). Some algae disintegrate into sand-grain-sized plates, some into powderlike sediments such as the fine mud inside the coral reefs off south and southwest Florida. Like seagrasses, attached algae move nitrogen from sediments to the water column.[4] List 6-2 names some bottom algae and Figure 6-2 displays three of them.

Holdfasts don't enable large algae to attach to soft substrates, but they still manage to occupy soft-bottom areas: they attach to the seagrasses that grow there: they use the plant as a sort of mooring rope. In the Indian River lagoon, fully 70 percent of all the algae are filamentous forms attached to seagrasses. By shading seagrass leaves, attached algae shorten the lives of the plants on which they depend, but many snails and others graze the leaves and help to keep them clean. Still, most seagrass leaves are shed along with their attached algae within sixty days of first emergence. The shed leaves of manateegrass form large floating mats; turtlegrass leaves wash in below

A green alga *(a Caulerpa species)*.

A red alga *(a Hymenella species)*.

A brown alga *(a Sargassum species)*.

FIGURE 6-2

Macroalgae Found in Florida Waters

them; and wave action breaks them up into detritus. Then the whole complex of disintegrating leaves, algae, and grazers becomes food for a host of sea and land animals.

Shed seagrass leaves with their algal dressing make a nourishing food for detritus eaters. In the water, bacteria, fungi, and zooplankton disassemble and ingest the leaves. In bottom sediments, tiny detritus eaters eat whole leaf particles, or strip bacteria and fungi from them, or ingest the fecal pellets dropped by other detritus eaters. Shrimp and small fish twitch up tiny clouds of debris from the bottom, suck them in, and grow on the nutrients they contain. Pink shrimp, voracious omnivores, find a feast on seagrass-bed floors. Blue crabs, too, are prodigious pickers-up of litter. Even the seagrasses themselves take nourishment from their own detritus.

SMALL LIFE IN SEAGRASS BEDS

To this point, except for seagrasses and macroalgae, most of the seagrass-bed inhabitants described here have been creatures too small to see. Just above the visibility threshold are hundreds more species of invertebrates. Lists 6-3, 6-4, and 6-5, which accompany Figure 6-3, identify some of the animals found. To give an idea of the numbers involved, the seagrass beds in Tampa Bay support up to 3,000 polychaete worms per square yard, and the seagrass beds in Apalachee Bay hold up to 1,600 amphipods per square yard as well as dozens or hundreds of populations of other species.

Besides offering a permanent home to many residents, seagrass beds are prime nursery grounds for many more animals: bryozoans, starfishes, sea anemones, worms, mollusks, crabs, and others. These creatures make of the seafloor a magical world. Says one snorkeler, swimming over seagrass beds in St. Joe Bay:

Sunlight sweeps over the seagrass in blazing golden lines as lacy piles of rose-colored algae roll past. Red sea urchins sit scattered about, grazing on broken fragments of seagrass and using their suction-cuplike

Holdfasts are structures by which macroalgae (seaweeds) attach to the rock, coral, seagrass, and other hard surfaces.

LIST 6-2
Algae on bottom sediments

These algae are attached to hard substrates off the west Florida coast:

Brown Algae
Dictyota dichotoma
Padina vickersiae
Sargassum filipendula
Sargassum pteropleuron
. . . and others

Red Algae
Chondria littoralis
Digenia simplex
Gracilaria species
. . . and others

Drift Algae
Laurencia species
Members of these families:
Acanthophora
Gracilaria
Hypnea
Spyridea

Source: Zieman and Zieman 1989, 44.

LIST 6-3
Foreshore residents (examples)

On the surface:
Ghost crab
Sand fiddler crab
. . . and dozens more

In the sediment:
Paper mussel
Rose petal tellin
. . . and dozens more

LIST 6-4
Near-shore bottom residents (examples)

On sand-mud floors:
Common marginella
Say's mud crab
. . . and dozens more

In bottom sediments:
Florida crown conch
Parchment worm
Purplish tagelus
Stout tagelus
. . . and dozens more

LIST 6-5
Seagrass bed residents (examples)

Among seagrasses:
Antillean glassy bubble
Atlantic bay scallop
Atlantic ribbed mussel
Broad-ribbed cardita
Elegant glassy bubble
Florida sea cucumber
Greedy dove shell
Hermit crab
Thorny sea star
True tulip
Variegated sea urchin
. . . and hundreds more

In seagrass bed sediments:
Candy stick tellin
Cross-barreled chione
Dwarf tiger lucine
Pointed venus
Promera tellin
Stiff pen shell
. . . and hundreds more . . .

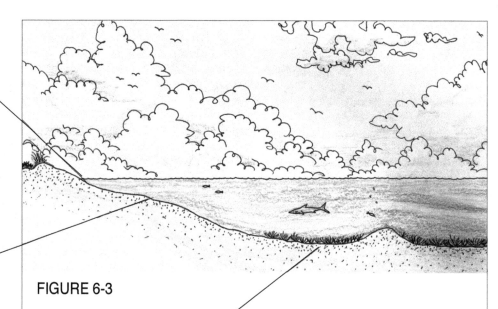

FIGURE 6-3

Seafloor Occupants (Tampa Bay area)

Of the three habitats shown, seagrass beds are by far the most densely occupied. Hundreds of invertebrate species may be present in a seagrass bed. Each animal has its own lifestyle. For example, an amphipod (*Cymadusa compta*) grazes algae from the tops of the seagrass blades at night, and eats detritus from the seafloor in the daytime.

Small differences in season or location alter the proportions in which these animal populations occur, and they also differ from south to north. An equally varied array with a somewhat different assortment of organisms occurs in more northern, temperate coastal waters.

Source: Zieman and Zieman, 1989, 48.

tube-feet to wave bits of shells over themselves as camouflage. Scallops hold their shells wide open, their tiny, sapphire-blue eyespots sparkling in the sunlight as they filter food from the water.

A flounder, buried in the sand with only its eyes uncovered to betray its presence, waits in ambush for an unwary small crab or fish to pass by— then it will lunge up out of the sand, all teeth, to seize it. Here and there, the red crowns of tube anemones sit at the openings of their elevator-shaftlike tubes. Upon being touched, an anemone rockets to the bottom of its tube so fast that an observer wonders if anything was ever there. . . .[5]

Since there are hundreds of species of colorful, oddly shaped invertebrate animals in Florida's seagrass beds, it is impossible to do them justice, but Figure 6-4 presents a few, to illustrate their diversity.

Not only are these animals diverse, they are also present in numbers so astronomical it is hard to imagine them. Consider, for example, just one crustacean, the pink shrimp, which makes a juicy morsel for dozens of predators that share its waters, and travels long distances across the Gulf and back, largely in the cover of seagrass beds.

The pink shrimp engages in a migration behavior that enables some individuals to survive in sufficient numbers to maintain the species population. Figure 6-5 shows the impressive journeys this animal makes from its spawning grounds to its nursery grounds and back.

Staghorn coral *(Acropora cervicornis)*. Corals look like branched shrubs, but they are invertebrate animals (see next chapter). Corals that start out in seagrass beds may ultimately build massive reefs, such as those off the Florida Keys.

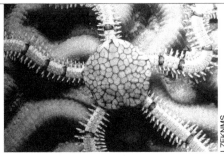

Reticulated brittle star *(Ophionereis reticulata)*. This animal roams sea¬floors, seagrass beds, and coral reefs. It captures and feeds on smaller invertebrates. When it captures one with its five arms, it turns its stomach inside-out and digests the animal while pulling it inside.

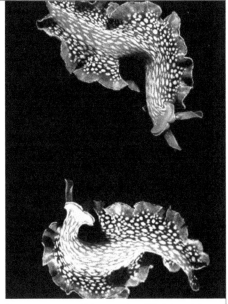

Lettuce nudibranch *(Tridachia crispata)*. This soft-bodied mollusk flutters through the water, a little like a butterfly. Although named for lettuce, it may be brown, yellow, or magenta as well as green. It easily conceals itself by nestling in the algae on which it feeds. It grows to a length of three inches.

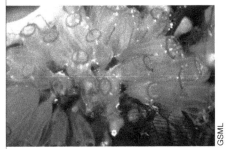

A sea squirt. This animal appears not at all like a close relative of ours, but its early development is similar to the development of vertebrate embryos. It is classed as a chordate, a member of the same phylum as the vertebrates.

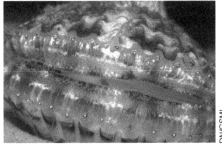

Calico scallop *(Argopecten gibbus)*. Scallops abound in seagrass beds. Each animal has numerous eyes, tiny blue "pearls" that form a line along the soft tissue that is extruded from between its shells.

Fire nudibranch *(Hypselodoris edenticulata)*. The bright stripes on this animal warn would-be predators that it is noxious.

FIGURE 6-4

Invertebrate Animals in Florida Seagrasses

How do these tiny marine animals manage their migrations across the open Gulf? Millions of them migrate from the cluster of little islands known as the Tortugas, nearly 70 miles west of Key West, to Florida's coast and back during their life cycle. Mature pink shrimp spawn in early spring in the open ocean off the Tortugas and produce minuscule larvae, only one one-hundredth of an inch long, barely visible. The larvae look like tiny snowflakes drifting in the water and, during the next day and a half, they go through five transformations. Then they begin to feed on planktonic plants and animals that are even tinier than they are, and go through several more stages of development. After about three weeks, they are beginning to look like shrimp, but are just over one-eighth inch long.

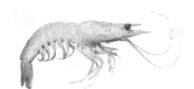

The pink shrimp *(Penaeus duorarum)*. Source: www.enjoygram.com/tag/scshrimp

During these transformations, the shrimp drift at sea and are largely at the mercy of ocean currents because they are capable of only a little

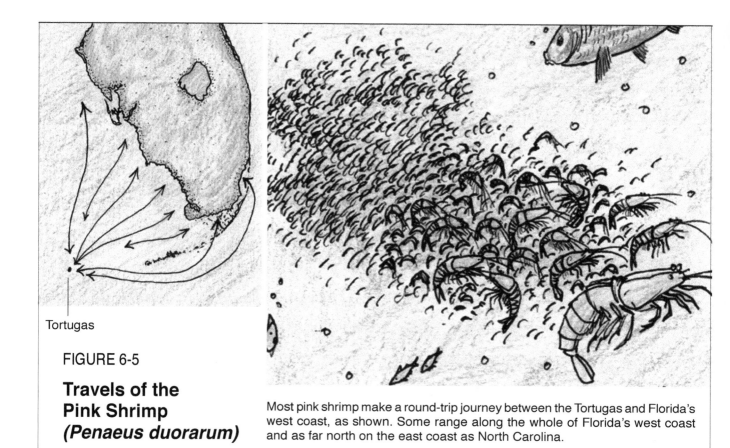

Tortugas

FIGURE 6-5

Travels of the Pink Shrimp (Penaeus duorarum)

Most pink shrimp make a round-trip journey between the Tortugas and Florida's west coast, as shown. Some range along the whole of Florida's west coast and as far north on the east coast as North Carolina.

**LIST 6-6
Menu for a pink shrimp**

Amphipods
Copepods
Detritus
Foraminiferans
Isopods
Juvenile shrimp
Mollusk larvae
Nematodes
Ostracods
 (tiny crustaceans)
Polychaetes
Sand
Shrimp larvae

Source: Zieman 1982, 58.

movement. Unless favorable currents carry them to inshore nursery grounds, where the next stage of their life cycle is spent, they will perish. Also, on any given day, some 20 percent of the population is lost to predators. The next day, of the population that remains, another 20 percent is lost.

On their way across the ocean, nearly all of the shrimp are either eaten by fish, jellyfish, and larger shrimp, or are carried by currents away from their inshore nursery grounds and die. Some 9,999 individuals out of every 10,000 are killed. Still, some 4.3 billion shrimp make it all the way to feed and flourish in the lush seagrass beds off Florida, and northward into the rich bayous of the Gulf states. List 6-6 displays the menu of tidbits they find in these rich feeding grounds. Now about 1/4 inch long, they bury themselves every day in the soft, estuarine mud and emerge every night to continue feeding, molting, and growing.

The young post-larval shrimp stay in the nursery grounds, in areas of shallow brackish to almost fresh water for a period of four to eight weeks. As they grow, they leave the shallow estuaries, marshes, and lagoons for deeper rivers, creeks, and bays. By July they are 2 to 3 1/2 inches long and by the end of August they are 5 inches long; they have doubled their weight in three weeks.

As the water grows colder, the shrimp cease growing. They remain in the shallow bays until the cold drives them out to seek deeper waters where temperatures are more stable. (This is the winter shrimp "run" that brings hordes of people with nets and lanterns to bridges.)

Then, as winter turns to spring, the young shrimp begin to develop sexually and this is when their offshore spawning migration occurs, which takes

the sexually mature shrimp back to their oceanic spawning grounds near the Tortugas. Some 21 to 35 days after they arrive back at their birthplace, fully mature, and seven inches long, they are ready to spawn and launch the next generation.

At spawning, each female shrimp can release from 300,000 to a million eggs at a time. The new population will be large enough to withstand all the pressures of predation and keep the species going.

The pink shrimp's migratory behavior is genetically programmed to fit the contours, distances, and seasons of the Gulf of Mexico. As a result, it can survive the hazards this passage presents and take advantage of the environment's resources. Millions of the ocean's days, nights, ebbs, and flows have molded and maintained the behaviors of this creature.[6]

Larger Animals

Seagrass beds make excellent nurseries for all kinds of juvenile animals, because they provide uncountable hiding places. List 6-7 names just a few of the juveniles that spend their young lives in seagrass beds, then move out to sea as adults.

Mature fishes are so numerous in seagrass beds that they defy counting. Figure 6-6 depicts a few common species, but nearly 50 families of fish are found just in west Florida's turtlegrass beds.

Sea turtles visit seagrass beds; in fact, turtlegrass is named for the green sea turtle, which eats so voraciously it has been called the seafloor buffalo. The turtle often snips the leaf at the bottom and lets the top float away, stimulating the plant to make new leaves. The behavior is reminiscent of the way deer prune shrubs and stimulate the growth of new foliage. Turtle-pruned leaves as well as turtle droppings add nitrogen to the system. Sea turtles receive attention in Chapter 8.

Manatees also visit seagrass beds. Manatees are primarily tropical animals, but in summer, Gulf coast waters and river mouths are warm enough for them. In winter, they take shelter in spring runs such as the Homosassa and Crystal rivers, whose translucent waters permit freshwater vegetation to grow luxuriantly. Manatees forage singly or as mother-calf pairs in estuaries and offshore seagrass beds. They spend six hours a day feeding and each one eats more than a hundred pounds of seagrass a day. They use their stiff facial bristles to clear the ground around the plants, then uproot them and shake them free of sediment.

Birds, too, dine under water over shallow seagrass flats. Herons and egrets wade, snatch up swimmers, and probe the bottom for infauna. Geese and ducks swim and dive to eat the underwater plants, invertebrates, and fish. The double-crested cormorant pursues fish under water; the osprey, bald eagle, and brown pelican fly and dive for them. Feeding in seagrass beds is efficient for birds, because the abundance of fish is so great. When rearing their offspring, pelicans have to deliver 120 pounds of fish to each nestling if it is to grow enough to fledge successfully. This is a tall order, but one that can be met by the forage in rapidly growing seagrass beds.[7]

LIST 6-7
Young fish in seagrass nurseries

Juveniles of these and many more species spend their young lives in seagrass beds:

Atlantic tarpon
Bonefish
Seahorse species
Florida pompano
Permit
Flathead (striped) mullet
Great barracuda
Long-horned cowfish

Source: Guide 2010, 247.

Menhaden fry, growing up in estuaries and along rivers, are important in the food web. Like herrings, they are bony and oily, and wherever they are abundant, larger fish thrive. Those that survive predation may grow to 25 pounds:

Yellowfin menhaden (*Brevoortia smithi*).

Large, roaming predator fish swirl in, snatch up their prey, and streak away. Top carnivores include king mackerel, barracuda, several sharks, and many more:

Blacktip shark (*Carcharhinus limbatus*). This fish grows to 6 feet in length.

Snappers, seatrout, and others begin their lives as juveniles in seagrass beds and grow to about 3 or 4 pounds as adults:

Spotted seatrout (*Cynoscion nebulosus*).

Larger fish in seagrass beds include stingray, permit, and others:

Stingray (*Dasyatis* species). The stingray swims over sand and mud bottoms in deep waters, and visits grassbeds to forage. Typically it grows to about three feet, but a few giants are six feet wide and ten feet long.

Permit (*Trachinotus falcatus*). This fish usually stays inshore around grass flats. It grows to 25 pounds.

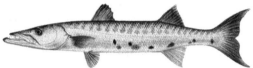

Great barracuda (*Sphyraena barracuda*). This fish grows to about 5 feet in length.

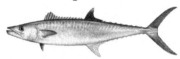

King mackerel (*Scomberomorus cavalla*). Mackerel weigh about 20 pounds when mature.

FIGURE 6-6

Marine Fish in Florida's Seagrass Beds

Source: Anon. c.1994 (Fishing Lines); drawings by Diane Peebles

PERSPECTIVE ON NEAR-SHORE ECOSYSTEMS

These two chapters have treated near-shore communities that harbor great biodiversity. Seagrass beds alone are more diverse than any other underwater ecosystems, even coral reefs, and they are more important as nursery and feeding grounds. They are, themselves, part of a broader landscape that functions as a unit. Many organisms migrate from one seagrass bed to another. Along west and north Florida shores, fish that are moving between salt marshes and deep offshore waters can swim under cover of seagrass beds and feed as they go. In Florida Bay, juvenile and adult animals can travel back and forth between mangrove swamps and coral reefs without leaving the cover of seagrass beds.[8]

That animals migrate so extensively around the Gulf reflects the fact that the waters along the shore are all part of a single system that supports marine life around the year. Upland ecosystems far inland around stream headwaters affect the health of coastal waters. Clean forests and marshes

purify the waters of rivers, creeks, and runoff from on shore. Freshwater flow determines the layering, mixing, and oxygen content of estuarine waters and is crucial to community structure. Streams must pulse as they have done historically to deliver the seasonal high and low water levels and the nutrient and sediment loads to which estuarine organisms are adapted.[9]

If one area becomes polluted or otherwise disturbed, its loss has broad impacts, not unlike the loss of a major wetland used by migratory birds. Losses of the forests alongside a river, diversion of a river's water, filling of marshes along the shore, or uprooting of seagrasses in an estuary have equally major repercussions. Not only communities within those environments, but neighboring and distant communities as well, decline and may even die out.

Besides supporting a profusion of life, seagrasses serve other vital roles. They help to protect shorelines from erosion. They reduce wave energy, accumulate sediment, and hold it in place. Storm tides may rise high along the shore and hurl battering waves against the land, dragging down sea walls and undercutting houses. But unless the water is so shallow that the seagrasses are exposed to the wind and scouring waves, the seagrasses hold on, and stabilize the bottom sediments. After the storm has passed, the seagrasses still remain, perhaps tattered, but able to quickly regrow. And if monster storms uproot the seagrasses, they still are useful. Thrown up on land as seawrack, they nourish beach life and vary salt marsh habitats. Even while floating, seagrasses are useful—small animals and fish hide and feed in floating seagrass.

Spotted cleaner shrimp (Periclimenes pedersoni) on pink-tipped anemone (Condylactus passiflora). Many species of cleaner shrimps dwell on other animals such as anemones and corals and serve their hosts by eating parasites and predators off their tissues. Like the shrimp, the anemone is an animal, but a radially symmetrical one. The stinging cells at the tips of its tentacles paralyze small prey, including fish, that happen to swim by; then the tentacles feed the prey into a mouth at the center of the animal. The shrimp, though, is immune to the anemone's poison.

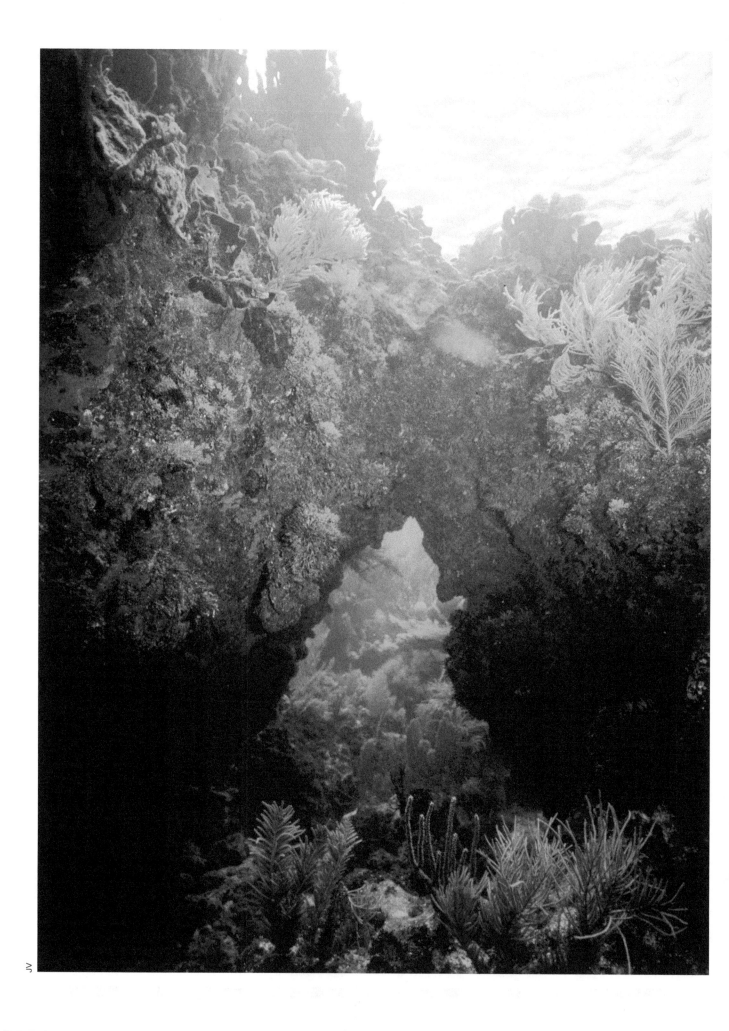

SPONGE, ROCK, AND REEF COMMUNITIES

The major communities that occupy the shallow waters and seafloors nearest the shore, notably mineral floor communities, mollusk reefs, seagrass beds, and algal beds, were covered in the last two chapters. This chapter covers the major ones that are farther out on the continental shelf: sponge beds, limestone outcrops, coral banks, and coral reefs.

Figure 5-2 (page 69) depicted the locations of some of these communities, but structures composed of, or derived from, living organisms such as sponges, limestone outcrops, and coral formations are scattered all over the continental shelf. Many support commercially important populations of fish and shellfish (see List 7-1). A few are selected for emphasis in this chapter, primarily the sponge communities on the west-coast continental shelf and the coral reefs off south Florida. Along the way, details are offered about some of the diverse and versatile sea creatures that inhabit them.

Native to Florida waters: Spiny candelabrum *(Muricea muricata)*, a coral in the Florida Keys reefs.

SPONGE COMMUNITIES

On the shelf off the west coast of Florida, old shorelines from times of lower sea levels remain as ridges that run for many miles in parallel bands at increasing depths and distances from shore. Between them lie vast plains of sand, broken in places by scattered limestone outcrops up to about six feet in height. The sand plains are relatively sparsely populated, but the limestone outcrops are like rich oases that support diverse communities of marine plants and animals. Leafy macroalgae and soft corals wave in the currents among colorful sponges, bushy bryozoans, flowerlike anemones, and transparent, berrylike tunicates.

All of the organisms just named are animals, but they lack the heads, arms, and legs that earth creatures like ourselves expect animals to have. Some of these animals grow attached to seafloors or outcrops in shapes that resemble plants, and in fact most people think they are underground ferns, shrubs, and trees. Other marine animals are shaped like sheets, plates, bowls, or mounds, depending on the species. Part of the fascination of life beneath the sea is the extraordinary variety of body forms seen in animals.

> Communities of organisms such as sponges, corals, and bryozoans growing on bottom sediments are called **live-bottom communities**.

OPPOSITE: A coral reef in John Pennekamp Coral Reef State Park, Monroe County. Although they look for all the world like ferns and flowers, these formations consist of multitudes of tiny animals.

LIST 7-1
Fishes and shellfishes associated with Florida's banks and reefs (examples)

Keys, Tortugas Banks
—Snapper

Keys, Tortugas Sanctuary
—Shrimp

Southwest Florida, Florida
Bay—Lobster and crab

Southwest Florida, 10,000
Islands—Crab

Central Florida, Sanibel
Grounds—Shrimp

Big Bend, Middle Grounds
—Shrimp, fish, scallop

West Florida
—No major banks

Florida-Alabama, Southeast
Grounds—Fish

Florida-Alabama,
Timberholes —Snapper

Note: Noncommercial fish also swim on the bottom: gobies, blennies, clinids, toadfish, skates, rays, batfish, and stargazers near shore; scorpion fish, sea robins, eels, and others farther out, and in southern waters tropical species such as damselfish, angelfish, wrasses, parrotfish, and others.

Source: Gore 1992, 115, table 3.

The next section explains the advantages of a body plan seen in many marine animals: the colonial form used by sponges, bryozoans, and others.

Animals Unlike Animals. Unlike land animal species, in which each animal is a separate independent individual, many marine animals form colonies of small, interconnected individuals. Sponges, bryozoans, corals, and sea squirts, which are among the most abundant of all aquatic animals, are all colonial forms.

The colonial lifestyle resolves a basic conflict for animals that filter microscropic prey from water. To obtain food successfully this way, it is an advantage to be relatively small, but small creatures are vulnerable to being devoured themselves. By building a body made up of repeated little units, the colonial filter feeder preserves its tiny food-gathering form, but collectively grows into a large organism whose size makes it somewhat resistant to being altogether devoured. If a colony is attacked by a predator, some of the individual units may die, but the undamaged members can give rise to new ones by budding or fission and quickly repair the damage.

Sponges. Sponges are colonies composed of many individually self-sufficient animal cells. If a living sponge is put through a shredder, the cells can swim about separately, refind each other, and regroup themselves into a whole sponge again—a trick no vertebrate animal can perform.

Because of their simplicity, sponges are sometimes dismissed as a failed attempt to construct a complex animal, but in terms of species number, they are as successful as the mammals. On rocky areas of the seafloor, they often outnumber all other animals. In samples taken from hard bottoms off the Florida coast, sponges routinely make up by weight up to three-fourths of the living material found.

Sponges lack mobility and have no jaws or claws to defend themselves, but they have a subtle and sophisticated set of chemical weapons: toxic molecules that render them inedible to all but a few predators that have evolved to tolerate them. Many of these molecules, which are so complex that they remain beyond the ability of chemists to synthesize, show promise as potential cancer drugs.

Figure 7-1 shows a few of the more than 60 species of sponges that reside in Florida's coastal waters. They are among the most colorful animals of the Florida coast. People may assign a "sponge color" of beige or gray to them, but some species are blue, brilliant yellow, orange, bright red, lavender, or even snow white. They come in many shapes. Chimneylike boring sponges rise above shoalweed beds near shore. Huge loggerhead sponges, taller than a man, sit farther out on the continental shelf. Sponges shaped like vases, barrels, bowls, stalks, and bunches of cigars cluster on the undersides of floating driftwood out at sea.

Some sponges are ingeniously adapted to live in special environments. The larval stage of the boring sponge bores tiny holes in the shells of other sea animals and creeps inside them, then grows large enough to deter predators. Along sheltered beaches where the wave action is gentle, a green or orange sponge the size of a fist may grow on a tiny hermit crab

A yellow finger sponge. This sponge grows abundantly along the Gulf coast of Florida.

Fire sponge *(Tedania ignis)*. Yellow boring sponges *(Siphonodictyon coralliphagum)* are growing on the fire sponge's surface.

Lavender tube sponge *(Spinosella vaginalis)*. This sponge can grow to some three feet in height. The fringe on the tips of the sponge is a coating of colonial anemones or sponge zoanthids *(Parazoanthus parasiticus)*.

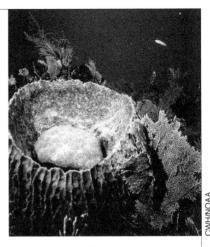

Vase sponge *(Ircinia campana)*. A golfball coral *(Favia fragum)* is growing in the bowl of the sponge.

FIGURE 7-1

Sponges Native to Florida Waters

shell and then gradually dissolve the shell away. Finally, the crab is left shell-less, forced to drag the sponge around wherever it goes. Eventually, the sponge becomes too heavy to carry and the crab either dies or moves out, but for a time, the sponge achieves greater mobility and access to more food than it could achieve on its own. (Perhaps this is what it means to sponge off someone?)

Sponge communities occur below the low-tide line in both estuarine and marine waters of the Gulf from about 6 to 150 feet down. They are especially prolific on the west-coast continental shelf, where they are mounted by the thousands on the seafloor, on shell piles, and on limestone outcrops. Together with corals, bryozoans, and others, they form structures that support many other attached and mobile species. Some sponges specialize in boring into rocks and create hollows for themselves beneath limestone ledges. Later, fish and invertebrates use these caverns as habitats. Today, due to overharvesting, only a few sponges remain in some areas, but they have some potential for recovery.

A close look at a single sponge can give a sense of the complex, interacting community it can contain. This sponge (let us say) is three feet across and weighs thirty pounds when full of water. Although at first glance it appears to be simply an inert lump on the seafloor, it is actually host to a prodigious number of residents. It is perforated by a maze of hollows

and tunnels, and an overwhelming number of other animals swarm all over it, in it, and under it, using its living tissues as holdfasts, homes, and even food. A sea whip is growing up through its middle. Plumes of hydroids and bushy bryozoans are attached to its outer surfaces. Algae, seagrasses, and corals are attached near the base. Several spiral worm shells and a marine snail have burrowed into its tissues, and several thousand snapping shrimp are hiding in all available spaces. A tiny green tunicate has spread colorful branches all over it, and masses of clear tunicates of several kinds have settled beneath it. Small anemones of two different species grow in the canals. A small, flattened crab with greatly modified claws scurries in and out of the crevices within the sponge and also travels from sponge to sponge. And there are still other residents: brittlestars, clams, and even fishes like gobies and blennies. In short, a single sponge can support a major marine community. Quiet as it looks, it is as busy as a city.

All of the residents possess special adaptations to life in their perforated host. Some have forms so modified that they cannot survive without its protection: a sponge-dwelling barnacle; a peculiar pale snapping shrimp that has lost all its pigment and spends its entire life cycle within the sponge's canals; and another tiny shrimp that is transparent. Greenish, warty nudibranchs chew out pits in their host and lay their eggs in frilly white ribbons. The hairy mud crab hunts for bristleworms and scaleworms in the cavities and crannies. Tiny pink mussels are embedded in the chambers, and there may be a host of polychaete worms—up to hundreds of thousands in one sponge.

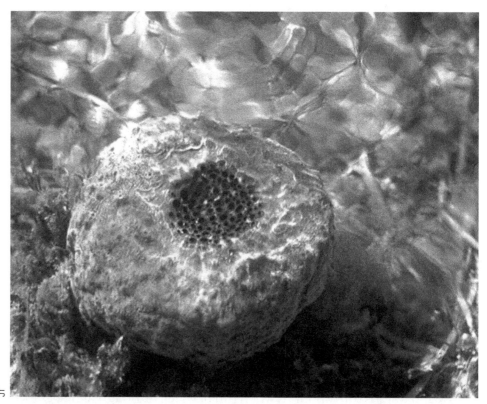

A sponge, two feet across. This big animal serves as an apartment house for dozens of other animals. It was seen in shallow water on the seafloor north of Cedar Key.

For the most part, the sponge meets these creatures' needs exactly as they need it to. Because the sponge constantly feeds itself by pumping a stream of nourishing water through all its chambers, it also delivers oxygen, dissolved nutrients, detritus, plankton, and bacteria to its residents. Each tenant partakes in its own way. The barnacles have legs with hairlike structures that filter food particles from the water. The hairy brittlestar perches near the surface of the sponge and gently waves its furry arms, sweeping up bits of plankton and detritus and wiping them off into its mouth. Occasionally, the star takes a bite of its host to vary its diet.

Waste disposal is managed the same way. As the community members take up their oxygen and nutrients from the passing fluid, they release wastes that the constant stream of water sweeps away. The water also disperses the tenants' eggs and sperm, casting them into currents that sweep them out to sea. There, they can be fertilized, grow and mature in the plankton, and then find other sponges in which to live.

The sponge community changes constantly. Some members come, others go. Larvae from elsewhere enter and grow to maturity in the sponge, never again seeing the outside world. Others first mature outside and then crawl in: red cleaning shrimp, blennies, gobies, and tiny young toadfish among them. Fish come around, snap up whatever creatures venture forth, and move on.

For all these creatures to thrive, the sponge must thrive. It must continue pumping to nourish the colony and dispose of its wastes. But as the community grows in size, it requires a greater and greater influx of nutrients and oxygen. Like a sprawling city, it experiences waste-removal problems. Pockets of urban blight develop, and community members become stressed.

The aging sponge grows increasingly sensitive to changes in its environment. If temperature, salinity, or acidity changes too abruptly, its pumping action slows beyond the point of recovery. Food builds up, decays, and produces toxic wastes. The sponge begins to turn into a mushy, rotten mess. Then its residents—worms, crabs, mussels, tiny anemones, snapping shrimp, and all—perish with their host. Or when the sponge is ripped from the bottom by a storm and hurled up on the beach by the frothing waves, then all this life comes to an end. But elsewhere, new sponges are just beginning to grow.

Bryozoans. Many other sets of marine animals are unlike animals to the human eye. Bryozoans (see Figure 7-2) often resemble bushes or mosses (the prefix bryo means "moss"). Corals are often shaped like shrubs. That these and many other filter feeders look like plants is no coincidence, for they must solve the same mechanical problems that plants must solve. Plants must arrange their small light-gathering units (leaves) into patterns that accommodate as many units as possible without letting any one unit block access of the others to the resource, sunlight. Filter-feeding colonial animals must arrange their small food-gathering units (polyps and others) into patterns that permit access for all to the resource, plankton and detritus borne along in the water current. The optimal solution to this challenge, the tree or bush shape, has evolved independently in both situations.

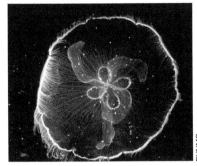

Native to Florida waters: Moon jellyfish *(Aurelia aurita)*. This free-swimming cnidarian is famous for its painful sting. Common along Florida beaches, it can grow to more than a foot across.

Bryozoans (bry-oh-ZOH-uns) are marine animals of two different phyla that form colonies shaped like trees, bushes, sheets, or coils of lace.

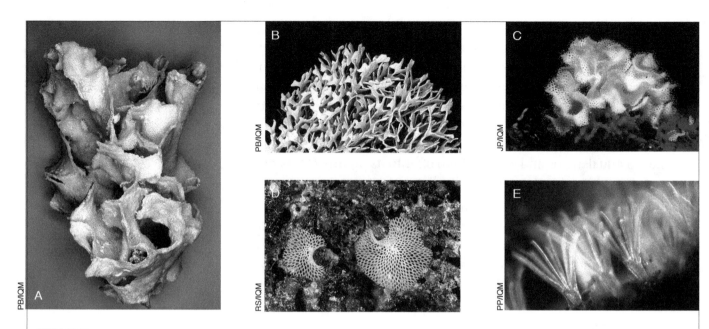

FIGURE 7-2

Ocean Animals: Bryozoans

A and B are the "skeletons" the animal colonies made before they died, showing how each tiny animal was attached to the others, forming a structure that allowed for access of every animal to the sea water. (A = *Hippomenella vellicata*; B = an *Adeonellopsis species*; C = a *Lodictyum species*).

D is a live colony of lace bryozoans (a *Triphyllozoon* species). E is a colony of bryozoans in which each tiny animal is extending its tentacle-like organs to obtain oxygen and filter food from the water.

CORALS AND THEIR KIN

Cnidarians are the animal phylum to which corals belong. Not a single member of that phylum occurs on land. Cnidarians are utterly strange to most people. They look more like plants than like "real" animals, because they are radially symmetrical, like many sponges. They have no legs, no eyes, no features that are recognizable as traits characteristic of land animals. They include jellyfish, hydroids, corals, and sea anemones among their numbers, and people may dismiss them as insignificant and primitive; in fact, the word jellyfish is almost synonymous with primitive. Yet the approximately 9,000 species within the cnidarian phylum represent 9,000 different ways to make a living using the simple and elegant radial body design of the group.

Cnidarians have neurons, basically the same as the brain cells in so-called "higher" animals. They also have muscle cells, which enable them to pulsate and move through the water. In addition, they possess deadly stinging cells, used for warfare against their own and other species. They are one of the few groups that can still hold the human superpredator at bay. When jellyfish move in on swimming beaches, people flee. All cnidarians have these stinging cells: microscopic harpoons, with the barb and line coiled up in a pouch. The slightest touch triggers the harpoon, sending it flying into the flesh of its prey. People can handle safely only those whose barbs fail to penetrate our skins.

Cnidarians do all this with a body composed of only two layers of living cells with a gelatinous layer between. They come in two basic models. One, the swimming jellyfish or medusa, has a mouth surrounded by stinging tentacles that hang down as the creature pulses its way through the water. The other, the sea anemone or polyp, sits attached to the bottom with the mouth and tentacles facing upward. Many species have life cycles that alternate between free-swimming jellyfish stages and attached polyps that look more like bushy plants than animals. In other species, thousands of tiny polyps interconnect to form colonies; it is these that build spectacular reefs in tropical waters. Each coral polyp grows within a tiny limestone cup, which is attached to the cups already there.

Three types of cnidarians dominate reefs: anemones, soft corals, and stony corals. The stony corals are the ones that build reefs; the soft corals are the ones that sway gracefully in the water. Lists 7-2 and 7-3 identify some of each.

Clear water is vital to reef building because reef-building corals have symbiotic algae housed inside their cells, which depend upon sunlight to conduct photosynthesis. The algae use the carbon dioxide and other wastes given off by the corals. The corals use the oxygen freed by the algae and derive 90 percent of their energy from sugars that the algae produce. The algae also make calcium carbonate and help with sugar and protein metabolism. This back-and-forth trading recycles virtually all the resources involved and enables the duo to thrive in nutrient-poor water. In fact, nutrient-poor water is ideal for them, because other organisms can not thrive there.

Few other reef-building organisms can grow in such conditions. Oysters, mussels, and reef-building worms need to live in water that is enriched with nutrients and detritus, but coral reefs thrive in the most nutrient-poor waters in the world. There, they have all other conditions going for them: a tropical climate, shallow water, and rocky structures of their own making, on which they can grow. But given an excess of nutrients, nonsymbiotic algae overgrow the corals and prevent new coral larvae from settling on them.

Corals withdraw during the day and feed at night, waving their tentacles, stinging their prey with tiny poison darts, and ingesting them. They defend themselves against suspended sediments, pollutants, even excess food, by secreting mucus, which the waves carry away.

Each coral grows best at a particular depth, determined by light availability and wave energy. Branching corals find optimal conditions at about 15 feet below the surface, brain and star corals at about 50 feet, and plate corals below them down to 100 feet or more. These depth preferences account for the zones seen on reefs.

Sponge communities and coral communities often grow together, with one or the other organism dominant. Corals (with some sponges) occupy many parts of the outer, and especially east-coast, continental shelf. In some areas, ivory tree corals grow in thickets some four to five feet high.

The **cnidarians** (nigh-DARE-ee-uns) are a large phylum of marine animals with a radially arranged body plan.

**LIST 7-2
Stony corals on Florida reefs**

Boulder coral
Brain corals
Branching coral
Elkhorn coral
Lettuce-leaf corals
Rose coral
Staghorn coral
Star coral
Starlet corals
Thick finger coral
Thin finger coral
Tube coral
Yellow porous coral
. . . and others, 63 species and subspecies in all.

Sources: Jaap and Hallock 1990, 593-594, table 17-3; Kaplan 1982.

**LIST 7-3
Soft corals and others on Florida reefs**

Bushy soft corals
Deadman's fingers
Encrusting soft coral
Knobby candelabra corals
Sea blades
Sea fan
Sea plume
Sea rods
Spiny candelabra
. . . and others, totalling 42 species and subspecies in all.

Sources: Jaap and Hallock 1990, 592, table 17-1; Kaplan 1982.

They can grow in areas as shallow as ten feet, but many stand on deeper limestone structures at the very edge of the continental shelf where they form solitary ridges and mounds in some places and extensive thickets in others. The latter, known as Oculina banks, cover many acres of the seafloor. The tiny, colonial animals that comprise the deepest corals grow slowly in their dark waters, only about a tenth of an inch a year. They depend on down-drifting phytoplankton to bring them energy from the surface.

Even in the depths at which they grow, the Oculina banks serve as hiding, feeding, breeding, and nursery grounds for crabs, mollusks, worms, anemones, small fish, shellfish, and large fish. A single coral colony may support hundreds of animals. Of decapods alone (crustaceans with ten appendages), researchers have identified 50 species living on these corals. Most of the community animals eat zooplankton and organic detritus. Some take nourishment from streams of mucus, which the corals constantly secrete to clear their crannies and crevices of suspended sediments and excess food particles.[1]

TROPICAL CORAL REEFS

Florida's famous tropical coral reefs are built of hundreds of species of animals. They vary from low, flat domes to long ridges. Multicolored, swaying sea fans and sea whips, rippling anemones, and darting schools of fish animate these structures. They are best developed outside, and parallel to, the Keys from eight to fifteen miles offshore, where the conditions they require are well met. The water is not only clear and low in nutrients but also warm, because the Keys provide a barrier against the relatively colder water of Florida Bay (Figure 7-3).

These shallow-water, tropical coral reefs are by far the most complex and extensive reef communities around Florida. More than 100 bank reefs stand outside of, and parallel to, the Keys and extend southwestward, to the Tortugas. Scattered among them are patch reefs, low, hollow domes of coral standing on the bottom.

Each bank reef is 300 feet long or more, with its top about three feet below the surface, and its seaward side about thirty feet down. Each is filled with old coral skeletons and rubble, the reef's own sediment, within which organisms can grow. Each has channels across it between the taller corals. These channels permit sediments carried by the current from inside the Keys to wash through the reefs without damaging them while cleansing them of metabolic wastes and delivering fresh oxygen and plankton. Figure 7-4 shows the structure of a bank reef and the corals that predominate at each level.

Scattered in the rubble around the bank reefs are smaller patch reefs surrounded by seagrasses. As they grow, patch reefs become roughly dome-shaped and about six feet high. Their stony corals close in, forming a canopy, the top flattens out due to wave action, and soft corals colonize the outside and undulate in the waves. Star corals and others grow on the margins.[2] Figure 7-5 depicts a typical patch reef.

CWH/NOAA

Staghorn coral *(Acropora cervicornis)*. Hundreds of animals are shown in this photograph. Each looks like a tiny anemone, seated in its own limestone cup, which is attached to the cups made by others.

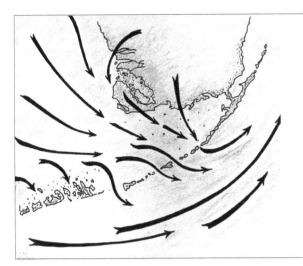

FIGURE 7-3

Currents across the Keys

The bank reefs lie parallel to the coast opposite Key Largo and from Big Pine Key to Key West. Because the Keys protect the reefs from the relatively colder water flowing out of the Everglades and Florida Bay, the reefs are best developed outside the longest Keys. Seaward of gaps between the Keys, there are fewer reefs.

Patch reefs are hollow inside, so they are a good place for fish and other animals to hide in. Around each dome, a zone of bare sand in the surrounding seagrass gives evidence that herbivores such as sea urchins and parrotfish often venture out to feed. The space inside the dome is at such a premium that it is time-shared. One set of fish and other animals lives in it by day and eases out at night to feed. The other set stays in by night and forages during the day.[3]

The diverse assemblages of corals on tropical reefs make stunning multicolored displays that resemble lush undersea gardens. Ocean swells surge back and forth across them and their leafy fronds and plumes sway to and fro.

Like natural old-growth forest communities and seagrass beds, Florida's coral reefs provide both shelter and food for hundreds of species of plants and animals. Shelter is ample because the reefs have a canopy (of branching corals), an understory (of other corals), and a substory (sediment). Food is abundant because the corals with their algae are, like trees on land or phytoplankton in water, primary producers of energy and proteins. Fish and other animals also bring energy and body tissues into the community, having taken their nourishment from environments outside the reef. List 7-4 gives a sense of the diversity on the reefs.

Among plants on a reef, single-celled algae live not only in the stony corals but in sponges and other animals that are growing on sediments of dead reef material. Multicellular algae form colorful crusts that help to cement the reef together, or dwell within the sand in reef crevices, or coat inactive older coral skeletons. Large algae form tiny plates within their own tissues and then, on dying, add calcium fragments to the reef rubble. Seagrasses grow shoreward of, and marginally into, the reef base.

Among animals, sponges of all shapes and colors are numerous, each a community in itself as described earlier. Diverse starfish, shrimp, anemones, mollusks, plumed worms and bristle worms, crabs, spiny lobsters, and too many others to name inhabit the reefs.

Tropical fishes are the butterflies of the reef. They are as showy as river fish are drab: they bear brilliant, almost fluorescent stripes and spots, and

Native to the Florida Keys reefs: Soft corals.

Native to the Florida Keys reefs: A knobby purple sea rod.

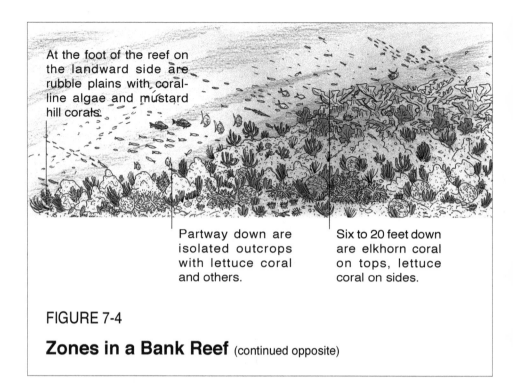

At the foot of the reef on the landward side are rubble plains with coral-line algae and mustard hill corals.

Partway down are isolated outcrops with lettuce coral and others.

Six to 20 feet down are elkhorn coral on tops, lettuce coral on sides.

FIGURE 7-4

Zones in a Bank Reef (continued opposite)

they swim in flashing schools among the corals. More than 150 species of tropical fish inhabit the Florida reef tract, twice as many as dazzle the eye, because, especially in the patch reefs, as many or more fish are concealed within hiding spaces in the limestone as those one can see. Figure 7-6 depicts a few of the tropical fishes on the reefs.

INTERACTIONS ON THE REEFS

With so many species of so many different groups, and with millions of years of evolution behind them, reef interactions are numerous and intense. Many organisms eat the coral mucus and in the process they clear the corals of debris. One crab induces the corals to mold themselves around its body, creating a custom-designed cave for protection. Then it uses its specialized legs to clear mucus, which it eats, from the coral. But not all relationships are beneficial to both participants; in many cases one exploits the other. For instance, a species of snail lives in pairs on sea whips, eating the polyps and leaving only enough so that the sea whips do not die. Some barnacles, too, digest corals to create spaces for themselves. Wormlike copepods live inside coral polyps. A damselfish destroys coral tissue, creating bare limestone skeletons on which algae can grow, then fiercely defends its territory like a land-starved farmer. The long-spined sea urchin grazes on reef algae, leaving cleaned limestone surfaces on which coral larvae can settle. A marine worm feeds on many coral species, as do many gastropod mollusks and fish: parrotfish, spadefish, damselfish, and butterflyfish. Bryozoans overgrow them, snails and worms prey on them. And after small animals have tunneled into the reef limestone, other animals may come to live in the spaces they have made. Crustaceans, mollusks, worms, crabs, and lobsters crawl through these spaces. Fish swim through them.[4]

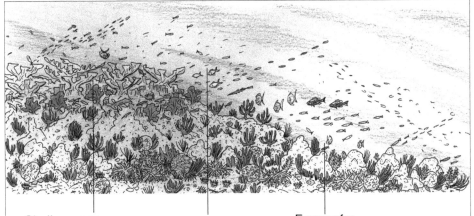

Shallow zone:
golden sea mat, bladed fire coral, green sea mat, and false coral. hill corals.

20+ feet down:
star coral in big mounds.

Forereefs:
Some spurs have additional growth on forereefs with corals, octocorals, and sponges.

The clearer the water, the deeper corals can live. Under optimal conditions, reefs can grow down to about 100 feet and corals with zooxanthellae can survive down to about 150 feet.

Source: Adapted from Voss 1988, 29, fig 6.

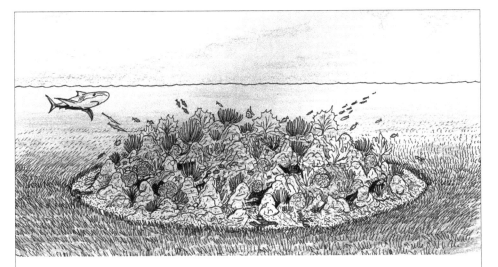

FIGURE 7-5

A Patch Reef

Patch reefs are hollow, so they offer sanctuary to resident animals. The populations within them differ from day to night and from season to season.

Source: Adapted from Voss 1988, 29, fig 7.

Native to Florida waters: Ivory tree coral *(Oculina varicosa).* A = the tree coral on site, deep on the continental shelf. B = a coral fragment. C = a closeup of the coral skeleton, showing the limestone cups in which the polyps grow.

Sponges have all kinds of relationships with corals. Some sponges bore into corals and weaken them, some bind living corals to the reef structure, and some protect the reef from other boring organisms. And mutual benefits are traded between corals and fish. The coral canopy offers shelter in which small fish can evade predator fishes that cruise around the reefs. Filter feeders and detritus-eating fish help to keep the water clear, enabling a maximum of sunlight to reach the coralline algae. The fishes' excreta

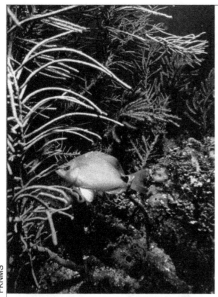

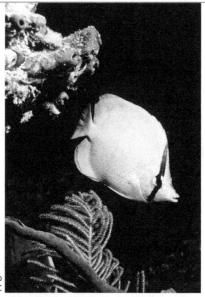

Spanish hogfish *(Bodianus rufus)*

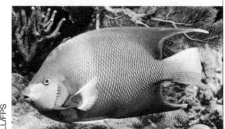

Hamlet fish (a *Hypoplectrus* species)

Spotfin butterflyfish *(Chaetodon ocellatus)*

Queen angelfish *(Holacanthus ciliaris)*

FIGURE 7-6

Tropical Fish in the Florida Keys Reefs

Native to the Florida Keys reefs: Pillar coral *(Dendrogyra cylindrus).*

drop to the rubble layer and feed polychaetes, bryozoans, and other detritus eaters there.

The corals themselves are predators. Some corals even attack and ingest each other. Fire corals colonize living soft coral branches. Stony corals extrude filaments that digest neighboring corals and then grow over them. Some corals defend themselves with specialized sweeper tentacles. Others employ chemical defenses and offensive weapons.[5]

The corals are susceptible to many disease-causing organisms. If winds and waves are calm and the weather is hot, bacteria may grow in the mucus and stress the corals. Black band disease is caused by several such bacterial species. Many more interactions among coral reef organisms remain to be discovered and understood.

THE REEFS IN CONTEXT

Like all Florida ecosystems, south Florida's tropical coral reefs are knit into the landscape and dependent on its natural functioning. Above all, they require protection from water that is rich in nutrients, because nutrients enable coral competitors to grow. The lay of the land naturally affords that protection, beginning at the Kissimmee River, where the rain that falls on the Florida peninsula begins its long journey southward. All the way south, the land's natural ecosystems help to keep the moving water clean and pure: the Everglades marsh, coastal mangroves, and seagrass beds all intercept and trap pollution. Ecosystem manager Maureen Eldredge did not exaggerate when she said, "All the ecosystems of south Florida are

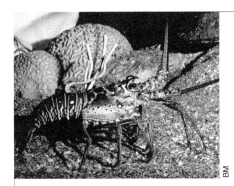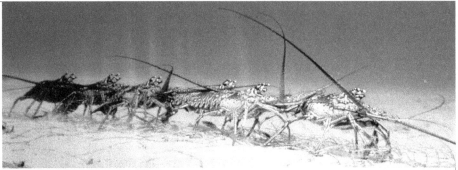

FIGURE 7-7

Caribbean Spiny Lobster *(Panulirus argus)*

The spiny lobster needs many intact and connected marine ecosystems to complete its life cycle. It lives on coral reefs and spawns off the reefs in deeper water. Its larvae develop in the plankton for many months, then settle among seagrasses. They grow up in live-bottom or mangrove communities, then move to patch reefs, and later as adults move to the margins of bank reefs. Adults conceal themselves in reef dens by day and move out to seagrass beds and sediment bottoms by night to feed.

The single-file formation protects every lobster (except the last one on line) from attack at the tail end, which is vulnerable. The parade takes place every fall, when newly mature spiny lobsters proceed from their homes among the corals to deeper water to mate. Then in late winter they line up and return home. They navigate using a sophisticated magnetic compass sense oriented to the earth's magnetic field.

Sources: Lyons and coauthors 1981; Jaap and Hallock 1990; Bennington 2003.

linked, from the Kissimmee River to the coral reefs."[6] They are linked in other ways, too. Mangrove swamps serve as nurseries for young fish and other animals that later will live around the reefs. Swamps and seagrass beds provide food for reef fishes and lobsters that emerge from the reefs to forage. Seagrasses offer protective cover for fish and other animals that move back and forth between the mangroves and the reefs. Some organisms use many adjacent ecosystems, including the reefs, as their habitat; the spiny lobster is an example (Figure 7-7).

As if in return for all these favors, the coral reefs protect the Keys, the surrounding seagrass beds, and the coastal mangroves from storm-caused erosion. The rubble from natural breakdown of the reefs washes up on beaches and helps replace other sand that has been washed away. Finally, all these systems protect the interior.

Given favorable environmental conditions, reef health and diversity can be outstanding. The reefs then serve not only as a sanctuary for fish and other animals, but as a self-supporting community in a challenging environment.

Beyond the estuaries, the seagrass beds, and the coral reefs, beyond the edge of the continental shelf, lies the open sea, deep and mysterious. This realm, too, is part of Florida's province, as the next chapter reveals.

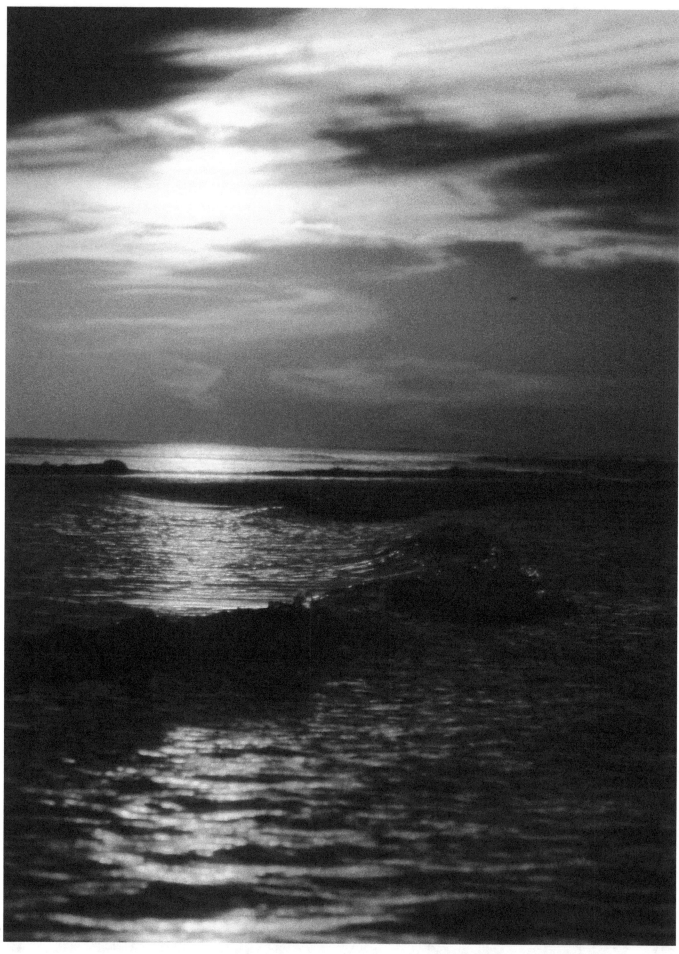

CHAPTER EIGHT

THE GULF AND THE OCEAN

Florida's connections with the Gulf of Mexico and the Atlantic Ocean extend beyond the state's borders, indeed, beyond the edge of the continental shelf. Many migratory species, including whales, sharks, marine turtles, and eels, spend parts of their lives in Florida or in our near-shore waters, and parts in the far ocean, thousands of miles away. But in truth, even without these connections, it would seem right to end this series of ecosystems with the oceans. If the Gulf of Mexico and the Atlantic Ocean are not within Florida's province, Florida is within theirs, and the wonders they contain draw us on to explore them before concluding this book on Florida ecosystems.

The oceans cover nearly three-quarters of the earth's surface and hold more than 100 times more space for living things than do the continents (Figure 8-1). They appear on the surface to be one huge body of water, but they have as many different habitats as the land. They have warm sunny surface waters, cold dark deep waters, and currents swirling past each other in different directions both horizontally and vertically. On the bottom, they have deep briny lakes, high mountain ridges, hot thermal vents, tall rock chimneys, and level plateaus. In deep ocean basins, cold water from both poles, which is denser than warm water, flows toward the equator along the abyssal seafloors. On the surface, major currents carry warm water from the equator towards the poles. From these, other currents spin off and move in huge, slow circles.

The oceans are up to seven miles deep, and they are inhabited from top to bottom by all manner of living things: plankton, algae, other plants, and every kind of animal—some swimming or drifting or floating, others attached to, or roaming on, the bottom. The diversity of life in the oceans may be even greater than on land—no one yet knows. Certainly the diversity of animal phyla is immense. Scientists estimate that the deep seas teem with as many as ten million species, most of them on the bottom and still undiscovered, but even explorers who never dip below the surface find great mobs of animals swimming and drifting in the waters off Florida.[1]

Of marine plant and animal populations, some resist the ocean's roaming currents and stay permanently within certain boundaries. Many species

Native to Florida waters: Bottlenose dolphin *(Tursiops truncatus)*. Known for their playfulness, these animals frolic and hunt fish in near shore waters along both coasts of Florida.

Diversity of groups of species (such as phyla, genera, or families) is called **taxonomic diversity** and indicates high ecological quality of an ecosystem. Taxonomic diversity among plants is greatest on land, but taxonomic diversity among animals is much greater in the ocean, which is inhabited by many phyla of animals not found on land.

OPPOSITE: Sunset over the Gulf of Mexico, Grayton Beach, Walton County.

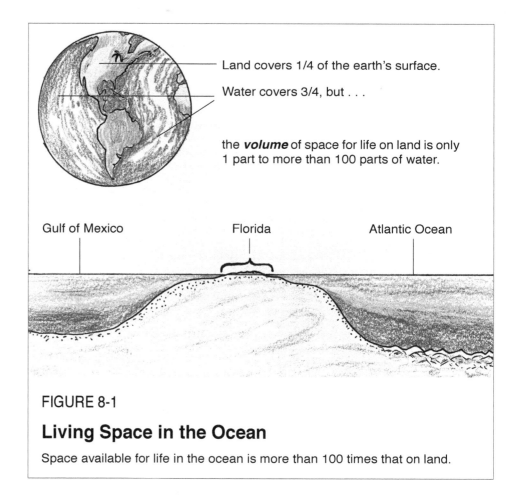

Land covers 1/4 of the earth's surface.

Water covers 3/4, but . . .

the **volume** of space for life on land is only 1 part to more than 100 parts of water.

Gulf of Mexico Florida Atlantic Ocean

FIGURE 8-1

Living Space in the Ocean

Space available for life in the ocean is more than 100 times that on land.

reside all their lives over the continental shelf and never stray beyond its edge. Many others stay in the deep ocean and never visit the continental shelf. There is even a well-defined, narrow zone directly over the continental slope, where certain populations, not found elsewhere, are concentrated. Presumably, this zone is different from other ocean habitats because cold water, rich in mineral nutrients, wells up continuously along the slope boundary.[2]

ALL PHOTOS: OAR/NURP

Lanternfish (a *Diaphus* species). Some 200 species of these fish, which can make their own light, swim in the ocean's depths.

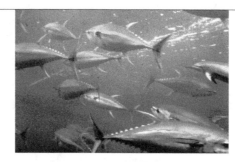

Yellowfin tuna *(Thunnus albacares)*. Schools of yellowfin pursue their prey throughout the Gulf and Gulf Stream and in turn are preyed upon by human hunters.

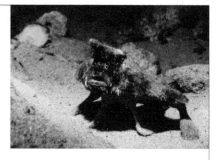

Roughback batfish *(Ogcocephalus parvus)*. This flattened fish "walks" on the bottom with its modified fins and attracts its prey by displaying a bright red color around its mouth.

FIGURE 8-2

Ocean Animals around Florida continued opposite

Some populations ride ocean currents, shifting locations daily, moving from inshore to offshore and back or from surface to deep water and back. Other populations shift with the seasons, just as do migratory birds and butterflies. (Chapter 5 described some of the animals that move in and out of Florida's estuaries daily, or seasonally, or during different parts of their life cycles.) Figure 8-2 provides a few examples of animals that occupy different spaces in the oceans.

Because the mosaic of marine environments around Florida is so complex and knowledge about them is so lacking, this chapter samples just a few parts of the ocean with which Florida has a special relationship. Of particular interest are the Gulf of Mexico, the Gulf Stream that runs north along the Atlantic Coast, and the Sargasso Sea.

THE GULF OF MEXICO

North of the Caribbean Sea, the Gulf of Mexico lies within the arc embraced by Florida on the east and Mexico's Yucatán peninsula on the south. Cuba lies across the opening to the Atlantic Ocean and the Caribbean. The Gulf is about 1,000 miles across from east to west, and somewhat oval shaped, with an area of about 600,000 square miles. It holds a huge mass of water, 800,000 cubic miles in volume.[3] Its floor displays the complex terrain shown in Figure 8-3.

Except for game fish and conspicuous animals, living things in the Gulf of Mexico, as in most of the world's seas, are mostly unstudied and even undiscovered, but the number of invertebrate species in the Gulf probably exceeds 10,000.[4] Estimates are shown in List 8-1.

Gulf Swimmers. The Gulf's pelagic fish are much better characterized than the invertebrates. They include some of the world's largest fish species: billfish (marlin, swordfish, sailfish), flying fish, offshore game fish (cobia, dolphin, king mackerel, wahoo), jacks, and mackerels (including Atlantic bonito and tuna), as well as many inconspicuous fish that swim

LIST 8-1
Invertebrates in the Gulf of Mexico (numbers of species)

Mollusks	450-500
Crustaceans	1,500
Polychaetes	600
Oligochaetes	200+
Echinoderms	400
Trematodes	200
Other worms	200
Cnidarians	600
Sponges	100
Other	5-10,000

Note: These numbers include zooplankton species. Among them are flagellates, ciliates, amoebas (forams and radiolarians), sporozoans, opalinates, and many more.

Source: Gore 1992, 139-140.

The **pelagic** ocean is the deep, open ocean. A **pelagic fish** is one that swims in the open ocean.

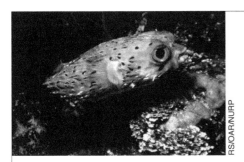

Balloonfish *(Diodon holocanthus)*. This fish inflates to swim and deflates to rest. It is shown here, resting on the floor of the Atlantic Ocean off the Florida Keys.

Golden crab *(Chaceon fenneri)*. Golden crabs are limited to continental slopes and are the largest crustaceans found on the slope off Florida.

Lobed ctenophore *(Bolinopsis infundibulum)*. These animals, which roam all over the ocean, are translucent and give off a bioluminescent glow.

**LIST 8-2
Marine mammals
in the Gulf of Mexico**

Whales
Blainville's beaked whale
Blue whale
Bryde's whale
Cuvier's beaked whale
Dwarf sperm whale
False killer whale
Fin whale
Gervais' beaked whale
Humpback whale
Killer whale
Melon-headed whale
Minke whale
Northern right whale
Pygmy killer whale
Pygmy sperm whale
Sei whale
Short-finned pilot whale
Sperm whale
True's beaked whale

Dolphins
Atlantic spotted dolphin
Bottlenose dolphin
Clymene dolphin
Common dolphin
Fraser's dolphin
Pantropical spotted dolphin
Risso's dolphin
Rough-toothed dolphin
Spinner dolphin
Striped dolphin

Manatees
West Indian manatee

Sources: Adapted from
Gore 1992, 163-164, table
8; and the Texas Marine
Mammal Stranding
Network, Corpus Christi.

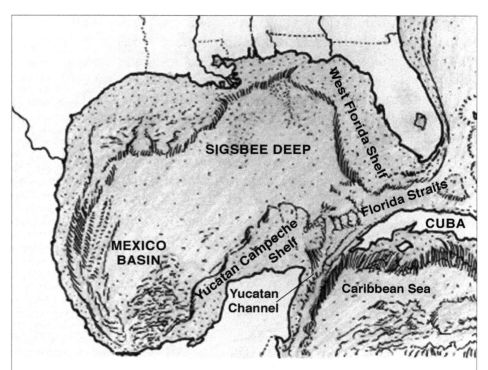

FIGURE 8-3

The Gulf Floor

The continental shelf breaks abruptly downward at the continental slope, which plunges from its edge, some 600 or more feet down, to its base, 10,200 feet down. The continental slope varies in steepness and is notched at intervals by valleys.

At the base of the slope lies a plain that holds two deep areas: the Mexico Basin and the Sigsbee Deep. The Mexico Basin holds scattered flat-topped mesas and ridges. The Sigsbee Deep supports hummocks with deep-sea corals and coral-based communities.

Elsewhere, off northwest Florida, cold water spews from major springs and seeps. Cold fresh water pours forth from the deep seafloor and cold salt water seeps from the base of the slope.

Source: Gore 1992, end pages.

in the water column and inhabit floating lines of seaweed. Figure 8-4 displays three of these spectacular fish.

Many marine mammals are present in the Gulf too, more than most people realize. Dolphins and manatees are well-known and well-loved visitors along the shores and in the mouths of rivers. However, whales around Florida are a relatively recent surprise, even though they were here long before we humans ever came. Surveys beginning in the early 1990s indicate that sperm whales, once harpooned to the edge of extinction, are now, perhaps, on their way back along both coasts of Florida. Killer whales also occur off both coasts; they roam in pods over the deep waters. List 8-2 names these and other marine mammals known to swim in the Gulf, for a surprising total of 30 native marine mammals altogether.

White marlin *(Tetrapterus albidus)*. This powerful fish swims throughout the Atlantic and Caribbean oceans feeding on squid and medium-sized fishes. It commonly grows to a length of 8 feet.

Swordfish *(Xiphias gladius)*. Before they were overfished, swordfish averaged 200 pounds; now they typically weigh less than 50. They range offshore worldwide as deep as 400-500 feet, feeding on squid, octopus, and many kinds of fish.

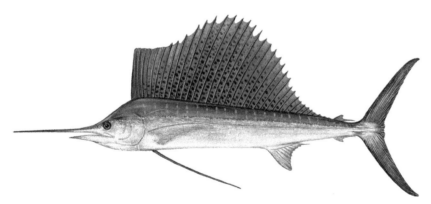

Sailfish *(Istiophorus platypterus)*. This fish swims off Panhandle Florida in water 100 fathoms deep, and off south Florida near the Gulf Stream. It commonly grows to 7 feet in length and can swim at 50 knots. It feeds on the surface or at middepths on smaller fishes and squid.

Base of lure Tip of lure

Native to the seafloor off Florida: Humpback anglerfish *(Melanocetus johnsoni)*. This deep-sea fish attracts its prey with a lure that is mounted on a stalk between its eyes. Bacteria living within the bulb at the tip of the lure are bioluminescent, so the lure glows in the dark ocean.

The bumps below the eyes are the male fish's enlarged chemical-sensing organs. He uses his chemical sense to find the female, who releases hormones into the water to aid the search.

FIGURE 8-4

Big Fish in the Pelagic Ocean

Source: Anon. c.1994 (Fishing Lines); drawings by Diane Peebles.

Animals in a hydrocarbon seep on the deep floor of the Gulf of Mexico. Shown are deep-sea mussels, worms, and a spider crab.

Animals on the Gulf Floor. Explorers who plumb the depths of the Gulf of Mexico make strange and wonderful discoveries. In 1996, two researchers returned from a trip to the seafloor with descriptions of a salt dome-associated ecosystem never before known. Salt domes are thought to have begun forming some 250 million years ago as the land that is now the Gulf floor first stretched apart, thinned out, and sank down, so that sea water began to run into it. The Gulf Basin was shallow at first, and for about 100 million years, salty water ran in, dried up, and accumulated again, creating massive layers of salt. These salt layers compacted and sediment running off the continent covered them with a heavy overburden (which geologists call caprock). As the basin floor sank down further and the Gulf grew deeper, water dissolved the salt out from beneath some of the domes and oil seeped in. And in some domes, the salt became liquefied and pushed up through faults in the caprock, forming mushroom-shaped columns and domes. There are 500 salt domes in the Gulf, some up to two miles across.[5]

The explorers found an extensive ecosystem surrounding the dome they visited. It is many miles across and probably at least centuries, if not millennia, old. Mussels, living almost entirely without oxygen, cluster wherever icy methane gas and oil are seeping out. Encircling the mussel beds, some fifteen miles out from the center, is a ring of tube worms, apparently a new species of polychaete worm, which the explorers describe as "flat, pinkish, centipedelike creatures . . . one to two inches long."[6]

Around the dome are "pockmarks" in the seafloor holding extremely salty lakes of brine where several species of shelled invertebrates, including clams and snails, live in enormous colonies. They appear to depend on bacteria to meet their energy and nutrient needs. The bacteria transform sulfur compounds available in the brine into hydrogen sulfide, and this serves as an energy source for the tube worms. The worms exist in colonies hundreds of square miles in area, at depths below 1,200 feet. The bacteria, mussels, and tube worms clearly form part of a food web: other animals feed on them. Lobsters prey on the mussels, snails eat the bacteria, and eels eat everything they can catch. The rest of the food web is unknown but may be extensive and important.[7]

Amazingly, fish also live more than a mile down on the Gulf floor. Among them are anglerfishes, brotulids, and many other grotesque, rarely seen species. Eels from the land's freshwater systems pass across this terrain en route to a rendezvous site in the Atlantic Ocean. Their story is told later in this chapter.

ATLANTIC CURRENTS: FISH, SHARKS, AND WHALES

One of the currents of interest in the Atlantic is the Gulf Stream, which flows out of the Gulf of Mexico around the tip of Florida and up the eastern seaboard, turning east when it arrives at Cape Cod and crossing the Atlantic to bathe the British Isles and environs with its warm water. Many ocean animals ride north along the Atlantic seacoast on that current. Then, to

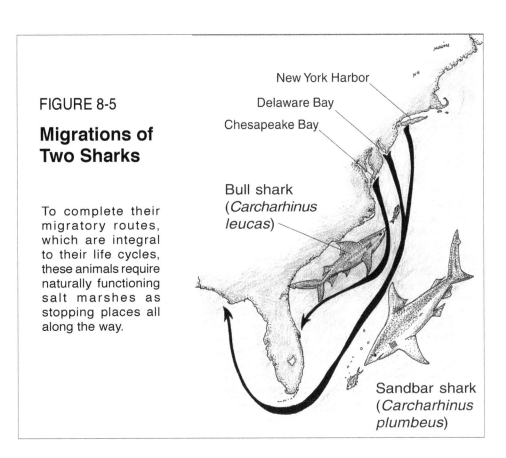

FIGURE 8-5

Migrations of Two Sharks

To complete their migratory routes, which are integral to their life cycles, these animals require naturally functioning salt marshes as stopping places all along the way.

New York Harbor
Delaware Bay
Chesapeake Bay

Bull shark (*Carcharhinus leucas*)

Sandbar shark (*Carcharhinus plumbeus*)

return south again, they instinctively swim against that same current. Fish, whales, sharks, and others make great migrations along the U.S. east coast, visiting Florida's estuaries and salt marshes along the way. These journeys resemble the long migratory flights of birds and butterflies, but because they take place out of our view, they are less well known.

Tuna, swordfish, and marlin migrate thousands of miles in the course of their lives. They travel with the Gulf Stream to cool northern waters to feed in summer, taking advantage of huge food stocks that develop there each year during the short but intense growing season. (Cold water contains more gases, notably oxygen and carbon dioxide, than does warm water. The oxygen allows faster respiration and the carbon dioxide allows more photosynthesis, hence the great productivity despite colder temperatures.) Then they return to warmer equatorial waters as winter comes.

Bull sharks migrate more than a thousand miles to find the resources they need to complete their life cycles. In winter, they move up the St. Lucie River towards Lake Okeechobee in Florida, and in summer, they travel as far north as Chesapeake Bay (see Figure 8-5). Among their prey are young sandbar sharks.

To escape their foes, sandbar sharks travel farther, both north and south. The young are born in estuarine tidal marshes around Delaware Bay and New York harbor; then as they grow, they migrate to warm, low-salinity estuaries of the Gulf of Mexico. When sexually mature, they travel several thousand miles back to their northern tidal-marsh pupping grounds to bear their young.

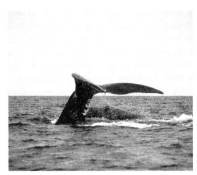

Native to Florida waters: Northern right whale *(Eubalaena glacialis)*. The flukes are raised high to power the huge animal's dive. The whale weighs an average of 60 tons when mature.

Young sandbar sharks grow as slowly as an inch a year, but they may live for more than 50 years. One sandbar male, tagged and released in Delaware Bay in 1965, was recaptured off Destin, Florida, in 1989. It had grown only 24 inches in 24 years.

Whales, too, migrate, and for northern right whales, near-shore waters off the east coast of Florida are a critical habitat. Northern right whales are the most depleted species of large whale in the world, and the only one that is in danger of becoming extinct in the near future. Due to hunting pressures, right whales now number only 600 or fewer individuals, as compared with more than 10,000 for the humpback whale. Only recently have marine biologists learned that these right whales, seen in summer off the coasts of Maine and Nova Scotia, spend their winters off the coast of Florida. It is here that they give birth to their calves, specifically in a narrow strip of water very near the coast, extending from Florida's Sebastian Inlet to the Altamaha River halfway up the Georgia coast. Off Georgia, this strip is 15 miles wide; off Jacksonville, the calving ground is only 5 miles wide. More right-whale sightings occur along the Florida coast than anywhere else in the world's oceans.[8] Other animals traveling to and from Florida swim all the way around the Atlantic Ocean, or to and from the Sargasso Sea.

THE SARGASSO SEA

Imagine that a ship is sailing to Africa from any port on Florida's east coast. First it travels about 500 miles across open water; then it encounters a vast meadow of floating seaweed. It travels nearly 1,500 miles across this meadow before reaching open water again. Finally, after 1,000 miles across open water, the ship reaches Africa's west coast. Figure 8-6 shows that the seaweed meadow occupies a huge oval, 2 million square miles in area, as big as the Caribbean and Mediterranean seas combined. It is named for *Sargassum*, a phylum of eight species of floating plants that circle endlessly in a clockwise loop around the Atlantic Ocean, drawn along on the west by the Gulf Stream, and on the north, east, and south by three other transatlantic streams (the North Atlantic Current, the Canary Current, and the North Equatorial Drift Current). The sargassum weeds may have originated long ago on a continental coast but now are a self-perpetuating community of floating plants that reproduce vegetatively in the ocean.

Several factors combine to make the Sargasso Sea unlike any other body of water in the ocean. It is said to be "the cleanest, purest, and biologically poorest ocean water ever studied." Within the Sargasso Sea, the water is warmer and therefore lighter—less dense—than in the surrounding ocean. This water forms a lens that floats on the salt water: its bottom is 3,000 feet deep and the top is three feet higher than sea level. This warm-water lens is bounded on all sides and below by cold, nutrient-rich water that moves around and under it, but doesn't migrate into it. As a result, the Sargasso Sea's water is nutrient poor—and because evaporation exceeds rainfall over this area of the ocean, it is also more salty than the surrounding water.

Native to Florida waters: Almaco jack *(Seriola rivoliana)*. The jack ranges widely in offshore waters and spawns offshore as well. A relatively small fish for the open ocean, it reaches a weight of about 20 pounds at maturity. Its young spend their early lives in sargassum weeds.

Native to Florida waters: Dolphin *(Coryphaena hippurus)*. This dolphin, not to be confused with the ocean mammal shown earlier, is the delicious fish prized by humans as mahi mahi. It swims in warm ocean currents offshore and feeds on flying fish and squid. It reaches an adult weight of 30 pounds, and can attain a speed of 50 knots. Dolphin juveniles spend their young lives floating among drifting sargassum weeds.

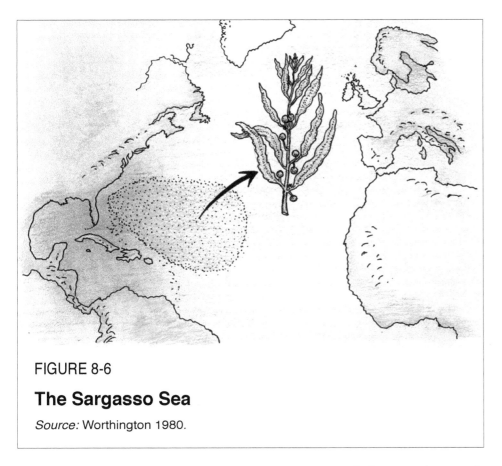

FIGURE 8-6

The Sargasso Sea

Source: Worthington 1980.

This unique environment supports some species of plants and animals that find in it the perfect habitat. Some live there permanently. Others seek it out for parts of their lives. Diatoms mass on the sargassum weeds. Sea turtles and eels from Florida's coastal sands and interior waters spend important parts of their lives there.

LAND TO SEA MIGRATIONS: SEA TURTLES

A heavy female loggerhead turtle, laden with eggs, lumbers out of the ocean and up the beach. She scoops out a nest in the sand, drops her eggs into it, and covers them up, then swims away again. Some 60 days later, 100 little hatchlings emerge and scramble for the open ocean.

When ready, the hatchlings all emerge, practically simultaneously. It may be that they hear each other stirring about when hatching time approaches, and the commotion within each egg arouses nearby babies to get busy, too. They benefit from each other's activity: when the eggs start thrashing about, the sand around them slips down as the turtles dig their way up, and the hatchlings easily escape the nest. Then they all scurry frantically toward the sea in a mob.

Another behavior favors their survival. The hatchlings nearly always emerge at night, rather than by day. Perhaps the heat of the sun keeps them quiet until nightfall. When they finally make their mad dash to the sea, their sudden appearance and hasty run for the water in the dark maximizes the chance that at least some will escape predation.

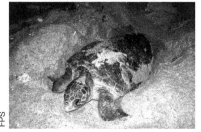

Visitor to Florida's shores: Logger-head turtle *(Caretta caretta)*. This loggerhead was photographed dig-ging her nest and laying her eggs in Bill Baggs Cape Florida State Park, Miami-Dade County.

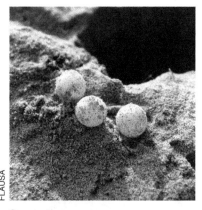

Sea turtle eggs.

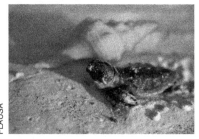

Born on a Florida beach: Baby log-gerhead turtle *(Caretta caretta)*. New hatchlings head straight for the surf and swim out into the open ocean.

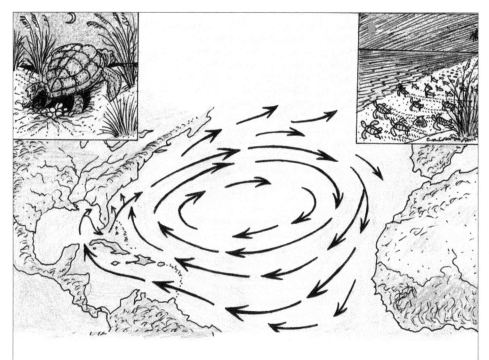

FIGURE 8-7

Loggerhead Turtle's Migratory Routes

Source: Adapted from Lohmann 1992.

Once out at sea, the young turtles pick up ocean currents and swim for several years around the Sargasso Sea as shown in Figure 8-7, feeding and growing to maturity. To rest between feedings, they sleep, floating on the waters with their flippers tucked over their backs.

How the turtles find their way to and from their nesting grounds is a riddle that remains unsolved. "As soon as they hatch," a biologist muses, "sea turtles swim across hundreds of miles of featureless ocean. As adults, they navigate home to nest. How do newly hatched sea turtles find their way?"[9] He has sought to find out by watching and tracking turtle hatch-lings on Florida's east coast with these questions in mind: Do they use the positions of the sun or stars? polarized light? odors? wind direction? the sound of waves breaking on the beach? the earth's magnetic field? Other migratory animals are known to do some or all of these things.

It is known that when newly hatched sea turtles first break through the surface of the sand, they are guided by light from the sky that is reflecting off the surface of the ocean. Under natural conditions, this reflected light is brighter on the water than on land, and the hatchlings hasten toward it in a mob and plunge into the waves. Then the waves guide them: they dive for the undertow and swim for the open ocean. (This is known because, during rare weather events such as hurricanes when the waves flow away from shore, the hatchlings swim the wrong way, into the waves and towards the land.) Lacking the guidance of light, wind, and waves, though, they still can orient using a magnetic sense that enables them to perceive the

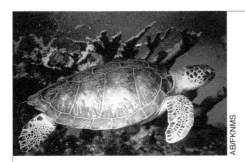

Green turtle *(Chelonia mydas)*. Called green because their body fat is greenish, these turtles were swimming in the Caribbean by the millions when Columbus arrived. Adults weigh up to 300 pounds and are the only sea turtles that live exclusively on plants. They feed on turtlegrass, hence the name. Young turtles swim in coastal waters all along the Americas, and adults nest mostly along the Central American coast.

Atlantic ridley *(Lepidochelys kempii)*. This is the world's rarest sea turtle and weighs at most 100 pounds when mature. It feeds on the shellfish, fish, and jellyfish it finds in seagrasses and estuaries along the Big Bend coast. Along U.S. shores it ranges from Texas to Maine, but it nests almost solely on a 20-mile stretch of beach in the western Gulf of Mexico.

Hawksbill *(Eretmochelys imbricata)*. This turtle has a beautiful brown shell decorated with gold flecks. It is an agile, small animal that lives on coral reefs and can climb over rocks to nest on beaches that other turtles cannot reach. It feeds on sponges and probably nests in Florida Bay.

FIGURE 8-8

Sea Turtles that Nest on Florida's Shores

The loggerhead turtle is a threatened species. The other four turtles are endangered.

Leatherback *(Dermochelys coriacea)*. This is the largest living sea turtle in the world. It may grow to 8 feet long and weigh 1500 pounds. Leatherbacks travel thousands of miles, dive thousands of feet deep, and swim in cold water as far north as Alaska. Their favorite foods are jellyfishes, especially the Portuguese man o' war.

Loggerhead *(Caretta caretta)*. So named because its head may be up to ten inches wide, the loggerhead feeds around coral reefs and rocks. It uses its powerful jaws to crush heavy-shelled clams and crabs, including horseshoe crabs, for its food. It weighs around 300 to 400 pounds and is the most common sea turtle in Florida, with about 50,000 nests recorded annually.

earth's magnetic field. (Under testing conditions, when the magnetic field is reversed, they reverse direction.)

When they are ready to mate, the turtles return to beaches near where they were born, then mate offshore. Again there is a puzzle: How do they find their way back? They may use a chemical sense to orient to the chemistry of river waters that flavor the beaches they were born on. Probably, too, they follow magnetic "stripes" on the ocean floor. However they do it, these ancient creatures are highly sophisticated navigators.

Five species of sea turtles occur in U.S. coastal waters today and all five visit Florida's shores. They are shown and described in Figure 8-8.

FRESHWATER TO SALTWATER MIGRATIONS: EELS

Eels are not snakes, as many people believe; they are fish. Snakes are air-breathing reptiles related to lizards and turtles, and they use lungs to breathe. Eels, like all fish, have gills for obtaining oxygen under water. American eels are freshwater fish; other eels, such as the moray eel, are marine. In direct contrast to the sea turtles just described, American eels spawn at sea and return to coastal and inland habitats to mature. They are among only a few species of catadromous fishes in the Americas.

No one knows how many eels live in Florida's rivers, lakes, and underwater caves. They may outnumber all other fish. Other streams along the coast have some 1,500 eels per acre.[10]

Eels remain segregated by gender throughout their adult lives. The females live in inland ponds, lakes, streams, and caves; the males in estuaries and coastal marshes. Both sexes mature at some ten to thirty years of age, and then undergo changes that enable them to navigate in dark water and to withstand marine salinity. They develop enlarged eyes that enable them to see deep in the ocean and special cells that rid their bodies of excess salts. Their digestive tracts shrink, their swim bladders toughen, and their skulls change shape. Their slime coating thickens. Previously mud-colored, they turn bronzy along their undersides and purple-black on top, camouflaged for ocean life. Now the females, ready for marine life, come down the rivers and join the males in coastal marshes.

Then, for reasons no one can explain, these fish from eastern North America, as well as their cousins (a different species) from Europe and the Mediterranean Sea, swim across the continental shelf, drop off its edge, and head for the open ocean. They congregate in the Sargasso Sea to mate, spawn and die, leaving behind hundreds of millions of tiny eel larvae.

The larvae are neither male nor female, and don't even look like animals. They look like transparent willow leaves, and only their tiny black eyes identify them as living things. For some 15 months, until spring a year after hatching, the larvae hide and feed in the sargassum weeds. Then they swim with ocean currents toward the shore. How they sort themselves out remains a mystery, but the American eels return to America and the European eels to Europe.

When they reach the coast, the young eels continue growing until they are 3 1/2 inches long; now they are called elvers. Finally, some become female and swim up the rivers, while some become male and stay in tidal areas. They become "yellow eels," yellow-green on top, pale beneath. Young ones feed at the mouths of caves and other dusky openings. Older ones develop better night vision and feed only at night.

Archaeologist Michael Wisenbaker marvels at the eels' ability to travel over land: "Eels scale dams, wriggle through aqueducts and navigate subterranean streams to reach their destinations. Sometimes they even crawl over dew-drenched fields—winding up in lakes with no links to the sea." There they may remain for 10, 20, or even 40 years before they return to the ocean to spawn.[11]

Native to Florida waters: American eel *(Anguilla rostrata)*. Thousands of eels inhabit Florida's underwater caves. These were photographed in Morrison Spring in Walton County.

FLORIDA AND THE OCEAN

The migrations of fish, sharks, whales, sea turtles, and eels link Florida to the ocean and the rest of the world and demonstrate again that, as in the terrestrial realm, more than one ecosystem is necessary to ensure the survival of wide-ranging creatures. But besides being a hub for marine migrations, Florida plays another, even more crucial, part in supporting life on this planet—it supports the health of the ocean itself.

The ocean modulates the climate, absorbing heat in summer and releasing it in winter, absorbing heat in the tropics and releasing it at the poles. The ocean also stores carbon, 20 times more carbon than all of the world's forests and other green plants combined, and this trapping of carbon helps counteract excessive greenhouse warming of the planet.[12]

It is the oceans' phytoplankton that accomplish this feat. They produce a third to a half of the planet's oxygen by way of photosynthesis. In the process, they convert atmospheric carbon dioxide, together with water, into sugars. Some 90 percent of the carbon is recycled through marine food webs to the atmosphere, but 10 percent drops to the ocean floor and does not return to surface currents for a thousand years.[13]

The ocean begins at the shore, and the shore is the edge of the land. How we manage Florida's terrestrial ecosystems, then, affects all of the life in the ocean and on the planet.

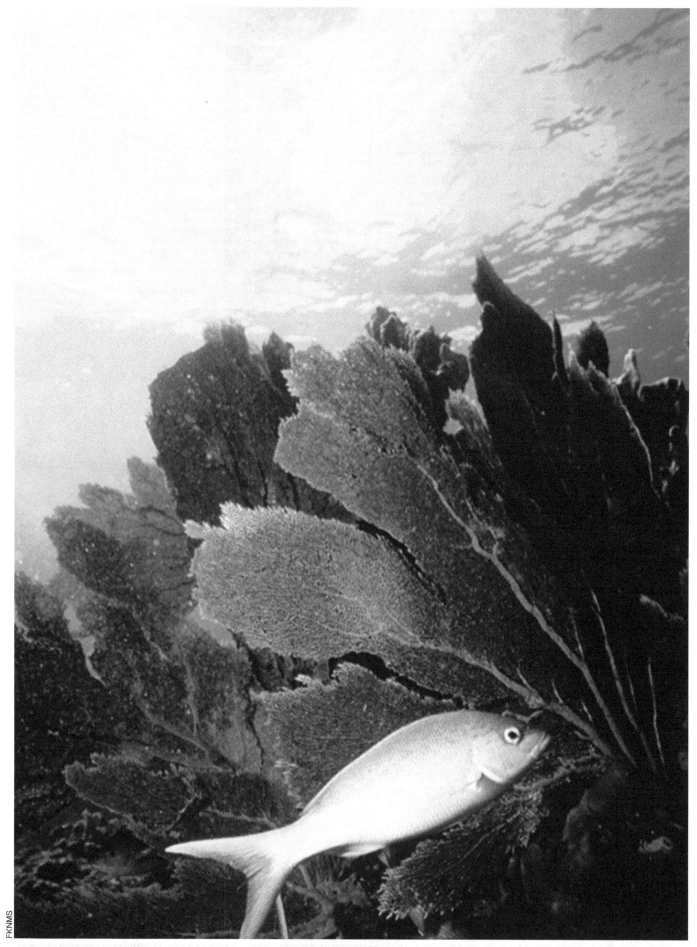

Yellowtail snapper (Ocyurus chrysurus) with seafan in the Florida Keys reefs.

REFERENCE NOTES

CHAPTER 1—FLORIDA'S AQUATIC ECOSYSTEMS

1. Statewide average annual rainfall, 1988 - 2013 (rounded to nearest whole number) from Florida State University Climate Center 2013.

2. Rivers flowing into Florida from the north: the Perdido, Escambia, Yellow, Choctawhatchee, Apalachicola, Ochlockonee, Aucilla, Withlacoochee, Suwannee, and St. Marys rivers.

3. Many lines of evidence testify to the origin of Florida's bedrock as part of what is now Africa. Fossils in Florida's and Africa's limestones from that time are the same. The slant of the magnetic field in materials laid down at that time is 49 degrees in Florida as in Africa, whereas the slant of other North American magnetic fields from the same time is 28 degrees. The rocky sediments deep below Florida's surface materials are of the same age as those of the African mountains.

4. Fernald and Patton 1984, 38.

5. The Floridan aquifer system provides water for several large cities, including Albany, Savannah, and Brunswick in Georgia; and Jacksonville, Tallahassee, Orlando, and St. Petersburg in Florida. In most places, the Floridan system is divided into two layers, separated by a less-permeable confining layer. Much of the Lower Floridan contains salty water, which cannot meet the water needs of most animals and plants in natural communities and is not useful for most human purposes.

6. The Biscayne is a major source of water for Key West, Dade, Broward, and the southeastern part of Palm Beach counties. Different parts of the Biscayne are made of different materials: sand, shell, silt, clay, and mixtures of these.

7. Inventory and definition of natural aquatic communities from *Guide* 2010, 3, 7.

8. Discussion of the term *natural* inspired by Clewell 2000.

9. Under abnormal circumstances, members of two different species may mate and produce hybrids, but usually the hybrids are sterile or unable to compete successfully with the parent species.

10. Mode of speciation from Palumbi 2002; rate from Norton 1986, 121–122; mechanisms from McCook 2002.

11. Species names for plants are from Wunderlin and Hanson 2003; for freshwater fish from Page and coauthors 2011; for marine fish from Anon. c. 1994 (Fishing lines); for amphibians and reptiles from Krysko, Enge, and Moler 2011; and for birds from Bruun and Zim 2001.

12. Heath and Conover 1981, 43; Winsberg 1990, 110; Anon. 1991 (Rainy rescue).

CHAPTER 2—INTERIOR WATERS: LAKES AND PONDS

1. Griffith, Canfield, Horsburgh, and Omernik 1997, 7.

2. Brenner, Binford, and Deevey 1990, 380-381.

3. Franz 1992.

4. Marjorie Stoneman Douglas, quoted in Huffstodt 1992.

5. Huffstodt 1991.

6. Statistics from Heath and Conover 1981.

7. Robert K. Godfrey, comment to D. Bruce Means 1987.

8. Brenner, Binford, and Deevey 1990, 370.

9. Karr and Chu 1999.

CHAPTER 3—ALLUVIAL, BLACKWATER, AND SEEPAGE STREAMS

1. Muir 1915, 100-101, 111.

2. Heath and Conover 1981, 109; Clewell 1991 (Physical environment), 18.

3. River sizes from Heath and Conover 1981, 120, fig. 149.

4. Nordlie 1990.

5. Endemic snails from Nordlie 1990.

6. Stolzenburg 1992.

7. O'Brien and Box 1999.

8. James D. Williams, comment to Ellie Whitney, June 2003.

9. Small stream fish from Bass (Gray) 1991 (Okaloosa darter); Bass (Gray) 1993 (Harlequin darter); Abdul-Samaad 1991 (Blackmouth shiner).

10. Anon. 1986 (Upper Suwannee River); Spivey 1992.

11. Southall 1986; Anon. 1986 (Upper Suwannee River); Spivey 1992.

12. Southall 1986.

13. Sampat 1996.

14. Harris, Sullivan, and Badger 1984.

15. Holtz 1986; Karr 1994; Karr and Chu 1999.

CHAPTER 4—AQUATIC CAVES, SINKS, SPRINGS, AND SPRING RUNS

1. Fernald and Patton 1984, 39.

2. Means 1985 (Georgia blind salamander).

3. Stamm 1991.

4. Florida Springs Task Force 2000; Scott, Means, Means, and Meegan 2002.

CHAPTER 5—COASTAL WATERS: ESTUARIES AND SEAFLOORS

1. Livingston (R.J.) 1991, 550.

2. Rudloe, A., Unpublished manuscript, 2000.

3. Gore 1992, 152.

4. Livingston (R. J.) 1991; seagrasses from Dawes, Hanisak, and Kenworth 1995; algae from Hall and Eiseman 1981; associated animals from Virnstein 1995; bacteria from Garland 1995; mollusks from Winston 1995 and Mikkelsen, Mikkelsen, and Karlen 1995; statistics on Indian River lagoon from Florida Biodiversity Task Force 1993, 3.

5. Livingston (R.J.) 1991, 563-564

6. Livingston (R.J.) 1991, 566.

7. Livingston (R.J.) 1991, 581.

8. Florida Biodiversity Task Force 1993, 3.

9. Florida Biodiversity Task Force 1993, 3.

CHAPTER 6—SUBMARINE MEADOWS

1. Iverson and Bittaker 1986; Zieman and Zieman 1989, 1.

2. Clewell 1976, 5.

3. Zieman and Zieman 1989, 24-25; Whaley 1990.

4. Holdfasts from Zieman and Zierman 1989, 43; seagrass structure from Clewell 1976, 7.

5. A. Rudloe, Unpublished manuscript, 2000.

6. Yokel 1984; Roger I. Hammer, letter to Ellie Whitney, November 2003.

7. Woolfenden and Schreiber 1973.

8. Importance of seagrass beds from Jaap and Hallock 1990.

9. Reiger 1990.

CHAPTER 7—SPONGE, ROCK, AND REEF COMMUNITIES

1. Jaap and Hallock 1990; Reed, Gore, Scotto, and Wilson 1982.

2. Jaap and Hallock 1990.

3. Voss 1988, 30, 32.

4. Wolkomir 1995; Kaufman 1977; Brawley and Adey 1981; Jaap and Hallock 1990.

5. Jaap and Hallock 1990, 603; Den Hartog 1977.

6. Eldredge 1992.

CHAPTER 8—THE GULF AND THE OCEAN

1. Estimate of ocean species from Norman 1988.

2. Angel 1993.

3. Gore 1992, 52.

4. Gore 1992, 139-140.

5. Salt dome ecosystem from Anon. 1997 (Gulf worms); description and number of salt domes from Gore 1992, 65-67.

6. Anon. 1997 (Gulf worms).

7. Anon. 1997 (Gulf worms).

8. Right whale information from Neuhauser 1993.

9. Lohmann 1992.

10. Horton 1987, 48-52.

11. Wisenbaker 1997.

12. Weber 1993, 41-43.

13. Weber 1993, 42-43.

BIBLIOGRAPHY

Abdul-Samaad, M. 1996.Delicate Balance (Blackmouth shiner). *Florida Wildlife* 50 (July-August): 32

Angel, M. V. 1993. Biodiversity of the pelagic ocean. *Conservation Biology* 7:4 (December): 760-772.

Anon. 1986. Upper Suwannee River. *ENFO* (September): 9-10.

Anon. 1991. Rainy rescue. *Tallahassee Democrat,* 12 January.

Anon. c. 1994. *Fishing Lines.* Tallahassee: Department of Environmental Protection.

Anon. 1997. Gulf worms. *Scientific American* (November): 24.

Bass, D.G., Jr. 1991. Riverine fishes of Florida. In Livingston 1991 (q.v.), 65-83.

Bass, Gray. 1991. Delicate balance (Okaloosa darter). *Florida Wildlife* 45 (May-June): 29.

————. 1993. Delicate balance (Harlequin darter). *Florida Wildlife* 47 (March-April): 9. 391

Bennington, S. 2003. Caribbean conga. *Blue Planet* (Summer): 8-10.

Brawley, S.H., and W.H. Adey. 1981. The effect of micrograzers on algal community structure in a coral reef microcosm. *Marine Biology* 61: 167-177.

Brenner, M., M. W. Binford, and E. S. Deevey. 1990. Lakes. In Myers and Ewel 1990 (q.v.), 364-391.

Clewell, A.E. 1976. Coastal wetlands (unpublished manuscript).

————. 1991. Florida rivers (The physical environment). In Livingston 1991 (q.v.), 17-30.

————. Restoring for natural authenticity. *Ecological Restoration* 18 (Winter): 216-217.

Conover, A. 1998. To reproduce, mussels go fishing. *Smithsonian* 29 0anuary), 64-71.

Dallmayer, R. D. 1987. 40Ar/39Ar age of detrital muscovite within lower Ordovician sandstone in the coastal plain basement of Florida. *Geology* 15: 998-1001.

Dawes, C.J., D. Hanisak, and W.J. Kenworth, 1995. Seagrass biodiversity in the Indian River Lagoon. *Bulletin of Marine Science* 57: 59-66.

Den Hartog, J. 1977. The marginal tentacles of *Rhodactis sanctithomae* (Corallimorpharia) and the sweeper tentacles of *Montastraea cavernosa* (Scleractinea). *Proceedings of the Third International Coral Reef Symposium*, Miami, Florida 1: 463-469.

Eldredge, M. 1992. Management of Florida Keys must involve entire ecosystem. *Marine Conservation News* (Winter): 10.

Fernald, E. A., and D. J. Patton, eds. 1984. *Water Resources Atlas of Florida*. Tallahassee: Florida State University Institute of Science and Public Affairs.

Fernald, E.A., and E.D. Purdum, eds. 1992. *Atlas of Florida*. Gainesville: University Press of Florida.

Florida Biodiversity Task Force. 1993. Conserving Florida's biological diversity: A Report to Govenor Lawton Chiles. Tallahassee: State of Florida, Office of the Govenor. Photocopy.

Florida Springs Task Force. 2000. *Florida Springs*. Prepared for D.B. Struhs, secretary, Department of Environmental Protection and the citizens of the state of Florida (November).

Florida State University Climate Center 2013. http://climatecenter. fsu.edu/products-services/data/statewide-averages/ precipitation.

Franz, S. 1992. Swarming mayflies. *Florida Wildlife* 48 (May-June): 6-7.

Garland, J. L. 1995. Potential extent of bacterial biodiversity in the Indian River Lagoon. *Bulletin of Marine Science* 57: 79-83.

Gore, R.H. 1992. *The Gulf of Mexico*. Sarasota, Fla.: Pineapple Press.

Griffith, G., D.E. Canfield, Jr., C.A. Horsburgh, and J.M. Omernik. 1997. *Lake Regions of Florida*. Corvallis, Ore.: U.S. Environmental Protection Agency.

Guide 1990. *Guide to the Natural Communities of Florida*. 1990. Tallahassee: Florida Natural Areas Inventory and Department of Natural Resources.

Guide 2010. *Guide to the Natural Communities of Florida*. 2010. Tallahassee: Florida Natural Areas Inventory.

Hall, M.O., and N.J. Eiseman. 1981. The seagrass epiphytes of the Indian River, Florida, I. Species list with descriptions and seasonal occurrences. *Botanica Marina* 24: 139-146.

Harris, L.D., with R. Sullivan and L. Badger. 1984. *Bottomland Hardwoods*. IFAS document 8-20M-84. Gainesville: IFAS.

Heath, R.C., and C.S. Conover. 1981. *Hydrologic Almanac of Florida*. Open-File Report 81-1107. Tallahassee: Florida Department of Environmental Regulation.

Holtz, S. 1986. Bringing back a beautiful landscape. *Restoration and Management Notes* (Winter): 56-61.

Horton, T. 1987. The passion of eels. In *Bay Country,* 48-52. New York: Ticknor and Fields.

Huffstodt, J. 1991. Lake Okeechobee. *Florida Wildlife* 45 (March-April): 10-12.

————. 1998. Saving the Florida Keys. *Florida Wildlife* 52 (May-June): 16-19.

Iverson, R.L., and H.F. Bittaker. 1986. Seagrass distribution and abundance in eastern Gulf of Mexico coastal waters. *Estuarine Coastal and Shelf Science* 22: 577-602.

Jaap, W.C., and P. Hallock. 1990. Coral reefs. In Myers and Ewel 1990 (q.v.), 574-616.

Johnson, C. 1996. Spring into summer. *Florida Water* (Spring/Summer): 2-5.

Jones, W. K., H. Cason, and R. Bjorklund. 1990. *A LiteratureBased Review of the Physical, Sedimentary, and Water Quality Aspects of the Pensacola Bay System*. Water Resources Special Report 90-3 (May). Pensacola: Northwest Florida Water Management District.

Kaplan, E.H. 1982. *A Field Guide to Coral Reefs: Caribbean and Florida*. Boston: Houghton Mifflin.

Karr, J. 1994. Marine and estuarine bioassessment, a presentation made at the Florida Surface Water Quality Conference, Tallahassee, 23 September.

Karr, J.R., and E.W. Chu. 1999. *Better Biological Monitoring*. Covelo, Calif.: Island Press.

Kaufman, L. 1977. The three spot damsel fish. Proceedings of the *Third International Coral Reef Symposium,* Miami, Florida 1: 559-564.

Krysko, K. L., K.M. Enge, and P. E. Moler. 2011. *Atlas of Amphibians and Reptiles in Florida*. Final Report, Project Agreement 08013, Florida Fish and Wildlife Conservation Commission, Tallahassee, Fla.

Livingston, A.E., ed. 1991. *The Rivers of Florida*. New York: Springer Verlag.

Lohmann, K.J. 1992. How sea turtles navigate. *Scientific American* (January): 100-106.

Lyons, W.G., D.G. Barber, S.M. Foster, F.S. Kennedy, Jr., and G.R. Milano. 1981. The spiny lobster, *Panulurus argus,* in the middle and upper Florida Keys. *Florida Marine Research Publication* 38 (February) .

McCook, A. 2002. You snooze, you lose. *Scientific American,* April: 31.

Means, D.B. 1985. (Georgia blind salamander). *Florida Wildlife* 39 (November-December): 37.

————. 1991. Florida's steepheads. *Florida Wildlife* 45 (May-June): 25-28.

Mikkelsen, P.M., P. S. Mikkelsen, and D.J. Karlen. 1995. Molluscan biodiversity in the Indian River Lagoon. *Bulletin of Marine Science* 57: 94-127.

Muir, J. [1916.] *Thousand-Mile Walk to the Gulf,* reprinted 1981. Boston: Houghton Mifflin.

Neuhauser, H. 1993. Florida waters critical to right whale survival. *Florida Naturalist* (Fall): 4-7.

Nordlie, F.G. 1990. Rivers and springs. In Myers and Ewel1990 (q.v.), 392-425.

Norman, M.E. 1998. The year of the oceans. *Earth Island Journal* (Spring): 23.

Norton, B.G., ed. 1986. *The Preservation of Species*. Princeton, N.J.: Princeton University Press.

O'Brien, C.A., and J.B. Box. 1999. Reproductive biology and juvenile recruitment of the shinyrayed pocketbook, *Lampsilis subangulata* (Bivalvia: Unionidae) in the Gulf coastal plain. *American Midland Naturalist* 142: 129-140.

Opdyke, N.D., D.S. Jones, B.F. MacFadden, D.L. Smith, P. A. Mueller, and R.D. Shuster. 1987. Florida as an exotic terrane. *Geology* 15: 900-903.

Page, L.M., M. Brooks, E.C. Burr, J.S. Beckham, J. Tomelleri, and J.P. Sherrod. 2011. *Peterson Field Guide to Freshwater Fishes*, 2nd ed. (Peterson Field Guides). Boston, Mass.: Houghton Mifflin.

Palumbi, S. 2002. Evolution, synthesized. *Harvard Magazine* (March-April): 26-30.

Peterson, R.T. and L.A. Peterson, *Peterson Field Guide to Birds of North America* (New York: Houghton Mifflin, 2008).

Pojeta, J., Jr., J. Kriz, and J.M. Berdan. 1976. Silurian-Devonian pelecypods and Palaeozoic stratigraphy of subsurface rocks in Florida and Georgia and related Silurian pelecypods from Bolivia and Turkey. *U. S. Geological Survey Professional Papers* No. 879: 1-39.

Reed, J.K., R. Gore, L. Scotto, and K. Wilson. 1982. Community composition, structure, areal, and trophic relationships of decapods associated with shallow- and deep-water *Oculina varicosa* coral reefs. *Bulletin of Marine Science* 32: 761-786.

Reiger, G. 1990. Symbols of the marsh. *Audubon* (July): 52-58.

Rupert, F., and S. Spencer. 1988. *Geology of Wakulla County, Florida*. Florida Geological Survey Bulletin No. 60. Tallahassee: Florida Geological Survey.

Sampat, P. 1996. The River Ganges' long decline. *World Watch* (July/August): 25-32.

Scott, T.M., G.H. Means, R.C. Means, and R.P. Meegan. 2002. *First Magnitude Springs of Florida, Open File Report No. 85*. Tallahassee: Florida Geological Survey

Southall, P.D. 1986. Living resources of the Suwannee. *ENFO* (September): 13-14.

Spivey, T. 1992. The Suwannee River. *Florida Water* (Fall): 12-14.

Stamm, D. 1991. Springs of passage. *Florida Wildlife* 45 (July-August): 19-23.

Stolzenburg, W. 1992. The mussels' message. *Nature Conservancy Magazine* (November/December): 16-23.

Suwannee River Task Force. 1989. Report pursuant to Governor Bob Martinez's executive order 88-246. Issues and Draft Recommendations. Tallahassee: State of Florida, Office of the Governor, 21 July. Photocopy.

USGSLIST (World Wide Web): 13 March 1998.

Virnstein, R.W. 1995. Anomalous diversity of some seagrass-associated fauna in the Indian River Lagoon, Florida. *Bulletin of Marine Science* 57: 75-78.

Voss, G.L. 1988. *Coral Reefs of Florida*. Sarasota, Fla.: Pineapple Press.

Weber, P. 1993. Safeguarding oceans. In *State of the World* 1994, ed. L.R. Brown, 41-60. New York: Norton.

Whaley, R. 1990. Causes of seagrass decline in the Tampa Bay area. *Palmetto* (Spring): 7-10.

Winston, J.E. 1995. Ectoproct diversity of the Indian River coastal Lagoon. *Bulletin of Marine Science* 57: 84-93.

Wisenbaker, M. 1994. Florida's aquatic cave animals. *Florida Wildlife* 48 (January-February): 14-17.

———. 1997. A well-traveled fish. *Florida Wildlife* 51 (March-April): 27-29.

Wolkomir, R. 1995. Seeking gifts from the sea, Sanibel-style. *Smithsonian* (August): 60-69.

Woolfenden, G.E., and R.W. Schreiber. 1973. The common birds of the saline habitats of the eastern Gulf of Mexico. In *A Summary of Knowledge of the Eastern Gulf of Mexico,* ed. J.I. Jones, R.E. Ring, M.L. Rinkel, and R.E. Smith, Section 3J. St. Petersburg: State University System of Florida Institute of Oceanography.

Worthington, L.V. 1980. Sargasso Sea. In *McGraw-Hill Encyclopedia of Ocean and Atmospheric Sciences*, ed. S.P. Parker, 397. New York: McGraw-Hill.

Wunderlin, R.P, and B.F. Hanson. 2003. *Guide to the Vascular Plants of Florida*. 2d. ed. Gainesville: University Press of Florida.

Yokel, B.J. The emigration of juvenile pink shrimp *(Penaeus duorarum)* from a south Florida estuary, 1962-1967: Final report to U.S. Bureau of Commercial Fisheries, 1984.

Zieman, J.C. 1982. *The Ecology of the Seagrasses of South Florida*. Fish and Wildlife Service Biological Report 82/25. Washington, D.C.: National Coastal Ecosystems Team, Office of Biological Services, U.S. Department of the Interior.

Zieman, J.C., and R.T. Zieman. 1989. *The Ecology of the Seagrass Meadows of the West Coast of Florida*. Fish and Wildlife Service Biological Report 85 (7.25). Springfield, Va.: National Technical Information Service.

APPENDIX

TERMS FOR FLORIDA'S AQUATIC ECOSYSTEMS

Beginning in 1981, the Nature Conservancy helped the state to establish the Florida Natural Areas Inventory (FNAI, pronounced EF-nay) to identify the state's natural communities, to single out noteworthy examples of each, and to locate populations of rare and endangered plant and animal species. The resulting *Guide to the Natural Communities of Florida* was released in 1990 and an updated *Guide* came out in 2010.

FNAI's guides are invaluable in providing descriptions and species inventories for Florida's ecosystems. The 2010 *Guide,* however, is incomplete with respect to Florida's aquatic ecosystems. Revised treatments appear for two types of coastal wetlands, salt marshes and mangrove swamps, but not for other coastal ecosystems or for lakes, ponds, streams, or underground caves. The latter categories await a later revision. However, the work already done enables users to appreciate the distinctions and diversity of all of Florida's natural aquatic communities.

The left column of this table lists the names chosen by FNAI in 1990 to identify Florida's aquatic ecosystems. The right column lists the alternative names used in this book, showing in what chapters they are described, mentioned, or depicted. Other authorities use other schemes. No one scheme is perfect: the diversity of systems reflects the diversity of the ecosystems themselves.

FNAI TERMS (2010)	TERMS USED IN THIS BOOK
Lacustrine (Lake/Pond) *Waters*	
Clastic upland lake	Clayhill lake—Ch 2
Coastal dune lake	Coastal dune lake—Ch 2
Coastal rockland lake	Coastal rockland lake—Ch 2
Flatwoods/prairie lake and Marsh lake	Flatwoods/prairie lake—Ch 2
	Cypress pond/donut—Ch 2
	Marsh lake—Ch 2
	Temporary/ephemeral pond—Ch 2
	Depression marsh—Ch 2
River floodplain lake and Swamp lake	Swamp lake—Ch 2
Sandhill upland lake	Sandhill lake—Ch 2
Sinkhole lake	Sinkhole—Ch 4

TERMS FOR FLORIDA'S AQUATIC ECOSYSTEMS (continued)

FNAI TERMS (2010) TERMS USED IN THIS BOOK

Riverine (Flowing) _Waters_

Alluvial stream .. Alluvial stream——Ch 3

Blackwater stream ... Blackwater stream——Ch 3

Seepage stream ... Seepage stream——Ch 3

 Steephead stream——Ch 3

Spring-run stream ... Spring-run/Spring-fed stream——Ch 3

Marine and Estuarine Water

(faunal systems)

Coral reef ... Coral reef——Ch 7

Mollusk reef ... Mollusk/Oyster reef——Ch 5

Octocoral bed

Sponge bed .. Sponge bed——Ch 6

Worm reef .. Worm/vermetid reef——Ch 5

Marine and Estuarine Water

(floral systems)

Algal bed .. Algal bed——Ch 7

Seagrass bed ... Seagrass bed——Ch 5, 7

Subterranean Waters

Aquatic Cave .. Aquatic Cave——Ch 4

Note: under "Marine and Estuarine" communities, FNAI also lists the following three community types: Consolidated substrate, Unconsolidated substrate, and Composite substrate. Little detail is provided about these systems and they are not treated in this book.

Source: Guide 1990, 3.

PHOTOGRAPHY CREDITS

AB/FKNMS = Commander Alan Bunn for FKNMS

ABS = Allen Blake Sheldon

AC = Andrew Chapman, Green Water Labs/BCI Engineers & Scientists

ARP/NOAA = Dr. Anthony R. Picciolo for NOAA

BC = Bruce Colin Photography

BM = Barry Mansell

CC/FPS = Carrie Canfield for FPS

CJ = Chris Johnson, www.FloridaLeatherbacks.com

CWH/NOAA = Commander William Harrigan for NOAA

DA = Doug Alderson

DA/FWM = Doug Alderson, Associate Editor, *Florida Wildlife*

DB/FPS = Dana Bryan for FPS

DBM = D. Bruce Means, Coastal Plains Institute and Land Conservancy

DEP/AQP = Department of Environmental Protection Aquatic Preserves

DN/GSML = David Norris for the Gulf Specimen Marine Laboratory

DP = Diane Peebles

EOL = Encyclopedia of Life, www.eol.org

EW = Ellie Whitney

FKNMS = Florida Keys National Marine Sanctuary

FLAUSA = Visit Florida

FPS = Florida Park Service, www.FloridaStateParks.org

GB/FFWCC = Gray Bass for FFWCC

GHM = Guy Harley Means

GSML = Gulf Specimen Marine Laboratory

GW/OAR/NURP = G. Wenz for OAR, NURP

HD/FKNMS = Heather Dine for FKNMS

HLJ/USGS = Howard L. Jelks for the U.S. Geological Survey

IM/OAR/NURP = Ian MacDonald for OAR/NURP

JD/FFWCC = Jay DeLong for FFWCC

JH = Joe Halusky

JH/RG = Jerry Hawthorne of River Graphics

JP/IQM = Justin Peach for Image Quest Marine

JR = Jeff Ripple, Photographer, PO Box 142613, Gainesville, FL 32614

JT = Jerry Turner, 28 Pebble Pointe, Thomasville, GA 31792

JV = James Valentine, Photographer

JV/FPS = James Valentine for FPS

JW/FPS = Jerry White for FPS

KC/FPS = Kathleen Carr for FPS

LL/FPS = Larry Lipsky for FPS

LZ/FKNMS = Larry Zetwoch for FKNMS

MAB = Mikhail A. Blikshteyn, www. CHEREPASHKA.com

MJA = Matthew Aresco, Biologist, Florida State University

MM = Mary Matthews, Photographer, Tallahassee

MS = Michael Spelman

MW = Michael Wisenbaker, Outdoor Photographer, Tallahassee

NB = Nancy Bissett, Green Horizon Land Trust

NB/USGS = Noah Burkhalter for the U.S. Geological Survey

NOAA = National Oceanographic and Atmospheric Administration

NURP = National Undersea Research Program, NOAA

OAR = Oceanographic and Atmospheric Research, NOAA

PB/IQM = Peter Batson for Image Quest Marine

PG/FKNMS = Paige Gill for FKNMS

PG/NOAA = Paige Gill for NOAA

PKS = Pam Sikes, Photographer, P.O. Box 997, Folkston, GA, stpsikes@alltel.net

PP/IQM = Peter Parks for Image Quest Marine

RB/OAR/NURP = R. Bray for OAR/NURP

RC/OAR/NURP = R. Cooper for OAR, NURP

RLH = Roger L. Hammer

RP/NOAA = Ron Phillips for NOAA

RPP = Rick Poley Photography, 12410 Green Oak Lane, Dade City, FL 33525

RS/IQM = Roger Steene for Image Quest Marine

RS/OAR/NURP = R. Steneck for OAR, NURP

RW = Russ Whitney

SFWMD = South Florida Water Management District

SMS = Steven M. Sikes

SSC = www.Seashells.com

TN/NOAA/NURP = T. Niesen, NOAA, NURP

USFWS = United States Fish and Wildlife Service

WR = William Rossiter, Cetacean Society Intl., www.csiwhalesalive.org

INDEX TO SPECIES

The several hundred plants, animals, and other living things that appear in this book's photos and lists are listed here by their common names, followed by their scientific names. Page numbers in boldface type indicate photos and drawings (eg., **60**). Page numbers in regular type indicate mentions of the species in the text and lists (eg., 60).

Finding species by their common names is often difficult, because, although there are standards for common names, names in popular use do vary and also change over time. Should it be difficult to locate a species by a familiar name such as "Tarpon," try prefacing the name with "American," "Atlantic," "Common," Florida," "Gulf," "Florida," Northern," or "Southern." The common name of the tarpon, for example, is "Atlantic tarpon." Endemic species are identified as such.

Most scientific names are italicized two-word phrases. The first word refers to the genus (a category that includes several or many closely related species). The second word identifies the species. The genus name is capitalized and the species name is always lower case even if it is a country or a person's last name. Thus the Atlantic tarpon's scientific name is *Megalops atlanticus*. In some instances, an organism is identified only down to the genus level. In that case, the entry reads like this: "Bogbutton, *Lachnocaulon* species."

In some instances, an organism is identified only down to the genus level. In that case, the entry reads like this: "Arrowhead (*Sagittaria* species)."

The authorities used here for common and scientific names are listed in the Reference Notes for Chapter 1 (note 11).

A

Actinocyclus species (a diatom), **71**

Adeonellopsis species (a bryozoan), **104**

Alabama waterdog *(Necturus alabamensis),* 27, 42, 45, 46

Alligator snapping turtle *(Macrochelys temminckii),* 42, 45

Almaco jack *(Seriola rivoliana),* 120

Alphabet cone *(Conux spurius),* 83

American alligator *(Alligator mississippiensis),* 28, 30, 42, 45

American eel *(Anguilla rostrata),* 38, 42, 55, 124, **124**

American lotus *(Nelumbo lutea),* **5,** 20, 26

American shad *(Alosa sapidissima),* 62, **77**

American white waterlily *(Nymphaea odorata),* 20

Angel wings *(Cyrotopleura costata),* **84**

Angulate periwinkle *(Littorina angulifera),* **83**

Anhinga *(Anhinga anhinga),* **65**

Antillean glassy bubble *(Haminoea succinea),* 92

Apalachicola dusky salamander *(Desmognathus apalachicolae),* 46

Aphanizomenon (a species of cyanobacteria), **22**

Apple snail *(Pomacea palludosus),* 60, 61

Apple snail eggs, **62**

Arrowhead (*Sagittaria* species), 20, 26

Atlantic bay scallop *(Argopecten irradians),* 92

Atlantic croaker *(Micropogonias undulatus),* **79**

Atlantic ribbed mussel *(Geukensia demissa),* 92

Atlantic ridley *(Lepidochelys kempii),* **123**

Atlantic sharpnose shark *(Rhizoprionodon terraenovae),* **79**

Atlantic spotted dolphin *(Stenella frontalis),* 116

Atlantic tarpon *(Megalops atlanticus),* 95

Aulacoseira (a species of algae), **22**

B

Balloonfish *(Diodon holocanthus),* **115**

Banded sunfish *(Enneacanthus obesus),* 45

Banded topminnow *(Fundulus cingulatus),* 45

Banded water snake *(Nerodia fasciata),* 28, 29

Bannerfin shiner *(Cyprinella leedsi),* 45

Barbour's map turtle *(Graptemys barbouri)* Florida endemic, 13, 40, 41

Barking treefrog *(Hyla gratiosa),* **35**

Beaded periwinkle *(Tectarius muricatus),* **83**

Beakrushes *(Rhynchospora* species), 26

Beaver *(Castor canadensis),* 25, 26, 42, 45, 54, 56

Belted kingfisher *(Megaceryle alcyon),* 26, 42

Big floatingheart *(Nymphoides aquatica),* 20

Black crappie *(Pomoxis nigromaculus),* 25, 45, 48

Black drum *(Pogonias cromis),* **79**

Blackbanded darter *(Percina nigrofasciata),* 39, 46

Blackbanded sunfish *(Enneacanthus chaetodon),* **35**

Blackmouth shiner *(Notropis melanostomus),* Florida endemic, 41, 45

Blackspotted topminnow *(Fundulus olivaceus),* 39, **46**

Blacktail redhorse *(Moxostoma poecilurum),* 39

Blacktail shiner *(Cyprinella venusta),* 39, 45, **46**

Bladderwort (*Utricularia* species), 20, **23,** 26

Blainville's beaked whale *(Mesoplodon densirostris),* 116

Blind cave crayfish *(Troglocambarus maclanei)*, 55, **56, 57**

Blue crab *(Callinectes sapidus)*, 76, 77, **78,** 91

Blue mussel *(Mytilus edilis)*, **84**

Blue whale *(Balaenoptera musculus)*, 116

Bluegill *(Lepomis macrochirus)*, **1,** 21, 25, 27, 39, 42

Bluenose shiner *(Notropis welaka)*, **47**

Bluespotted sunfish *(Enneacanthus gloriosus)*, **24,** 25, 39

Bluestripe shiner *(Cyprinella callitaenia)*, Florida endemic, 41

Bonefish *(Albula vulpes)*, 95

Bonnethead shark *(Sphyrna tiburo)*, vi, **74**

Bottlenose dolphin *(Tursiops truncatus)*, 75, **113**

Boulder coral *(Colpophyllia natans)*, 105

Bowfin *(Amia calva)*, 21, 25, 27, 47, 63

Brain corals *(family Faviidae)*, 105

Branching corals *(Acropora florida* and others), 105

Broadleaf arrowhead *(Sagittaria latifolia)*, 20

Broad-ribbed cardita *(Carditamera floridana)*, 92

Bronze frog *(Lithobates clamitans)*, 46

Brook silverside *(Labidesthes sicculus)*, 25, 39, **47**

Brown alga (a *Sargassum* species), **91**

Brown algae *(Dictyota dichotoma, Padina vickersiae, Sargassum filipendula, Sargassum pteropleuron)*, **91**

Brown bullhead *(Ameiurus nebulosus)*, 27

Brown darter *(Etheostoma edwini)*, 46

Brown water snake *(Nerodia taxispilota)*, 42, 45

Bryde's whale *(Balaenoptera brydei)*, 116

Bryozoans, 76, 91, 99, 100, 101, 102, 103, **104**
 See also Lace bryozoans

Bullfrog *(Lithobates catesbeiana)*, 27

Bushy soft coral *(Plexaura homomalla)*, 105

C

Calico scallop *(Argopecten gibbus)*, **93**

Candy stick tellin *(Scissula similis)*, 92

Caribbean seagrass *(Halophila decipiens)*, **88,** 89

Caribbean spiny lobster *(Panulirus argus)*, 107, **111**

Carolina fanwort *(Cabomba caroliniana)*, 20

Cattails *(Typha* species), 22, 33, 42

Chain diatom (a single-celled algal species), **71**

Chain pickerel *(Esox niger)*, 25, 45

Channel catfish *(Ictalurus punctatus)*, 45

Chicken turtle *(Deirochelys reticularia)*, **25**

Chubsucker *(Erimyzon* species), 21, 27, 45

Clearnose skate *(Raja eglanteria)*, **75**

Clymene dolphin *(Stenella clymene)*, 116

Coastal darter *(Etheostoma colorosum)*, **47**

Coastal shiner *(Notropis petersoni)*, 39

Coleochaete (a species of algae), **22**

Common dolphin *(Delphinus* species), 116

Common marginella *(Prunum apicinum)*, 92

Common musk turtle *(Sternotherus odoratus)*, 28, 42, 45

Common snapping turtle *(Chelydra serpentina)*, 28, 42, 45

Common snook *(Centropomus undecimalis)*, **50**

Common water-hyacinth *(Eichhornia crassipes)*, an exotic pest plant, 11

Coontail *(Ceratophyllum demersum)*, 26

Crappie *(Pomoxis* species), 21, 25, 42

Crayfish *(Procambarus spiculifer)*, **56**

Creek chub *(Semotilus atromaculatus)*, 46

Cross-barreled chione *(Chione cancellata)*, 92

Crystal darter *(Crystallaria asprella)*, Florida endemic, 41

Cuvier's beaked whale *(Ziphius cavirostris)*, 116

D

Darters *(Ammocrypta, Crystallaria, Etheostoma,* and *Percina* species), 42, 45

Deadman's fingers *(Alcyonium digitatum)*, 105

Deep-sea mussels (species unknown), **118**

Deep-sea spider crab (species unknown), **118**

Deep-sea worms (species unknown), **118**

Desmidium (a species of algae), **22**

Diatoms *(Pleurosigma* species, *Actinocyclus* species), **71**

Dollar sunfish *(Lepomis marginatus)*, **24,** 45

Dolphin (fish) *(Coryphaena hippurus)*, **120**

Drift algae *(Laurencia* species and families *Acanthophora, Gracilaria, Hypnea, Spyridea)*, 90, 91

Duckweed (a *Lemna* species), **9,** 20, 26

Dwarf sperm whale *(Kogia sima)*, 116

Dwarf tiger lucine *(Codakia orbiculata)*, 92

E

Eastern mosquitofish *(Gambusia holbrooki)*, **33**

Eastern mud turtle *(Kinosternon subrubrum)*, 28, 30, 42

Eastern newt *(Notophthalmus viridescens)* 25

Eastern oyster *(Crassostrea virginica)*, 83-85, **85**

Eastern purple bladderwort *(Utricularia purpurea)*, **23**

Ebony jewelwing *(Calopteryx maculata)*, **24**

Elegant glassy bubble *(Haminoea elegans)*, 92

Elkhorn coral *(Acropora palmata)*, 105

Encrusting soft coral *(Sympodium* species), 105

Everglades pygmy sunfish *(Elassoma evergladei)*, 45

F

False killer whale *(Pseudorca crassidens)*, 116

Fin whale *(Balaenoptera physalus)*, 116

Fire nudibranch *(Hypselodoris edenticulata)*, **93**

Fire sponge *(Tedania ignis)*, **101**

Flagfin shiner *(Pteronotropis signipinnis)*, 39, **47**

Flamingo tongue snail *(Cyphoma gibbosum)*, **82**

Flathead (striped) mullet *(Mugil cephalus)*, 95

Flier *(Centrarchus macropterus)* 25, 27, 45
Florida cave amphipod *(Crangonyx grandimanus)*, 55, **56**
Florida cooter *(Pseudemys floridana)*, 28, 42, 45
Florida crown conch *(Melongena corona)*, 92
Florida gar *(Lepisosteus platyrhincus)*, 25, 27
Florida Keys sailfin molly *(Poecilia* cf. *latipinna)*, 31
Florida Keys sheepshead minnow *(Cyprinodon* cf. *variegatus)*, 31
Florida pompano *(Trachinotus carolinus)*, **79,** 95
Florida sea cucumber *(Holothuria floridana)*, 92
Florida softshell turtle *(Apalone ferox)*, 28
Fraser's dolphin *(Lagenodelphis hosei)*, 116
Frog's-bit *(Limnobium spongia)*, 20, 26

G

Georgia blind salamander *(Haideotriton wallacei)*, 55, **56**
Gervais' beaked whale *(Mesoplodon europaeus)*, 116
Ghost crab *(Ocypode quadrata)*, 92
Gizzard shad *(Dorosoma cepedianum)*, 42, 45
Golden crab *(Chaceon fenneri)*, **115**
Golden shiner *(Notemigonus crysoleucas)*, 25, 27
Golden topminnow *(Fundulus chrysotus)*, 25, 27
Goldenclub *(Orontium aquaticum)*, 26
Golfball coral *(Favia fragum)*, **101**
Goliath grouper *(Epinephelus itajara)*, **79**
Great barracuda *(Sphyraena barracuda)*, 95
Greater flamingo *(Phoenicopterus ruber)*, **60**
Greater siren *(Siren lacertina)*, **25**
Greedy dove (snail) shell *(Anachis avara)*, 92
Green alga (a *Caulerpa* species), 60, **91**
Green turtle *(Chelonia mydas)*, **123**
Gulf flounder *(Paralichthys albigutta)*, **76**
Gulf pipefish *(Syngnathus scovelli)*, 39
Gulf sturgeon *(Acipenser oxyrinchus desotoi)*, **63**
Gulf toadfish *(Opsanus beta)*, **75**

H

Halloween pennant dragonfly *(Celithemis eponina)*, **31**
Hamlet fish (a *Hypoplectrus* species), **110**
Harlequin darter *(Etheostoma histrio)*, Florida endemic, 41, 45, **47**
Hatpins *(Eriocaulon* species), 26
Hawksbill sea turtle *(Eretmochelys imbricata)*, **123**
Hermit crab (superfamily Paguroidea), 92
Hippomenella vellicata (a bryozoan), **104**
Horned searobin *(Prionotus* [or *Bellatar] militaris)*, **12**
Hornwort (a *Ceratophyllum* species), 20
Humpback anglerfish *(Melanocetus johnsoni)*, **117**
Humpback whale *(Megaptera novaeangliae)*, 116

I

Inland silverside *(Menidia beryllina)*, 39

Ironcolor shiner *(Notropis chalybaeus)*, 25, 39, 45
Isthmochloron (a species of algae), **22**
Ivory tree coral *(Oculina varicosa)*, 105, **109**

J

Jingles *(Anomia simplex)*, 80

K

Killer whale *(Orcinus orca)*, 116
King mackerel *(Scomberomorus cavalla)*, **115**
Knobby candelabra corals *(Eunicea* species), 105
Knobby purple sea rod (a *Eunicea* species), **107**

L

Lace bryozoans *(Triphyllozoon* species), **104**
Lace murex *(Chicoreus dilectus)*, **83**
Ladyfish *(Elops saurus)*, **79**
Lake chubsucker *(Erimyzon sucetta)*, 27
Lanternfish (a *Diaphus* species), **114**
Largemouth bass *(Micropterus salmoides)* 25, 27
Lavender tube sponge *(Spinosella vaginalis)*, **101**
Least bittern *(Ixobrychus exilis)*, **17**
Least killifish *(Heterandria formosa)* 25
Leatherback sea turtle *(Dermochelys coriacea)*, **123**
Lettuce nudibranch *(Tridachia crispata)*, **93**
Lettuce-leaf corals *(Pectinia lactuca)*, 105
Limpkin *(Aramus guarauna)*, 61, **62**
Lined topminnow *(Fundulus lineolatus)*, 25
Lizard's tail *(Saururus cernuus)*, 26
Lobed ctenophore *(Bolinopsis infundibulum)*, **115**
Lodictyum species (a bryozoan), **104**
Loggerhead sea turtle *(Caretta caretta)*, 121, **122, 123**
Longear sunfish *(Lepomis megalotis)*, 39
Long-horned cowfish *(Lactoria cornuta)*, 95
Longnose shiner *(Notropis longirostris)*, 39
Lousiana waterthrush *(Parkesia motacilla)*, 42

M

Madtom *(Noturus* species), 42
Manateegrass *(Syringodium filiforme)*, **88,** 89, 91
Margined sea star *(Astropecten articulata)*, **67**
Marshpennywort *(Hydrocotyle vulgaris* and other species), 20, 26
Meadowbeauty *(Rhexia* species), 26
Medusa (a *Nausithoe* species), **72**
Melon-headed whale *(Peponocephala electra)*, 116
Merismopedia (a species of cyanobacteria), **22**
Micrasterias (a species of algae), **22**
Microcystis (a species of cyanobacteria), **22**
Minke whale *(Balaenoptera acutorostrata)*, 116
Mole salamander *(Ambystoma talpoideum)*, 27

Moon jellyfish *(Aurelia aurita)*, **103**
Mosquito fern (an *Azolla* species), 20
Mosquitofish *(Gambusia affinis)*, 45
Mud snake *(Farancia abacura)*, 27, **44**
Mud sunfish *(Acantharchus pomotis)*, **44,** 45
Mudmidget (a *Wolffiella* species), 26

N

North American river otter *(Lutra canadensis)*, 42
Northern right whale *(Eubalaena glacialis)*, 116, **119**
Nudibranch *(Phylliroe* bucephala), **70**
Nudibranch species (phylum *Gastropoda)*, 72

O

Okaloosa darter *(Etheostoma okaloosae)*, Florida endemic, 41
Okefenokee pygmy sunfish *(Elassoma okefenokee)*, 25
One-toed amphiuma *(Amphiuma pholeter)*, 46
Osprey *(Pandion haliaetus)*, 51
Oyster. *See* Eastern oyster

P

Panic grasses *(Panicum* species), 26
Pantropical spotted dolphin *(Stenella attenuata)*, 116
Paper fig *(Ficus communis)*, **83**
Paper mussel *(Amygdalum papyrium)*, 92
Parchment (tube) worm *(Chaetopterus variopedatus)*, 92
Parrot feather watermilfoil *(Myriophyllum aquaticum)*, 20
Peninsula cooter *(Pseudemys peninsularis)*, 45
Permit *(Trachinotus falcatus)*, 95
Pickerelweed *(Pontederia cordata)*, 26
Pillar coral *(Dendrogyra cylindrus)*, **110**
Pineland waterwillow *(Justicia angusta)*, endemic, **23**
Pink shrimp *(Penaeus duorarum)*, 77, 91-95, **94**
Pink-tipped anemone *(Condylactus passiflora)*, **97**
Pipefish (a *Syngnathus* species), 39, 48, **87**
Pirate perch *(Aphredoderus sayanus)*, 25, 27, 39, 42
Plainbelly watersnake *(Nerodia erythrogaster)*, 28
Pleurosigma (a diatom species), **71**
Pointed venus (clam) *(Anomalocardia brasiliana)*, 92
Polychaete worm/worms (class *Polychaeta)*,
 13, 94, 102, 111, 115, 118
Pondlilies *(Nuphar* species), 26, 42
Pondweeds, *(Potamogaton* or *Elodea* species), 20
Primrosewillow *(Ludwigia repens)*, 20
Promera tellin *(Tellina promera)*, 92
Purple reeffish *(Chromis cyanea)*, **12**
Purplish tagelus *(Tagelus divisus)*, 92
Pygmy killer whale *(Feresa attenuata)*, 116
Pygmy killifish *(Leptolucania ommata)*, 25, 27, 45
Pygmy sperm whale *(Kogia breviceps)*, 116

Q

Queen angelfish *(Holacanthus ciliaris)*, **110**

R

Rainwater killifish *(Lucania parva)*, 39
Red alga (a *Hymenella* species), **91**
Red salamander *(Pseudotriton ruber)*, 46
Red scaleworm *(Levensteiniella kincaidi)*, **81**
Redbelly watersnake *(Nerodia erythrogaster)*, 45
Redbreast sunfish *(Lepomis auritus)*, 42, 45
Redear sunfish *(Lepomis microlophus)*, 25, 39, **56**
Redeye chub *(Notropis harperi)*, 25
Redfin pickerel *(Esox americanus)*, 27, 45
Red-footed sea cucumber *(Pentacta pygmea)*, **68**
Reticulated brittle star *(Ophionereis reticulata)*, **93**
Risso's dolphin *(Grampus griseus)*, 116
River cooter *(Pseudemys concinna)*, 42
River frog *(Lithobates heckscheri)*, 42
River otter *(Lutra canadensis)*, 45
Rose coral *(Manicina areolata)*, 105
Rose petal tellin *(Tellina lineata)*, 92
Roughback batfish *(Ogcocephalus parvus)*, **114**
Rough-toothed dolphin *(Steno bredanensis)*, 116
Rushes *(Juncus* species), 26

S

Sacred lotus *(Nelumbo nucifera)*, an exotic pest plant, **15**
Sailfin molly *(Poecilia latipinna)*, 30
Sailfin shiner *(Pteronotropis hypselopterus)*, 39, 46, **47**
Sailfish *(Istiophorus platypterus)*, **117**
Saltmarsh snake *(Nerodia clarkii)*, 30
Sand fiddler crab *(Uca pugilator)*, 92
Sand seatrout *(Cynoscion arenarius)*, **79**
Sandweed *(Hypericum fasciculatum)*, **23**
Sawgrass *(Cladium jamaicense)*, 26
Say's mud crab *(Dyspanopeus sayi)*, 92
Scenedesmus (a species of algae), 22
Scytonema (a species of cyanobacteria), **22**
Sea blades *(Pterogorgia* species), 105
Sea fan *(Gorgonia ventalina)*, 105
Sea plume *(Pseudopterogorgia* species), 105
Sea rods *(Rumphella* species), 105
Sea squirt (phylum *Chordata)*, **93**
Seahorse species *(Hippocampus* species), 95
Sei whale *(Balaenoptera borealis)*, 116
Seminole killifish *(Fundulus seminolis)*, **33**
Shark eye or moon snail *(Polinices duplicatus)*, **83**
Sheepshead *(Archosargus probatocephalus)*, **79**
Shinyrayed pocketbook *(Lampsilis subangulata)*, **43**

Shoal bass *(Micropterus cataractae)*, Florida endemic, 41
Shoalweed *(Halodule wrightii)*, **88**
Short-finned pilot whale *(Globicephala macrorhynchus)*, 116
Shortnose sturgeon *(Acipenser brevirostrum)*, Florida endemic, 41
Sirens *(Siren species)*, 25, 27
Skyflower *(Hydrolea corymbosa)*, **23**
Slender spikerush *(Eleocharis species)*, 26
Soft corals (order Alcyonacea), **105**
Southern cricket frog *(Acris gryllus)*, 27
Southern leopard frog *(Lithobates sphenocephala)*, 28
Southern tessellated darter *(Etheostoma olmstedi)*,
 Florida endemic, 41, **47**
Southern watergrass *(Luziola fluitans)*, 20
Spanish hogfish *(Bodianus rufus)*, **110**
Speckled chub *(Macrhybopsis aestivalis)*, 42
Speckled madtom *(Noturus leptacanthus)*, 46
Sperm whale *(Physeter macrocephalus)*, 116
Spikerush *(Eleocharis species)*, 20, 26
Spinner dolphin *(Stenella longirostris)*, 116
Spiny candelabrum *(Muricea muricata)*, **99,** 105
Spiny jewel box *(Arcinella arcinella)*, **83**
Spiny softshell *(Apalone spinifera)*, 45
Sponge zoanthid *(Parazoanthus parasiticus)*, **101**
Spot *(Leiostomus xanthurus)*, 27
Spotfin butterflyfish *(Chaetodon ocellatus)*, **iii, 110**
Spotted bass *(Micropterus punctulatus)*, 45
Spotted cleaner shrimp, *(Periclimenes pedersoni)*, **97**
Spotted gar *(Lepisosteus oculatus)*, 45, **62**
Spotted sunfish *(Lepomis punctatus)*, 39
St. John's wort *(Hypericum species)*, 26
Staghorn coral *(Acropora cervicornis)*, **93,** 105, **106**
Star coral *(Montastraea cavernosa)*, 105
Starlet corals *(Siderastrea siderea)*, 105
Stiff pen shell *(Atrina rigida)*, 92
Stout tagelus *(Tagelus plebeius)*, 92
Stream bogmoss *(Mayaca fluviatilis)*, 20, 26
Striped bass *(Morone saxatilis)*, **38,** 42
Striped dolphin *(Stenella coeruleoalba)*, 116
Sundews *(Drosera species)*, 26
Sunray venus *(Macrocallista nimbosa)*, **85**
Suwannee bass *(Micropterus notius)*, Florida endemic, 41
Suwannee cooter *(Pseudemys concinna suwanniensis)*,
 Florida endemic, **40,** 41, 45
Swamp darter *(Etheostoma fusiforme)*, 25, 27
Swordfish *(Xiphias gladius)*, **117**

T

Tadpole madtom *(Noturus gyrinus)*, 27
Taillight shiner *(Notropis maculatus)*, 27
Tapegrass species *(Vallisneria species)*, 88

Thick finger coral *(Porites porites)*, 105
Thin finger coral *(Porites divaricata)*, 105
Thorny sea star *(Acanthaster planci)*, 92
Threadfin shad *(Dorosoma petenense)*, 25, 45
Tricolored heron *(Egretta tricolor)*, **51**
Tropical royalblue waterlily *(Nymphaea elegans)*, **23**
True tulip (shell) *(Fasciolaria tulipa)*, 92
True's beaked whale *(Mesoplodon mirus)*, 116
Tube coral *(Tubastrea species)*, 105
Turtlegrass *(Thalassia testudinum)*, **88,** 89
Two-lined salamander *(Eurycea bislineata)*, 46
Two-toed amphiuma *(Amphiuma means)*, 25, 28

V

Variegated sea urchin *(Lytechinus variegatus)*, 92
Vase sponge *(Ircinia campana)*, **101**

W

Warmouth *(Lepomis gulosus)*, 25, 39, 42
Water milfoil *(Myriophyllum species)*, 26
Water spangles *(Salvinia minima)*, 26
Waterhyssop *(Bacopa monnieri)*, 20
Waterhyssop *(Bacopa species)*, 26
Waterlily *(Nymphaea species)*, 26, 42
Watermeal *(Wolffia species)*, 26
Watershield *(Brasenia schreberi)*, 26
Waterspider bog orchid *(Habenaria repens)*, 20
Weed shiner *(Notropis texanus)*, 39, 45
Wentletrap *(Epitonium species)*, **83**
West Indian manatee *(Trichechus manatus)*, 95, 116
Western mosquitofish *(Gambusia affinis)*, 25, 27, 30
White marlin *(Tetrapterus albidus)*, **117**
White waterlily *(Nymphaea odorata)*, 26
Widgeongrass *(Ruppia maritima)*, **88**
Wood duck *(Aix sponsa)*, **53**
Woodville [karst] cave crayfish *(Procambarus orcinus)*,
 a Florida endemic species, **v, 57**
Worm seashell *(Vermicularia knorri)*, **83**

Y

Yellow boring sponge *(Siphonodictyon coralliphagum)*, **101**
Yellow bullhead *(Ameiurus natalis)*, 25
Yellow finger sponge (phylum *Porifera*), **101**
Yellow porous coral *(Porites astreoides)*, 105
Yellow waterlily *(Nymphaea mexicana)*, 26
Yellow-bellied slider *(Trachemys scripta)*, 28
Yellow-eyed grass *(Xyris species)*, 26
Yellowfin tuna *(Thunnus albacares)*, **114**
Yellowtail snapper *(Ocyurus chrysurus)*, **126**

GENERAL INDEX

This index points to ecosystems, groups of organisms, geological features, and other topics treated in this book. It shows where information pertaining to particular counties of Florida may be found, and where lists, drawings, maps, and diagrams appear. It identifies with boldface numbers pages where definitions of terms are given.

The many species of animals, plants, and other groups that appear in this book have their own index, which precedes this one.

A

Alachua County, 17, 28, 59
Alapaha River (photos), 6
Algae, **22, 87**
 On coastal seafloors (list), 91
 Photos, 91
Alien species, **12**
Alluvial stream, **36**
Anadromous (fish), **38,** 124
Animals, **14-15**
Aquatic cave at Wakulla Springs (drawing), 54
Aquatic plants, **21**
Aquifers, **7,** 7-10, 32
 diagram, 9
 maps, 8,
Atlantic Ocean, 118-120
 Currents, 118-120
 Migrations, 119-124
 Sargasso Sea, 120-121
Aucilla River (photo), 49

B

Bacteria, **14-15**
Bank reef (drawing), 108
Banks (on seafloors)
 Fishes of (list), 100
Bay County, 59
Bays
 Photo, 66
 Plants and animals in (list), 75
 See also Estuaries
Bedrock, 1, 2, 45
Benthos/benthic community, **23**
Big Blue Lake (photo), 26
Big Shoals on Suwannee River (photo), 48
Bivalves, **83**

Blackwater stream, **36**
 Photo, 44
Bradford County, 44
Bryozoans, **103,** 104

C

Catadromous (fish), **38,** 124
Caves, aquatic, 53-56
 Animals in (lists), 55
Choctawhatchee River (photo), 42
Citrus County, 50, 59, 60, 64
Clastic (sediments), **3**
Clay, 3
Clay County, 44
Clayhill lake (diagram), 19
Cnidarians, **105**
Coastal dune lake (photo), 30
Cobbles, **3**
Coelenterates. *See* Cnidarians
Columbia County, 35, 48, 59
Conchs on the move (photo), 82
Confined aquifer, **7,** 32
Continental drift, 2
Continental shelf, **3**
 Map, 11
 Natural communities on (map), 69
Continental slope, **3**
Creeks, **35**
Cyanobacteria, **22**
Cypress dome/donut, **28**

D

Depression marsh, **29**
Detritus, **40**
Diatoms, **22**
Dixie County, 51
Dolostone, **2**
Dystrophic, **33**

E

Emergent plants, **21**
Endemic species, **15**
 Endemic fish in Florida streams (map), 41
Ephemeral pond, **29**
Escambia Bay flow patterns (drawing), 74
Estuarine community, 133
Estuarine-tolerant (plant/animal), **68**
Estuaries, **50,** 66-85

 Fish in, 79
 Map, 69
 Natural communities in (list), 67
 Photos, 50, 66
 Suwannee River estuary (photo), 50
 See also Seafloors
Eutrophic/Eutrophication, **33**
Exotic species, **12**

F

First-magnitude spring, **1, 58**
Floating plants, **21**
Florida
 Aquatic biodiversity, 10-11
 Aquifer maps, 8, 9
 Aquifers, 7-10
 Coastal landmarks (map), 69
 Continental shelf, **3**
 Earlier contours (diagram), 11
 Early history, 1-2
 First appearance above sea level, 3-4
 Groundwater, 5-7
 Lakes (map), 18
 Native species, 12-15
 Natural communities, 11-12
 Platform (drawing), 3
 Streams (map), 37
 Surface sediments, 2-3
 Surficial aquifers (diagram), 9
 Undersea history (drawings), 2
 See also Lakes and ponds, Streams, Caves, Sinks/Sinkholes, Springs, Estuaries, Seafloors, Seagrass beds, Sponge communities, Rock communities, Reef communities
Florida Bay (photo), 66
Floridan aquifer system, **7,** 32, 54
 Diagrams, 8, 9
Foreshore habitats
 Animals in (list), 92
Fungi, **14-15**

G

Gastropods, **83**
Gilchrist County, 1, 35, 59
Glades County, 29
Gravel, **3**
Groundwater **1,** 5-7, 54
 See also Aquifers

Guana River tributary (photo), 49
Gulf of Mexico, 115-118
 Currents across the Keys (drawing), 107
 Floor of (drawing), 116
 Invertebrates in (list), 115
 Marine mammals in (list), 116
 Sunset (photo), 113

H
Hamilton County, 59
Hendry County, 29
Hernando County, 59
Highlands County, 29
Hillsborough River (photo), 123
Holdfasts, **91**
Hydraulic pressure, **58**
Hydroperiod, **29**

I
Infauna, **80**
Invasive species, **12**
Invertebrates, **14-15**
Invertebrates Gulf of Mexico (list) 115

J
Jackson County, 59
Jefferson County, 49, 59

L
Lacustrine community, 132
Lake Alice, Gainesville (photo), 16
Lake County, 17, 59
Lake Okeechobee (photo), 29
Lakes and ponds, 16-33, **17**
 Animals in (lists), 21, 25, 27-28, 30, 31,
 Classified (list), 18
 Cycling of, 30-32
 Florida lakes (map), 18
 Microscopic plants in (photos), 22
 Plants in (lists), 20, 26
 Plants in (photos), 23
 Zones in (diagram), 20
Leon County, v, 26, 33, 56, 59
Levy County, 5, 49, 51, 59
Liberty County, 49
Limestone, **2**
 Photos, 5
Limnetic zone, **19**
Littoral zone, **19**
Live-bottom communities, **99**
Lafayette County, 50, 59

M
Macroalgae, **22, 87**
Macrofauna, **80**
Madison County, 59
Maps

Bays and estuaries, 69
Continental shelf features, 69
Endemic fish in Florida streams (map), 41
Florida Platform, 3
Floridan aquifer system, 8
Florida's surficial aquifers, 9
Gulf of Mexico, 116
Lakes, 18
Streams, 37
Marine community, 133
Marine sediments, **2**
Marion County, 59, 61, 62
Marsh, **19**
Martin County, 29
Meiofauna, **80**
Microalgae, **22, 87**
Microfauna, **80**
Miami-Dade County, 122
Migrations
 Blue crab, 78
 Eels, 55, 124
 Fish, 76
 Freshwater animals, 76
 Marine animals, 96
 Sea turtles, 121-123
 Sharks, 119-120
 Shrimp, 77, 92-95
 Whales, 120
Monroe County, 99

N
Native species, **12**
Natural community/ecosystem, **13**

O
Ocean space compared with land, 114
Ochlockonee River (photo), 41
Okaloosa County, 40, 44, 45, 46, 47
Okeechobee County, 29
Oligochaete (worms), **80**
Oligotrophic, **33**
Orange County, 17, 32
Organic (sediments), **3**
Osceola County, 17

P
Palm Beach County, 5, 29
Pasco County, 49
Patch reef (drawing), 109
Peacock Spring (photo), 53
Peat, **3**
Pelagic fish, **116**
Pelagic ocean, **116**
 Big fish in (drawings), 117
Perched aquifer, **7**, 32
Phytoplankton, **22**
Pinellas County, 83

Pink shrimp
 Journey of (drawing), 94
 "Menus" (list), 94
Plankton, **22**
Plants, **14-15**
Polk County, 17
Polychaete (worms), **80**
Pond, **17**
 See also Lakes and ponds, Temporary pond
Prairie lakes (photos), 28, 29
Protista, **14-15**

R
Reefs (on seafloors)
 Algae on (list), 91
 Animals in bottom sediments (list), 92
 Bank reef (drawing), 108
 Bryozoans, 103, 104
 Corals, 104-111
 Diagram of, 92
 Fishes of (list), 100
 Inhabitants of, 77-85
 Patch reef (drawing), 109
 Residents and visitors (list), 108
 Shellfishes of (list), 100
 Soft corals of (list), 105
 Sponge communities, 99-103
 Stony corals of (list), 105
 Zones of (drawing), 108-109
 See also Banks; Reefs
Rise, **58**
Riverine community, 133
Rivers, **35**
 Of Florida (map), 37
 See also Streams

S
Sand, **3**
Sandhill lake (diagram), 19
Santa Fe River (photo), 34
Santa Rosa County, 40, 44, 46
Sargasso Sea (diagram), 121
Seagrasses, **87**
 Animals in (list), 92
 First-magnitude, listed, 59-60
 Itemized (list), 88
 Marine fish in (drawings), 96
 Photos, 86, 88
 Source of (diagram), 59
 Young fish in (list), 95
Seaweeds, **87**
Sediments, **2**-3
Seepage stream, **36**
 Origin of (drawing), 45
Silt, **3**
Silver River/Spring (photo), 61
Sinks/sinkholes, 57

Photo, 1
Wet sink (drawing), 57
Spawn/spawning, **78**
Speciation, **13**
Species, **12**
 See also Endemic, Exotic, Invasive,
 Native species
Species losses, 15
Spring run, **36**
Springs, **58**
 Photos, 52, 55, 61
Spring-fed stream/spring run, **36**
St. Johns County, 49
Steephead stream, **36**
 Origin of (drawing), 45
Streams, **35**
Streams, 34-65, **35**
 Alluvial, 37, 40-42
 Animals in (lists), 42, 45, 46
 Blackwater, 37, 43
 Fish habitats in (list), 39
 Florida (map), 37
 Plants in (list), 42
 Quality, 48-51
 Seepage, 37, 43-45
 Spring runs, 59-65
 Steepheads, 36
 Tributaries to Apalachee Bay (list), 73
 See also Suwannee River
Submersed plants, **21**
Subterranean community, 133
Surficial aquifer, **7,** 32
Surficial aquifer system, **8**
Suwannee County, 50, 53, 60
Suwannee River, 45-51
 Photos, 48, 50, 51

Swallet, **58**
Swamp, **19**
Swamp lake (photo), 27

T
Taxonomic diversity, **113**
Taylor County, 60
Tectonic plates, 2
Temporary pond, **29**
 Photos, 31

U
Unconfined aquifer, **7,** 32

V
Vertebrates, **14-15**
Volusia County, 60

W
Waccasassa River (photo), 49
Wakulla County, v, 53, 58, 60
Wakulla Spring (photo), 55
Wakulla Springs cave (drawing), 54
Walton County, 29, 40, 45, 113, 125
Washington County, 26
Water table, **6,** 32, 53
Wetland, **19**
Wetland plants, **21**

Z
Zooplankton, **22**
 Photos, 72
Zooxanthellae, **106**

The other two books in this series of Florida's Natural Ecosystems and Native Species:

Florida's Uplands by Ellie Whitney and D. Bruce Means.
Covers the ecosystems and species of Florida's high pine grasslands, flatwoods and prairies, interior scrub, temperate hardwood hammocks, rocklands and terrestrial caves, and beach-dune systems.

Florida's Wetlands by Ellie Whitney and D. Bruce Means and Anne Rudloe.
Covers the ecosystems and species of Florida's seepage wetlands, interior marshes, interior swamps, coastal intertidal zones, and mangrove swamps.

Florida's Magnificent Coast by James Valentine and D. Bruce Means.
Stunning photography by James Valentine of the coasts from the Georgia border on the Atlantic around the peninsula and through the Keys along the Gulf of Mexico to the Alabama border in the panhandle. Text on the magnificent ecology of Florida's coasts by D. Bruce Means.

Florida's Magnificent Land by James Valentine and D. Bruce Means.
Stunning photography of the wild areas of the state's panhandle and peninsula by James Valentine. Text on the magnificent ecology of Florida's land by D. Bruce Means.

Florida's Magnificent Water by James Valentine and D. Bruce Means.
Stunning photography by James Valentine, both above and below the many forms of the state's waters, and the wild creatures that live in and near them. Text on the magnificent ecology of Florida's waters by D. Bruce Means.

Florida's Living Beaches: A Guide for the Curious Beachcomber by Blair and Dawn Witherington.
Comprehensive accounts of over 800 species, with photos for each, found on 700 miles of Florida's sandy beaches.

Everglades: River of Grass, 60th Anniversary Edition by Marjory Stoneman Douglas with an update by Michael Grunwald.
Before 1947, when Marjory Stoneman Douglas named the Everglades a "river of grass," most people considered the area worthless. She brought the world's attention to the need to preserve the Everglades. In the Afterword, Michael Grunwald tells us what has happened to them since then.

Florida's Rivers by Charles R. Boning.
An overview of Florida's waterways and detailed information on 60 of Florida's rivers, covering each from its source to the end. From the Blackwater River in the western panhandle to the Miami River in the southern peninsula.

Florida's Birds, 2nd Edition by David S. Maehr and Herbert W. Kale II. Illustrated by Karl Karalus.
This new edition is a major event for Florida birders. Each section of the book is updated, and 30 new species are added. Also added are range maps and color-coded guides to months when the bird is present and/or breeding in Florida. Color throughout.

Nature's Steward by Nick Penniman.
Chronicles the development of southwest Florida using the modern-day Conservancy of Southwest Florida as the lens through which to examine environmental history.

Myakka by Paula Benshoff.
Discover the story of the land of Myakka. This book takes you into shady hammocks of twisted oaks and up into aerial gardens, down the wild and scenic river, and across a variegated canvas of prairies, piney woods, and wetlands—all located in Myakka River State Park, the largest state park in Florida. Each adventure tells the story of a unique facet of this wilderness area and takes you into secret places it would take years to discover on your own.

The Trees of Florida, 2nd Edition, by Gil Nelson.
The only comprehensive guide to Florida's amazing variety of tree species, this book serves as both a reference and a field guide.

The Springs of Florida, 2nd Edition, by Doug Stamm.
Take a guided tour of Florida's fascinating springs in this beautiful book featuring detailed descriptions, maps, and rare underwater photography. Learn how to enjoy these natural wonders while swimming, diving, canoeing, and tubing.

St. Johns River Guidebook by Kevin M. McCarthy.
From any point of view—historical, commercial, or recreational—the St. Johns River is the most important river in Florida. This guide describes the history, major towns and cities along the way, wildlife, and personages associated with the river.

Suwannee River Guidebook by Kevin M. McCarthy.
A leisurely trip down one of the best-known and most beloved rivers in the country, from the Okefenokee Swamp in Georgia to the Gulf of Mexico in Florida.

Exploring Wild South Florida by Susan D. Jewell. Explore from West Palm Beach to Fort Myers and south through the Everglades and the Keys. For hikers, paddlers, bicyclists, bird and wildlife watchers, and campers.

Easygoing Guide to Natural Florida, Volume 1: South Florida by Douglas Waitley.
Easygoing Guide to Natural Florida, Volume 2: Central Florida by Douglas Waitley.
If you love nature but want to enjoy it with minimum effort, these are the books for you.

CPSIA information can be obtained
at www.ICGtesting.com
Printed in the USA
BVHW09s0024260918
528484BV00002B/2/P

9 781561 648689